miley cyrus: this is her life

cyrus:

Brittany Kent

Photography by Joe Magnani

BERKLEY BOULEVARD BOOKS, NEW YORK

THE BERKLEY PUBLISHING GROUP

Published by the Penguin Group

Penguin Group (USA) Inc.

375 Hudson Street, New York, New York 10014, USA

Penguin Group (Canada), 90 Eglinton Avenue East, Suite 700, Toronto, Ontario M4P 2Y3, Canada
(a division of Pearson Penguin Canada Inc.)

Penguin Books Ltd., 80 Strand, London WC2R 0RL, England

Penguin Group Ireland, 25 St. Stephen's Green, Dublin 2, Ireland (a division of Penguin Books Ltd.)

Penguin Group (Australia), 250 Camberwell Road, Camberwell, Victoria 3124, Australia
(a division of Pearson Australia Group Pty. Ltd.)

Penguin Books India Pvt. Ltd., 11 Community Centre, Panchsheel Park, New Delhi—110 017, India

Penguin Group (NZ), 67 Apollo Drive, Rosedale, North Shore 0632, New Zealand
(a division of Pearson New Zealand Ltd.)

Penguin Books (South Africa) (Pty.) Ltd., 24 Sturdee Avenue, Rosebank, Johannesburg 2196, South Africa

Penguin Books Ltd., Registered Offices: 80 Strand, London WC2R 0RL, England

MILEY CYRUS: THIS IS HER LIFE

While the author has made every effort to provide accurate telephone numbers and Internet addresses at the time of publication, neither the publisher nor the author assumes any responsibility for errors, or for changes that occur after publication. Further, publisher does not have any control over and does not assume any responsibility for author or third-party websites or their content.

Copyright © 2008 by Brittany Kent
Cover design by Lesley Worrell
Cover photo © Joe Magnani
Interior photos © Joe Magnani
Book design by Georgia Rucker Design

PRINTING HISTORY
Berkley Boulevard trade paperback edition / October 2008

ISBN: 978-0-425-22538-7

PRINTED IN THE UNITED STATES OF AMERICA

10 9 8 7 6 5 4 3 2 1

CONTENTS

introduction:

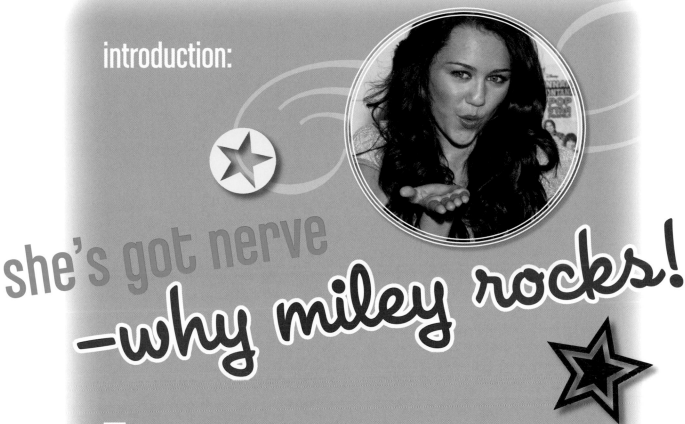

she's got nerve
—why miley rocks!

These days, stars can be known for absolutely anything . . . or for doing nothing at all. Superstar Miley Cyrus is the opposite—she seems able to do just about *everything*, and she does all of it really well!

People ask me all the time why I love Miley, and what it is about her that attracts so many young fans. I tell them that along with being a gifted comic actress, having a really cool voice and lots of catchy songs, *and* being a beautiful role model, Miley's beloved because she's so real.

Another reason for Miley's popularity lies in how inspirational she is, and yet how easy she is to relate to.

Miley was not always a household name, of course—she was an ambitious young girl living in the long shadow of her successful father, country rocker Billy Ray Cyrus. Some might think that coming from that background made it easy for Miley to achieve her goals, but while having money and connections never hurt anyone in the entertainment business, those things can only help get you in the door; once you're there, you have to be able to convince the world that you belong there.

Miley's goal has never been simply to be famous for the sake of fame. Her dreams have been to be a working actress and an inspiring, exciting singer and live performer. It wasn't enough for her to be

Billy Ray Cyrus's daughter; Miley wanted to make a name for herself the old-fashioned way, through hard work and pure talent.

"A lot of the time people won't refer to me by my name; they will call me Billy Ray Cyrus's daughter," Miley has said. "This is the reason I really want to do this, to say I am Miley Cyrus and that I can do this, too. You can either take it or leave it, but I am going to keep going and you don't have to like me, but I really wish you would. I love my dad, but I really want to get away from being known as Billy Ray Cyrus's daughter!"

Those are not the words of a girl looking to tag along on her father's fame; those are the words of a girl determined to make her father and herself proud.

I guess that's the *real* reason I wrote this book, and it's probably the reason you're buying it—Miley Cyrus has enough confidence to know she has talent that is a gift from God and the admirable nerve to push herself in all areas to learn, have fun, and put smiles on all of our faces. She's truly an inspirational young woman.

I hope you have as much fun reading this behind-the-scenes look at every facet of Miley's life and career as I did writing it. Study carefully because—who knows?—you might be inspired by Miley to follow your *own* dreams.

xoxo Brittany Kent

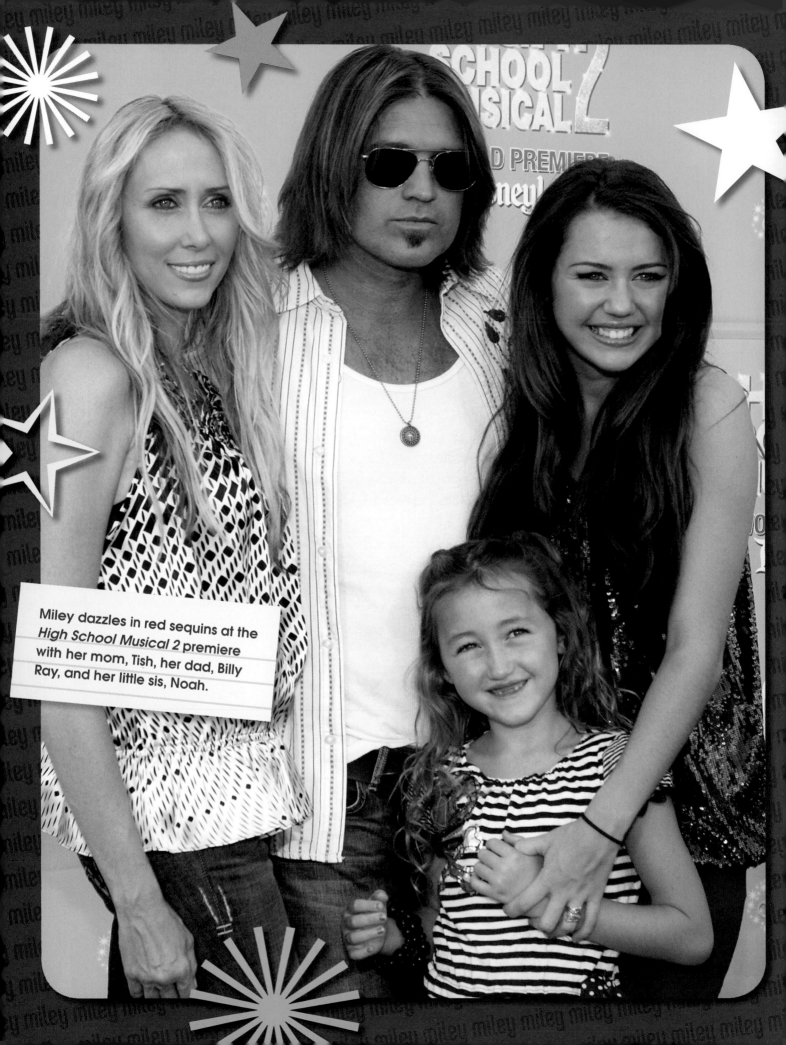

Miley dazzles in red sequins at the *High School Musical 2* premiere with her mom, Tish, her dad, Billy Ray, and her little sis, Noah.

life's what you make it: miley's early years!

In the early '90s, a song called "Achy Breaky Heart" was everywhere, making line dancing cool (temporarily!) and catapulting its singer, country crooner Billy Ray Cyrus, to instant fame. His success, which he compared to a "rocket ride" on ABC's *Primetime*, was so huge that Billy Ray has said it made him "forty million dollars" that first year.

But despite the financial rewards, Kentucky-born Billy Ray, who also helped to popularize the mullet hairstyle (okay, maybe *that* wasn't such a great thing), saw his superstar status go out of fashion faster than his hair. He had the name recognition, but Top 40 radio had cooled on him and he failed to win any of the five Grammys for which he was nominated.

The son of a Democratic politician, Billy Ray had been living the rock-star lifestyle, but found himself ready for a change after his first marriage unexpectedly ended. Then he met and fell in love with Leticia (Tish to friends) Finley, who accepted him as he was and shared his dream of raising a family.

Faced with a choice—either work twice as hard to parlay his initial success into something more lasting, or focus for a while on being a good partner to Leticia and a good father to the kids they planned to have—Billy Ray took the high road.

"You know what, this train may come off the tracks," he later explained to ABC News, "but I'm going to be a dad. I'm going to be a husband and try to have something in my life that is right."

It was into this tumultuous time that Destiny Hope Cyrus was

born, on November 23, 1992, in Franklin, Tennessee. She could not have known the drama her arrival had caused, but she would grow up feeling the love her father showed for her by deciding to devote himself more to her and less to his career.

Not that Billy Ray and Tish settled down and became a boring mom and dad! When her loving parents were married at Billy Ray's sprawling, five-hundred-acre ranch outside Nashville, the *Tyrone Daily Herald* reported that Billy Ray wore "blue jeans and a cut-up sweatshirt" while Tish "wore a dress over a catsuit." Also, Billy Ray never completely abandoned his career; he continued recording and had an array of country hits, steadily working back toward that initial success. But he still put Tish and their kids first in his life.

Even though Destiny was Billy Ray and Tish's first child together, she was certainly not alone growing up. Billy Ray had a son named Christopher Cody from another relationship of his, Tish had daughter Brandi and son Trace from a previous relationship of hers, and the madly-in-love couple would later bring son Braison Chance and daughter Noah Lindsey into the world. Six kids! Just call them "The Cyrus Bunch."

The Cyruses consider themselves to be a very *traditional* kind of *nontraditional*, blended family, one that stays together through thick and thin.

Years later Miley confessed, "I get picked on by the older ones and get to pick on the younger ones, so it all kind of evens out!"

She told *PBS Kids* that to this day she shares a bedroom with little sister Noah, who is the light of her life.

"I think I'm a pretty good sister. When I'm traveling I always bring stuff back for my sibs," she said. But when she and her siblings are doing battle, "I lock myself in my room. I'm the middle child, so I've got an older brother and sister who will be like, 'You're acting

RUMOR PATROL!

One persistent rumor that drives Miley crazy is that her real mom died when she was a little girl, and/or that Tish is her stepmother. The truth is, Tish *is* Miley's real mom! The rumor probably was started by some of her youngest fans who could not separate the *character* Miley Stewart (whose mother, played by Brooke Shields in scenes where Miley thinks about her, passed away) from the *real* Miley Cyrus!

so immature!' and then I'll say, 'Well, I *am* younger than you!' Then I've got a younger brother and sister and I'll say that to them, and they'll say the same thing back. We fight back and forth and it always helps to get away from it for a bit. My mom is always like, 'Rest on it, then wake up and say what you have to say.' Especially when I get tired and hungry, I get cranky and say things I regret."

Miley's home life when she's not working is probably just like yours—filled with love but not without some sibling shenanigans.

At the Disney Channel up fronts she noted, "When I get home, I'm really not in the mood to deal with my brother or my little sister, and so usually I'm kinda snapping at them and I get in trouble, but they understand. They bring it on themselves. It's not my fault!"

Popstar! asked Miley if her brothers reminded her of Miley Stewart's bratty older brother Jackson on *Hannah Montana*. Bingo!

"My brothers are the same as Jackson—my *little* brother is. Me and my big brother are best friends. But my little brother's . . . kind of into the pranking and trying to get me in trouble and my little sister is along with my little brother; they're like a team. And then my big sister's awesome."

> **"Especially when I get tired and hungry, I get cranky and say things I regret."**

DiSNEY PRINCESS!

Just like Miley Stewart, Miley Cyrus has a pretty normal life when she isn't onstage, performing. Still, growing up, she did enjoy a few perks for being the daughter of a multimillionaire singer/songwriter.

For one thing, as she said at the Disney Channel up fronts, "I don't really have the whole 'chore' thing, but my only chore is hanging out with my little sister. She is wild, so that's kind of, you know, my punishment if I'm not acting the way I should!" Billy Ray confirms that Miley has never had to take out the trash.

"I just learned how to use the dishwasher!"

she recently admitted to *PBS Kids*. "That was our rule. The first time, it was like a movie. The bubbles started coming out. I was like, 'Oh, wait, maybe I'm not supposed to just pour the soap all over the inside. Oh, that little container? That's where I'm supposed to put it!' I got in so much trouble!"

She also goofed by shrinking the fave pair of jeans of her mom, Tish. She'd tossed them in the dryer, a major no-no in a house full of tall, long-legged people.

Always looking on the bright side, Miley said, "Now she's got really cute capris!"

Isn't Destiny Hope one of the prettiest names imaginable for a little girl? But no one has actually called Miley by that name since shortly after she was born.

As quoted in *Life Story: Miley Cyrus*, Billy Ray says, "She's just always been smiling. As a little baby, she just had that smile on her face, and as you talk to a little baby you say, 'Oh, she's smiling,' and all that smiling suddenly just became 'Miley.'"

Along with flashing her broad smile, Miley also quickly set herself apart from her peers by demanding attention at every turn. For example, when Billy Ray would be at a gig, she always tried her best to upstage her hardworking daddy.

"I would just go on tour with him and my dad says I would escape from the nanny and run out onstage and have my own little show!" Miley recalled on *Regis & Kelly*. The first song she learned all the way through was Nat King Cole's "L-O-V-E" from the 1998 Lindsay Lohan movie *The Parent Trap*, but the first songs she managed to blurt out onstage while her father was trying to work were the Elvis Presley classics "Blue Suede Shoes" and "Hound Dog."

Billy Ray was back to working, but soon discovered he badly needed a more stable job, one that would not find him traveling away from Tish and his children quite so often. In an AIM interview, Miley recalled:

"It was hard when he was gone on tour all the time, but once i was like 3 he took a little break to take time for his fam i love seeing him back in action on the show =) me parents are really cool! i love chillin wiff em"

Always a handful, Miley's energies usually were focused on singing. "I was always singing the loudest in the shower," she told *PBS Kids*. "I'd be in there for forty-five minutes singing. And I still do! Sometimes I come home and I have my own concert!"

This determination would be somewhat of a silver lining when her family was uprooted, moving to Toronto, Canada, for four years beginning when she was only nine

iT'S A ZOO!

When interviewed for *Popstar!* in July 2006, Miley moped that she "misses my horsies and my puppies and my cat—all my animals, I miss them a lot! I have about seven horses, four dogs, two kitty cats, and eight or nine chickens. And then there's deer and there's animals everywhere because we live on a farm!"

Currently Miley's main pooches are her Shih Tzu, named Loco (which means "crazy" in Spanish), and her Yorkie, named Roadie.

In January 2008, it was reported that Miley had decided to legally change her name from Destiny Hope Cyrus to Miley Ray Cyrus in honor of her father, Billy Ray. At first, fans doubted she'd do this, but Miley confirmed her intentions and filed the necessary paperwork in March, ahead of a May hearing that would finalize the switch.

The public notice Miley filed stated she wished to make her commonly used name match her legal name. Miley told *Entertainment Tonight*'s Jann Carl that she had just always been called Miley by family and friends, so it was only natural to want to make it official. She picked Ray as yet another sign of her love for her father.

"I am getting my license," she told *Access Hollywood*, "so instead of having a thousand different names on it, just having Miley Ray . . . is also kind of cool because my name and my dad's name look alike."

years old. Billy Ray had landed a great, starring role on the PAX-TV series *Doc*, playing a country M.D. trying to adjust to life in the big city. Miley was desperately homesick for Tennessee despite frequent visits, but she had something to distract her—the possibility of her first appearance on TV! Miley started begging to have a small part on *Doc*, a battle she waged for several years before winning it.

See, there was somewhat of a tug-of-war in the Cyrus household over Miley's big dreams of a career in entertainment.

Billy Ray, aware of how wild the ride could be, discouraged his daughter from entering such a punishing profession.

"My dad tried to keep me out of the business," Miley told the *New York Times*, "but my mom was always trying to help me out. My mom is always right!"

At a Disney Channel press conference early in *Hannah Montana*'s run, Billy Ray was asked about his kids going into showbiz, to which he replied, "I always tell them, take a look at everything I did and don't do that." His opinion definitely comes from an educated, protective place.

While in Toronto, Miley studied acting relentlessly. Billy Ray said of his daughter, "The best thing is watching her grow and spending time together, watching her evolve as an actress, knowing she didn't just fall into it. She came to Toronto while I was doing *Doc* in Toronto . . . and studied very, very diligently from great coaches. She really applied herself toward this. She really worked hard to get to this point. For me to be able to see her as—evolving and growing as an actress and also realizing her dream—is very rewarding."

While studying, Miley also tried out for movies and other projects that would film near her Nashville home or her Canadian home-away-from-home. She was thrilled when, at age ten, she landed a bit part in Tim Burton's surreal movie *Big Fish*, which was filmed in Alabama, just one state over from Tennessee. In her first silver-screen appearance, Miley plays eight-year-old Ruthie, who tags along with a group of boys as they stake out the house of a rumored witch. When the boys' language gets too blunt, she pipes up, "You shouldn't swear—there's ladies present!" Her only other line comes when her brother sets off to enter the witch's house on a dare: "Edward, don't!"

This was not exactly a breakout kind of role for Miley, but it gave her experience on a set and placed her in a critically acclaimed major motion picture that also featured major stars such as Ewan McGregor, Helena Bonham Carter, and many others.

To reward his irrepressible offspring for a job well done, Billy Ray finally arranged for Miley to play a little girl named Kylie on the "Men in Tights" episode of *Doc*. It, too, was not a large part, but Miley received close-ups and had to carry an important scene on the challenging drama, which she did with real confidence.

How did she get so good so fast?

You might say she has performing in her blood, with Billy Ray spending the rest of the '90s honing his skills as a showman, older sister Brandi becoming proficient on the guitar (she also attends school in hopes of being a professional photographer), and older brother Trace growing into a fine singer and guitarist. Trace would later cofound the cool indie band Metro Station along with Mitchel Musso's brother Mason.

In one of her most revealing interviews on her drive to become a performer, Miley told *Popstar!* that she "just always loved to dance and I wanted to do Broadway for a long time." Far from New York City or Los Angeles, the entertainment capitals of the country, Miley had improvised . . . with amazing results!

"I was like, 'While I'm in school, I might as well get some dancing and cheerleading.'"

> ## "While I'm in school, I might as well get some dancing and cheerleading."

Cheerleading became an excellent primer for Miley, a way to practice a form of dancing, to build herself up athletically, and to get her used to performing in front of an audience. As she told *Popstar!*, it also was a wake-up call about the pressure-filled world of auditioning, something that would come in handy later, when she was trying out for acting roles.

"You're always so nervous before you audition (for cheerleading) because just like auditioning for a movie or anything, they're going to be pretty harsh, so no matter what they're going to honestly think, they're going to be like, 'You stay, you go home.' That was the most nerve-racking part. They call everyone in a room and either say, 'You're going to be on the poopy squad and you're horrible, go take lessons,' or they have you come in and they're like, 'We need you to come in three more times.' But usually they'll just call you and tell you you made it."

As millions of girls know, cheer can truly help encourage the setting and achieving of goals of all kinds.

"Any time I had to tumble or I had to get a certain skill and I wasn't sure if I could do it—any of those moments were pretty scary. When I started working, I had to do a round-off back handspring tuck. And that one was pretty scary because I didn't know how . . . but now I do!" she asserted to *Popstar!* in August 2007.

Miley was no slacker—she worked hard, making the Premier Tennessee All Stars. "The training is pretty harsh, but it's so worth it once you're onstage and getting trophies," she told *Life Story.*

By age eleven, Miley had performed on TV and in a movie and was about to appear in country artist Rhonda Vincent's "If Heartaches Had Wings" music video as the younger version of a young mother overwhelmed by life's ups and downs. She had become an outgoing, confident young lady, one dead set on making acting and singing her life's work. As much as her father feared for her—his feelings would later be beautifully captured in their hit duet "Ready, Set, Don't Go"—Billy Ray had to admit that Miley's mom, Tish, had had a point when she stuck up for Miley's showbiz goals.

"The most important thing is really staying true to yourself. That's what my mom taught me," Miley told *Us.* "(My mom is) the most beautiful girl, not only on the outside but on the inside. She's teaching me how to be a good person."

The next opportunity to cross Miley's path would be a major step toward her . . . Destiny!

Miley's relationship with her father, Billy Ray, is legendary. Being not only his firstborn daughter, but also a natural entertainer cut from the same cloth as Billy Ray, have probably endeared her all the more to her father.

Her daddy devotion is not only because, as she told the *New York Times*, "in real life, he is a little less strict!" than the dad he plays on TV, but also Billy Ray is not the family disciplinarian. "My dad's like the easy one and if my mom says no, it's like, 'Daddy, I love you,' " Miley has revealed. But just because Billy Ray is an old softie, that doesn't mean Miley isn't punished!

To *PBS Kids*, Miley said, "My dad has never grounded me. He's more of the 'fun' parent. He tells my mom to do it! He'll say, 'She was so bad today, you've got to ground her!' " But Miley also has admitted that when she gets in trouble, it's often for talking back.

Typical punishments for Miley range from restricted use of her beloved Sidekick or computer to being grounded . . . which is hard to enforce when she's on tour or filming!

Miley and Billy Ray usually get along like best friends, but when they fight, they tend to fight over nonsense that has less to do about each other than with all the stress that comes with being in the public eye.

"If we feel like we're both in a bad mood, we just don't talk," she explained to *PBS Kids*. "I was late leaving the set one day because I had to get my makeup done—I got into the products! He was waiting for an hour in the car. So we got into a fight and he told my mom to ground me."

Miley gave one of her most touching interviews regarding her special relationship with her father to *Popstar!* in April 2007, while the teen magazine was covering the annual Disney Channel Games.

Asked if her dad ever embarrasses her (because aren't everybody's parents embarrassing sometimes?), Miley replied, "I just love my dad so much that now I can't even say anything because he gets so sad when he thinks he's embarrassing me." She described how, when they go out shopping together, "He'll be like, 'Yeah, just try your stuff on and come and get me when you need me. I don't want to embarrass you. I don't want to be in your way.' I'm like 'Dad!' "

Billy Ray is so protective of his little girl that he's been known to bring her granola bars, Mike and Ike candies, and Dots when she's under the weather. The most extravagant thing he'll do when Miley is sick or just having a bad day is bring her (and her mom!) chocolates and roses.

"My dad's the best dad in the world!" Miley told *Popstar!*. But even Billy Ray can't do *everything* right. "He'll come home [with a] totally cheap necklace that he thinks is just so cute and it's just *not*. But he'll give it to me and it's just so sweet that he brings it home . . . I have lots of good memories from my dad."

Probably the most moving example of Miley and Billy Ray's love is their duet "Ready, Set, Don't Go," from his hit Disney album *Home at Last*. In it, Miley sings from the perspective of a young girl itching to spread her wings, and Billy Ray sings from the perspective of her supportive but reluctant father.

But maybe the final proof of Miley's devotion to her father is that she has legally changed her name to Miley Ray after him—now, *that's* love!

> **"There's times where I just have to step back and let her do her thing. You'll never hear me give her advice, unless she asked for it. You'll hear her give me a lot of advice!"**
> **—Billy Ray Cyrus on Miley**

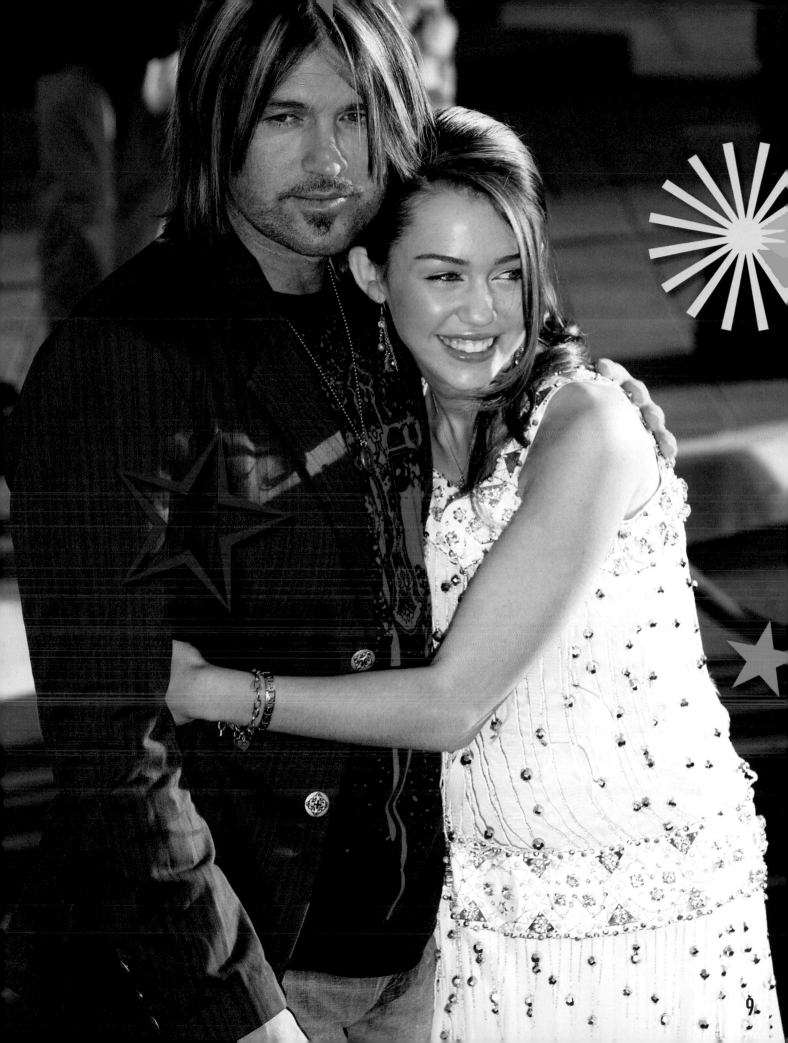

DO YOU HAVE
Star Quality?

Find out if you have what it takes to be the next Miley Cyrus!

I'm likely to be quiet...
A. around large groups!
B. only if absolutely necessary!

I'd rather spend my time...
A. writing poetry!
B. at dance rehearsal!

If people talk about me...
A. it bugs me!
B. it's okay by me!

If I were in the school play, I'd...
A. be nervous!
B. be the lead *again*!

When it comes to having my picture taken, I...
A. am okay with it!
B. can't get enough!

If I met Miley, I'd...
A. be scared to say hi!
B. ask her for advice!

If someone criticizes me, I...
A. use it to grow!
B. ignore it!

Behind the Scenes!

Your impressive talents might be best suited for *off* the stage . . . consider writing music or directing movies!

Diamond in the Rough!

You've got strong skills and a desire to have your voice heard . . . but *nothing* comes easy, so keep working hard!

Star in the Making!

People already recognize your unique talent . . . add to that your charisma and you really *could* be a future superstar!

THE *Ultimate* MILEY TRIVIA TEST

Are you Miley's biggest fan? If you think you know Miley better than she knows herself, take this challenging quiz to test your knowledge!

1. In which state was Miley born?
A. Tennessee
B. Kentucky
C. California

2. What middle name did her mom give her?
A. Destiny
B. Ray
C. Hope

3. What was the name of Miley's first major tour?
A. Meet Miley
B. Life's What You Make It
C. Best of Both Worlds

4. On what Top 40 hit does Miley duet with her father?
A. "Ready, Set, Don't Go"
B. "Start All Over"
C. "Achy Breaky Heart"

5. Miley told *Popstar!* the word "Arkansas" is a special code word she and Emily Osment use in front of Mitchel Musso. What is it code for?
A. To call each other later
B. Cute boys they're talking about
C. Plans they have to prank him

6. Which of these is the name of a pet Miley has at one time owned?
A. Loco
B. Paco
C. Poquito

7. Miley often puts one of these over the "i" in her name when signing autographs. What is it?
A. Star
B. Smiley face
C. Heart

8. Miley first appeared on Disney Channel in what special episode?
A. *Hannah of Waverly Place*
B. *That's So Suite Life of Hannah Montana*
C. *That's So Sweet That Hannah's in the House*

9. During her first Disney Channel Games, Miley lost in rock, paper, scissors to which female superstar?
A. Vanessa Hudgens
B. Ashley Tisdale
C. Raven-Symoné

10. Miley's big bro Trace is the lead singer in which up-and-coming rock band?
A. Paramore
B. Panic At the Disco
C. Metro Station

11. Which holiday song did Miley sing at her first Walt Disney Christmas Parade?
A. "Rockin' around the Christmas Tree"
B. "Silent Night"
C. "Jingle Bells"

12. Miley and Cyndi Lauper presented the Best New Artist Grammy to what famous singer?

A. Taylor Swift

B. Rihanna

C. Amy Winehouse

13. What is Miley's favorite color?

A. Brown

B. Green

C. Pink

14. What is one of Miley's biggest fears?

A. Being onstage

B. Flying

C. Ghosts

15. When Ellen DeGeneres asked Miley which Jonas Brother was her favorite, whom did she pick?

A. Nick

B. Joe

C. Kevin

16. Miley's first TV appearance was on which drama?

A. Law & Order

B. Friday Night Lights

C. Doc

17. The first album Miley ever bought was by which artist?

A. Britney Spears

B. Good Charlotte

C. Herself

18. Miley has said she "idolizes" which female singer?

A. Madonna

B. Mariah Carey

C. Kelly Clarkson

19. In school, Miley was involved in which activity?

A. French club

B. Cheerleading

C. Detention

20. In the song "See You Again," who does Miley quote as saying, "She's just bein' Miley"?

A. Miley's best friend, Lesley

B. Mitchel Musso

C. Nick Jonas

Answers

10. C	20. A
9. A	19. B
8. B	18. C
7. C	17. A
6. A	16. C
5. B	15. A
4. A	14. B
3. C	13. C
2. C	12. C
1. A	11. A

0–5 Right
Miley newbie!
You may not have all the answers, but keep reading!

6–10 Right
Miley booster!
You're definitely more Miley-informed than most!

11–15 Right
Miley superfan!
You really know your Cyrus stuff! Good work!

16–20 Right
Miley genius!
You may know more about Miley than she knows about herself!

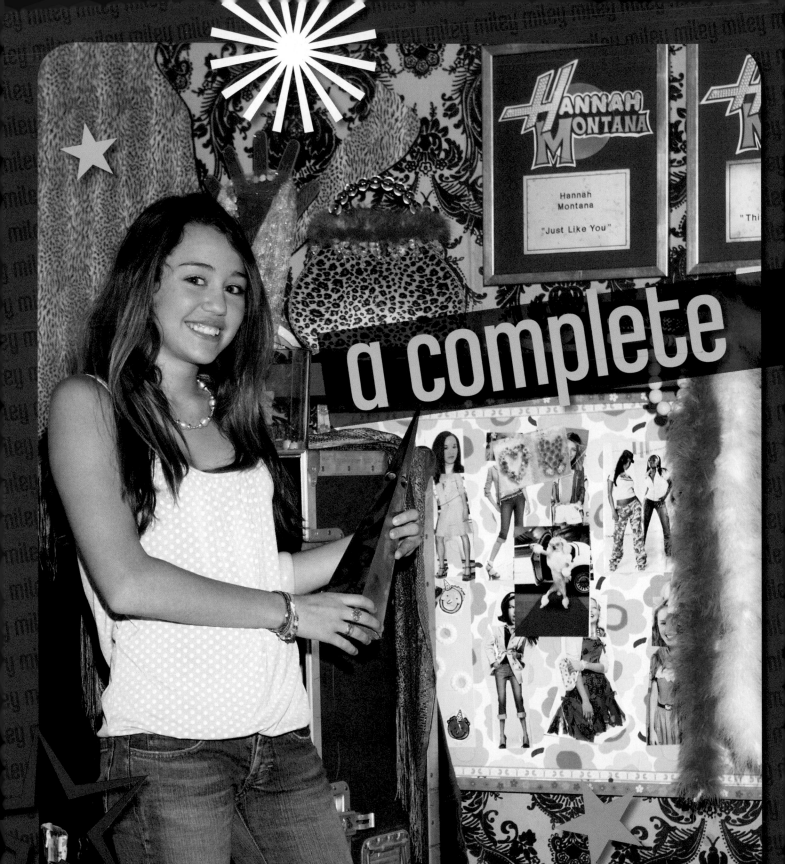

HANNAH MONTANA

Hannah Montana "Just Like You"

a complete

the best of both worlds: hannah history!

Hannah Montana, the biggest tween-targeted TV series in history, began life like any other show—as one of a million ideas being pitched as the next big thing in entertainment.

Michael Poryes, a writer on the popular early '90s show *Saved by the Bell*, was riding high at Disney Channel on the success of the first show he'd ever created, Raven-Symoné's *That's So Raven*. For his next project, he cooked up the idea of a young girl who hides her life as a famous pop star from her friends called *The Idol Life*.

Brilliant, right?

The Disney Channel liked the basic idea, and brought in Emmy Award–winning producer Steve Peterman (who'd worked on famous shows such as *Murphy Brown* and the Brooke Shields comedy *Suddenly Susan*) and his writing partner Gary Dontzig to see how they felt about it.

"Everybody at some time in their life wants to be a rock 'n' roll star," Peterman said at a Disney Channel press conference. "I had band in high school; some of you may have been in bands or played air guitar. I loved that story. But what I also loved about it was Michael created a girl who knew that being a celebrity was great, but that what was most important in life was your family and your friends."

As Miley told popstaronline.com, she always identified with the role for these same reasons. "She's artistic, but behind it all, all she wants is to be with her family and friends. I thought that was a really good thing because it shows that it's not all about the fame or money!"

With some revisions, the pilot was written and the creative team started looking for the right actors. The show's creators have said that they searched for actors all over the world. Billy Ray had always thought Miley would be great on a kids' series and that Disney Channel would be a good home for his wholesome eleven-year-old daughter. So Miley excitedly tried out . . . for the part of sidekick Lilly???

That's right: Miley was going out for the role of Lilly Romero (later changed to Lilly Truscott) until she was encouraged to read the part that would eventually be hers. By all accounts she did very well in her tryout as Lilly, but something wasn't *right*.

Peterman remembered, "There was one girl we kept coming back to. We saw the tape of this skinny, little stick of a girl from Tennessee with this amazing face and these incredible eyes. . . . She was green and inexperienced . . . you couldn't take your eyes off her. There was a wonderful transparency. A sense of a young girl wanting desperately to be something. It was what you would need to see in a girl who would become a rock star."

Whenever fans assume that Miley won the part of Hannah Montana easily thanks to her famous last name, Miley's quick to point out, "Just like everyone else, I had to go through months and months of auditioning. I started the process when I was eleven!" Those auditions are easy to find on YouTube, and they reveal Miley's progress as an actress and also confirm a surprising fact—Miley Stewart's name was originally Zoe Stewart, then was changed to Chloe Stewart (to avoid sounding too much like Nickelodeon's *Zoey 101*).

The problem with her first three auditions for the role of Miley Stewart was not with her talent. " 'You're so young, you're too small . . . maybe in a couple of years there will be something you can audition for' " is how Miley recalls the response from Disney Channel. Even though everyone thought Miley might be too young to anchor an important new show, they loved her talent so much they kept seeing her.

She certainly had the right attitude: "You can bring the whole building. I'll sing for everybody!" she told them.

"This little girl opened up her mouth and this voice came out of her that was from somebody twice as big and several years older with this amazing voice," Peterman said. "And then, of course, then we realized, of course, Miley Cyrus is the daughter of Billy Ray Cyrus, and those genes were very apparent."

¡IDENTITY CRISIS!

an issue Miley has had to overcome is the fact that she, Miley Cyrus, is playing a girl, Miley Stewart, who's secretly a superstar, Hannah Montana. It can get a little surreal for her, causing her to wonder momentarily, "Who am I?" Eventually she learned to have fun with it and to take it as a particularly tough acting challenge.

"Sometimes when I go into my dressing room at lunch," she told *Popstar!* of seeing herself in the Hannah wig, "I'm like, 'Is that me?' It's really cool because it looks nothing like me, which is the point, but it's really neat to see it!"

For a relative newcomer, Miley has handled the dual role of Hannah/Miley Stewart with incredible skill, and she's been able to handle her fame versus her desire to be a normal girl with the same attention to balance. For Miley, focusing on her family and on being grateful for her many blessings have helped keep her head from swelling and also have enabled her to keep her head clear on the distinctions between characters and real life.

Celebrities deal with this kind of issue all the time—nobody is as perfect as they appear to be in teen magazines, and not too many people are able to dress up at movie premieres and look that flawless. It can be a dazzling thing, but Miley knows it's what's in her heart that's real—the rest is certainly fun, but it's also make-believe.

Always conscious of her privilege in playing Hannah, Miley doesn't take her separation of real and fantasy to any extremes—you won't find her bashing Hannah or acting upset if a young fan calls her "Hannah" at a meet-and-greet. That's because it all boils down to self-confidence—something Miley has had down pat ever since she was a little girl.

Frustrated that she kept trying out and kept getting good feedback but couldn't seem to seal the deal, Miley offered to pay for her own flight to come back one more time. Disney Channel's president of entertainment, Gary Marsh, heard about this and insisted she be given another look.

"Well, they wanted you to do seven auditions, but I only had to do four auditions," Miley said at the *New York Times* Sixth Annual Arts & Leisure Weekend in response to a fan's question.

The fourth time was the charm, and everyone decided that Miley *was* Hannah Montana—no doubt about it.

Once Miley had the part, the idea came up of hiring her real-life father, Billy Ray, to play the part of Robbie Stewart.

"I didn't know if I was right for her dad," Billy Ray told the *New York Times*. "The last thing I would want to do is screw up Miley's show."

Concerns aside, the powers that be soon decided that

BILLY RAY PLAYS ROBBIE

Billy Ray's experience on TV would be useful to a cast of young people, and having her real father working by her side would also give confidence to their young lead.

Even more interesting, the casting of Billy Ray and Miley Cyrus changed the direction of the show. As originally written, Hannah was not from the South. Producers recognized that having characters from the "heartland" would be a big plus for the series, since that element is so underrepresented in sitcoms. This twist is where so many of Hannah's catchphrases came from, including her famous exclamation "Sweet niblets!"

As Miley told Kelly Ripa and guest host Jeff Gordon on *Regis & Kelly* in June 2006, "They take things we'll say or joke around about and put it in the show."

Another good reason for hiring Billy Ray was supplied by Miley herself in her first *Popstar!* cover story. "It's good to have him on set. It's a lot easier on my mom because there's five of us . . . she can be home and taking care of them and getting them to school and getting all their stuff organized."

With father and daughter cast, it was time to turn their attention to finding the perfect BFF for Miley Stewart, Lilly Truscott. Emily Osment auditioned for the role and was a front-runner from the very beginning. Miley's acting had grown from her first audition, but Emily was already an old pro, having appeared on TV and in movies—and it didn't hurt that she also has an Oscar-nominated big brother (*The Sixth Sense* star Haley Joel Osment) to look up to. Disney felt that Emily had a great wisecracking, all-American "tough" quality, which was what they were looking for in their Lilly.

For the part of Oliver Oken, Disney brought in TV and movie actor Mitchel Musso, who had just starred in the Disney Channel Original Movie *Life Is Ruff*. Mitchel told *Popstar!* in 2006 that his audition was as wacky as they come. "You know, they called me and . . . I went in and I was like, 'Heck, I'm at Disney where everybody is crazy and fun and they're just so happy!' " So the playful actor decided to act out a scene where his character was sneaking into a second-floor window by using

> "They take things we'll say or joke around about and put it in the show."

the casting room's desk as the window ledge. "If you saw the pilot, it was the scene where I was supposed to be climbing through this window with Emily trying to find Hannah Montana. (The casting people) said I'm supposed to be climbing through a window, so I said, 'Can I lose this chair and use your desk?' So they're all sitting at this big desk and they go, 'Okay, go!' Then, of course, I'm climbing up on their desk and they're like freaking out, going, 'What is this kid doing?' But, I mean, it worked out so well because that's what (Oliver) was supposed to be doing. I guess I just did something that nobody else did." Peeking above the tabletop at the people who would decide if he had the part, Mitchel cracked everyone up—it was *exactly* the kind of stunt Oliver Oken would pull!

This kind of all-or-nothing approach is one the entire cast came to embrace later—they call it "go big or go home," and it means that on rehearsal days (Monday and Tuesday), the actors are free to try different things to see if they'll work. If they get laughs, the writers incorporate them into the final scripts.

Auditioning for the slapstick-driven part of Miley's big brother Jackson, experienced theater actor Jason Earles also impressed the producers when he did something nobody else did—make them laugh! Jason was the only one of their final-round actors who made a sketch involving a ventriloquist's dummy hilarious. Casting Jason was a bit of a risk, considering he's quite a bit older than the teenage character of Jackson (Jason turned thirty-one in 2008), but his youthful appearance coupled with his amazing acting—they envisioned him doing a "master class" on acting for his younger costars—overruled any other considerations.

With their dream cast in place, filming began!

"I tried to say I wasn't, but I was a little nervous," Miley said of that first day. "I was like, 'This is going to be all eyes on me,' and it can be nerve-racking because it's almost like someone's judging you at all times. But once I went in there, it was nothing like that. It was all like family!"

"The first day, I remember . . . I had met Miley previously and I had met Jason and I had met Mitchel, too," Emily recalled for *Popstar!* magazine. "I had basically met everybody except for Billy. (Then) I met him, and that was amazing. And the whole cast clicked. "We were, like, *instantly* best friends, so that was great!" said Emily.

Other names considered before "Hannah Montana" was picked:
- Anna Cabana
- Samantha York
- Alexis Texas

Other names considered before "Miley Stewart" was picked:
- Zoe Stewart
- Chloe Stewart

Other show titles considered before *Hannah Montana* was picked:
- *The Idol Life*
- *The Secret Life of Zoe Stewart*

When children work as actors, there are strict laws that they must have on-set schooling for a certain number of hours every day. "They showed us to the schoolroom and we did school for like three hours," Emily confirmed. But after school, the *real* work began.

"We did table reads forever," Emily said, referring to the process where actors sit around a big table and read their parts just to get used to the dialogue and to give the writers a clear idea of anything that might not be working. "But," she added, "it was so much fun. And we went to In-N-Out the very first day and we were constantly together . . . so it was good. And it's still like that."

It helps that Billy Ray treats everyone on set like family, creating a warm and inviting environment that is reflected in the show itself.

In the same *Popstar!* interview, Mitchel backed up Emily's memory that everyone was comfortable with each other instantly. "To tell you the truth, when we shot the pilot, we just all connected right away. In the audition room, me and Miley and Emily went in together and it was just like, 'This is the team! This is the trio! This is great!' And ever since then . . . best of friends!"

Besides Miley, someone who had a little bit of nervousness as *Hannah Montana* began filming was Jason Earles. He told *Popstar!* that he was "a little intimidated going into it because of the relationship, you know . . . Miley and her dad. They obviously are really family, but that lasted for like a week and ever since then it's just been fun. Everybody really cares about each other and we get along and I think you can see it in the episodes. There's real chemistry there. We *really* have fun playing with each other."

Butterflies aside, everyone agrees that from the very beginning it was apparent that *Hannah Montana* was a winner. "We got this cast together, we did our first pilot, and Michael and I looked at each other and we said, 'We are going to be working on this until these kids are graduating college,'" Steve Peterman remembered.

And the fans were there from the beginning, too: debuting on March 24, 2006, in the United States, *Hannah Montana* scored the highest ratings for any tween-targeted channel in seven years, drawing in more than 5.4 million viewers.

As the first episodes were shot, Miley gained more experience. Memorizing was, at first, a challenge for the twelve-year-old, since the cast gets only a day to learn all their new lines after the writers hand in a revised, final script, but the heavy rehearsal process helped.

"We rehearse so much and we, like, go over it so much in our mind so much, naturally you hear it and—you don't hear your own lines. I know (Emily's) lines better than my lines. I hear hers so it's kind of like in my head already. It's pretty easy. You do it—we have three days to rehearse."

At a Disney Channel press conference, Mitchel said, "I also think that memorizing the lines is really easy because Steve and Michael and Sally and all the other writers totally capture all of our characters."

Miley's biggest problem was that she began mouthing other people's lines without even realizing it. Luckily, she nipped that bad habit in the bud before it got out of hand.

"Interesting!" is how Miley described working with her father every day. While attending a charity event, she was asked to speak about working with Billy Ray instead of an actor who's not related to her. "Sometimes it's good, sometimes it's bad. It kind of depends, you know, on how the day is flowing." But overall, she told gathered press that "sharing this journey with my dad and every day just getting to hang out with my best friend and be with my dad all day" was pure fun.

She also sometimes finds it a little surreal to be acting alongside her father . . . especially when the scene calls for a somber moment. "Sometimes, we'll have these touching scenes, but once they say 'Cut,' we're laughing. We're like, 'This is so not us!' But it's still really fun. It's good for us to get to be together and spend time together," she told popstaronline.com.

Asked what the best part of *Hannah Montana* was in those days, Mitchel said, "Getting to know each other more and getting to know each others' families and how we act and how we are. Just all about us. I mean . . . we're totally best friends, I mean, we're

in this for a good three-year run or possibly more—hopefully more!"

Miley's own favorite part, as she told *Life Story*, was "just going to the set with my dad and getting to see the environment and how much fun it is and how much joy and encouragement there is on the set. Everyone is working together on set, because you're all a team on the show, so it's not like negativity that is going on anywhere else."

The young cast discovered that while they were not *exactly* like the parts they were playing—Mitchel never thought of Miley and Emily as the slightly geeky types they play, and they saw him as more of an actual chick magnet than Smokin' Oken's wannabe chick magnet—they were similar enough that the friendship they were portraying blossomed naturally in real life. They would inject their own pet phrases into the scripts, making the whole thing as real as a sitcom could be.

In fact, Miley was enjoying the show so much she told *PBS Kids* that she'd probably watch *Hannah Montana* as a fan if she weren't on it. "It's hard, because I've already worked on a particular show for a week and I know everything that's happened already. When I watch, I'm like, 'Okay, I've seen this already,' and I get spaced out. I've tried to watch it and see what I would like about it, and what the fans like about it."

Believe it or not, the stars couldn't watch themselves on TV at home when their series premiered—they were working that night! But Emily told *Popstar!* that the show's producers still made the premiere night special for everyone. "It was actually nice because they brought the whole cast together, we had a huge party, and they set up this huge, gigantic big-screen TV and we all watched it on one of the sets, so it was so much fun. We were with everybody. 'Oh, I know your line!' So it was really funny!"

You've heard of overnight fame? That's what happened to the kids of *Hannah Montana*, who were forced to deal with it almost before they realized it was happening.

"We shot about twelve, thirteen episodes before it actually came out," Mitchel remembered to *Popstar!*. "Just watching it was, like, just watching me on TV . . . when I went home and I actually *saw* myself on my TV, it was like, 'Oh, my gosh!' It was a totally different feeling. It changed everything from then on!"

Of the sudden rush of recognition he experienced everywhere he went, Mitchel said, "I love it. I absolutely love it. There's nothing to 'deal with.' It's so cool. It's my favorite. I just want to let all the girls know that if they want to go crazy and grab my hand, that's okay!"

For Jason, the loss of anonymity was a bit strange. "It's taking a little while to get used to it . . . it is still a little weird that all these people know so much about you and you've never met them, but it's cool." He's definitely had his share of crazy fan encounters! "There's been some funny ones where I'll be walking outside, outside at, like, the mall. These three girls came screaming out of a store and they were really excited to meet me and they wanted to take pictures and stuff and I thought it was really cool, but then I asked them how old they were and they were like nineteen. I was like, 'You guys are sort of old for a Disney show!' but they didn't care. They were really excited about it."

Miley, in particular, was shocked that she was unknown one day and famous the next. She told Maya Motavalli of MediaVillage .com that she simply never expected it. "I thought it would take people a while to get on track with it or whatever (because of all the different characters). It caught on pretty quick. I'm really stoked. I love working on it, so I'm happy people are enjoying what we've been doing."

Now that *Hannah Montana* is the number-one tween series in history, Miley's achieved one of her dreams and is actively inspiring many of us toward our own. Asked by *PBS Kids* what advice she has for others who hope to be successful actors, she said, "I think just believe in yourself and be true to yourself. When I was younger, my mom would say that and I'd think, 'That's so silly, like *that* ever really works. It's acting!' But my mom said that even when you're on camera and in character, you have to be true to yourself. Because you don't want to be putting on a show for the rest of your life."

Great advice from a great role model!

ACRO-NaMES!

Popstar! asked the *Hannah Montana* kids to suggest words for each letter of their names that really sum up who they are. Check out their revealing answers!

M "Musical!"
I "I guess you could say interesting!"
L "Loving, I guess."
E "Energetic!"
Y "Young!"

E "Eclectic."
M "Mysterious."
I "Independent."
L "Lovable."
Y "Yakky! I talk all the time . . . *as* you can tell!"

M "Maggie Gyllenhaal . . . merry men . . . mannequin . . . no, how about memorable?"
I "Intelligent."
T "Talented?"
C "Charisma."
H "Happy!"
E "Encouraging."
L "Loving."

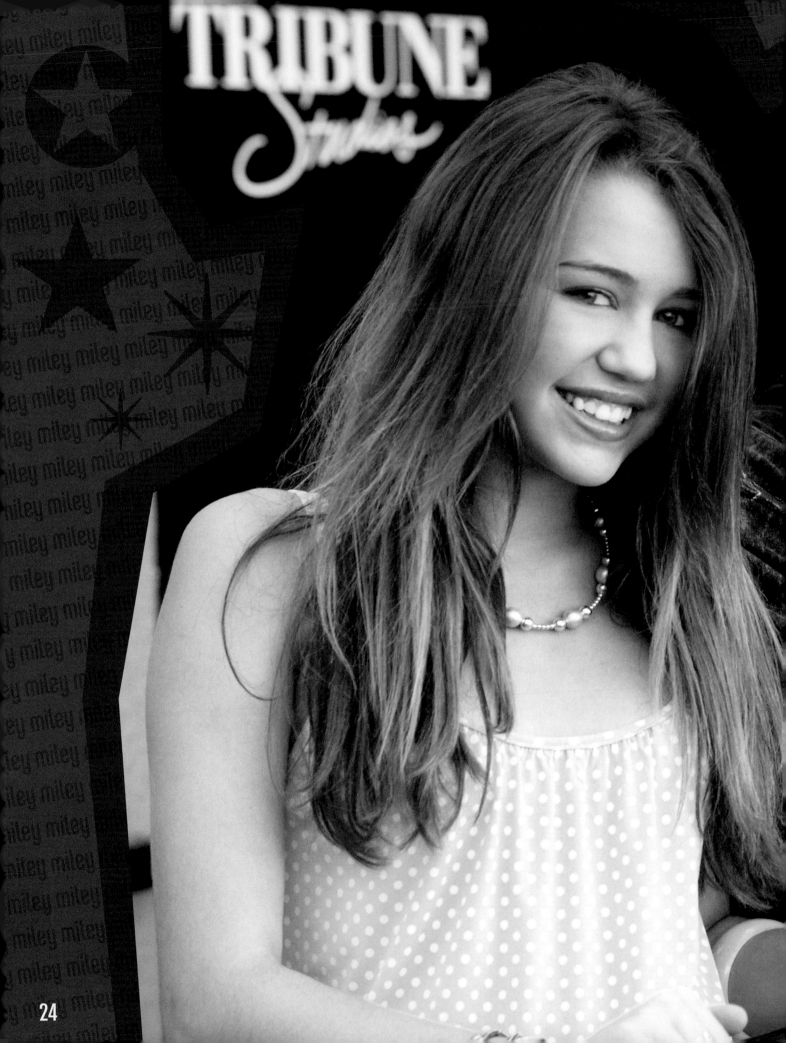

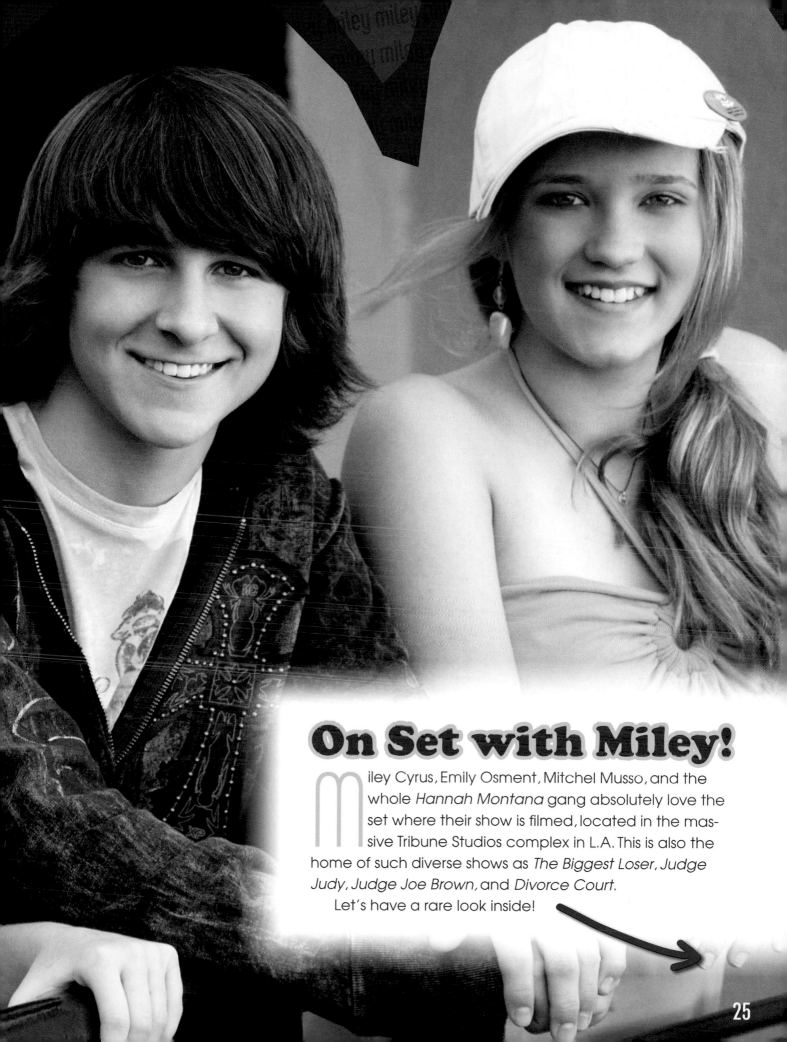

On Set with Miley!

Miley Cyrus, Emily Osment, Mitchel Musso, and the whole *Hannah Montana* gang absolutely love the set where their show is filmed, located in the massive Tribune Studios complex in L.A. This is also the home of such diverse shows as *The Biggest Loser*, *Judge Judy*, *Judge Joe Brown*, and *Divorce Court*.

Let's have a rare look inside!

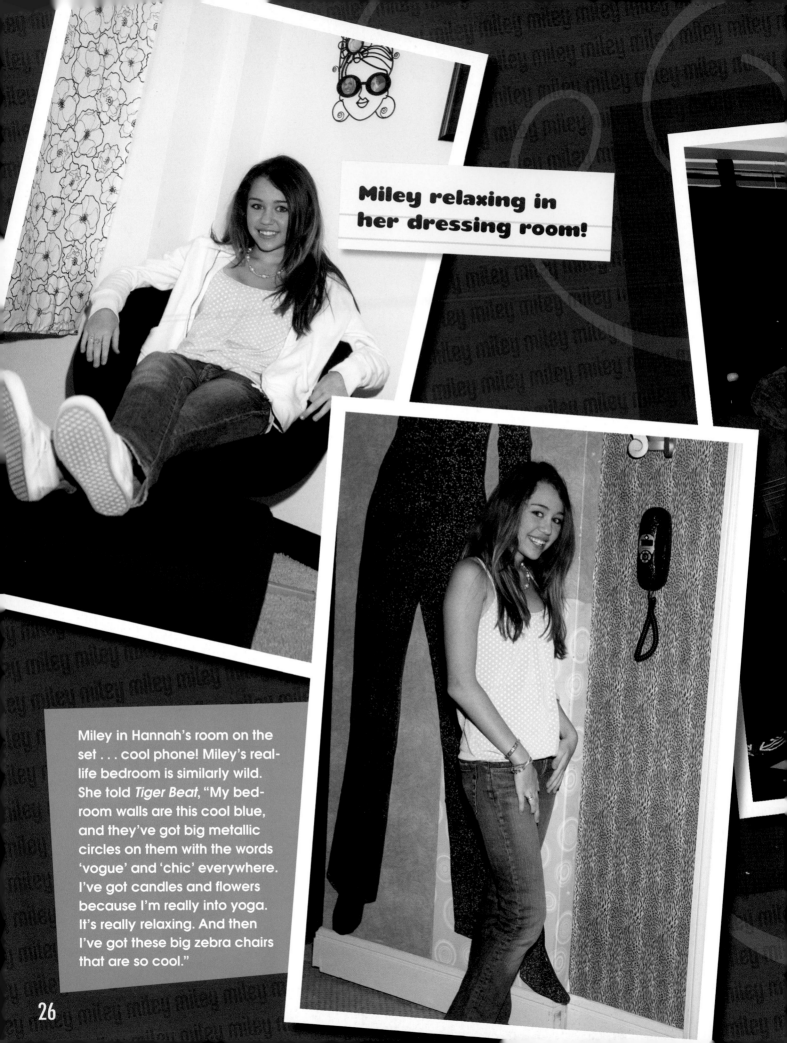

Miley relaxing in her dressing room!

Miley in Hannah's room on the set . . . cool phone! Miley's real-life bedroom is similarly wild. She told *Tiger Beat*, "My bedroom walls are this cool blue, and they've got big metallic circles on them with the words 'vogue' and 'chic' everywhere. I've got candles and flowers because I'm really into yoga. It's really relaxing. And then I've got these big zebra chairs that are so cool."

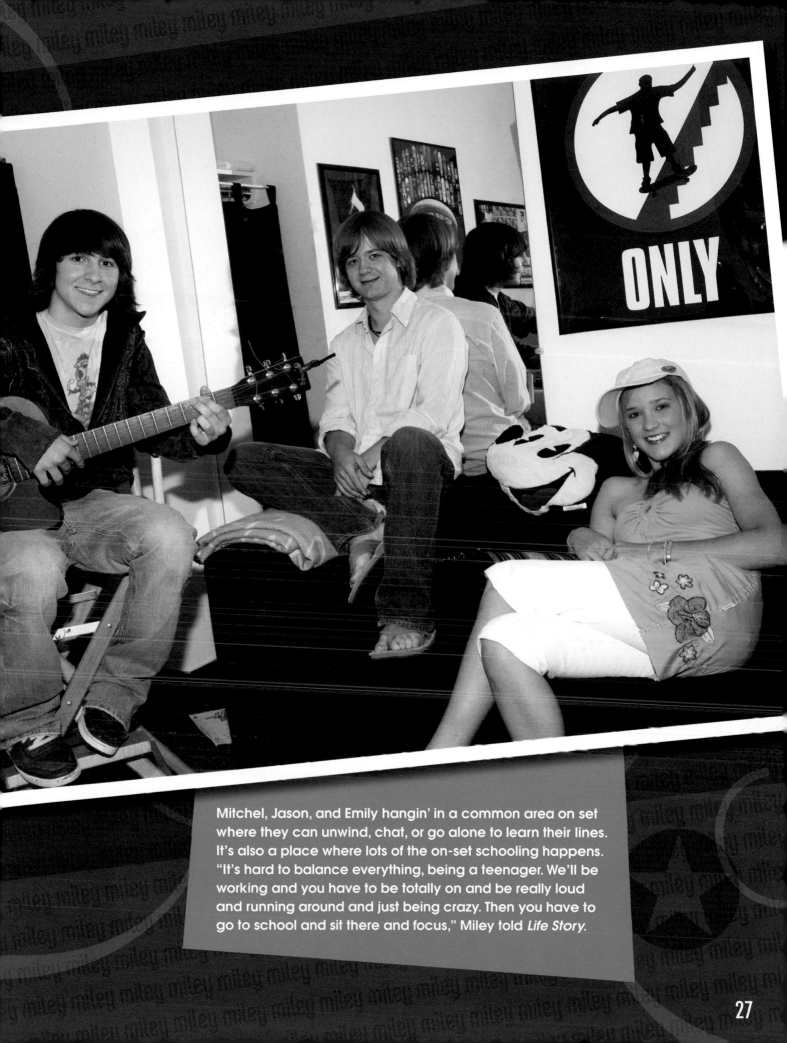

Mitchel, Jason, and Emily hangin' in a common area on set where they can unwind, chat, or go alone to learn their lines. It's also a place where lots of the on-set schooling happens. "It's hard to balance everything, being a teenager. We'll be working and you have to be totally on and be really loud and running around and just being crazy. Then you have to go to school and sit there and focus," Miley told *Life Story*.

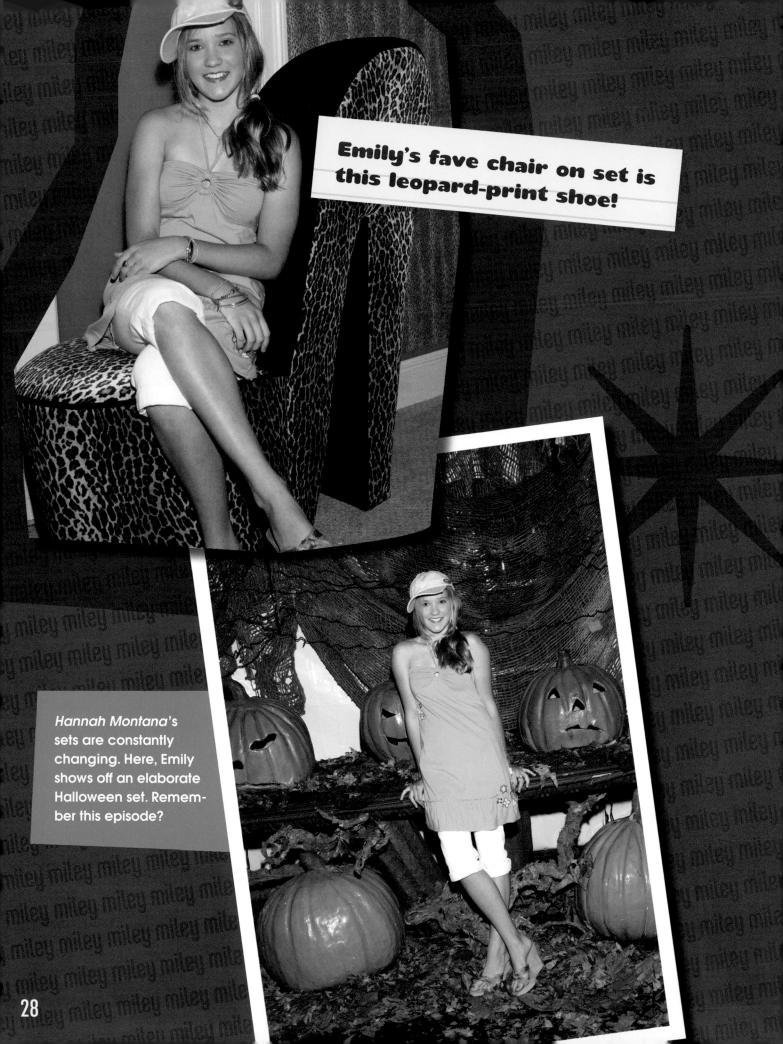

Emily's fave chair on set is this leopard-print shoe!

Hannah Montana's sets are constantly changing. Here, Emily shows off an elaborate Halloween set. Remember this episode?

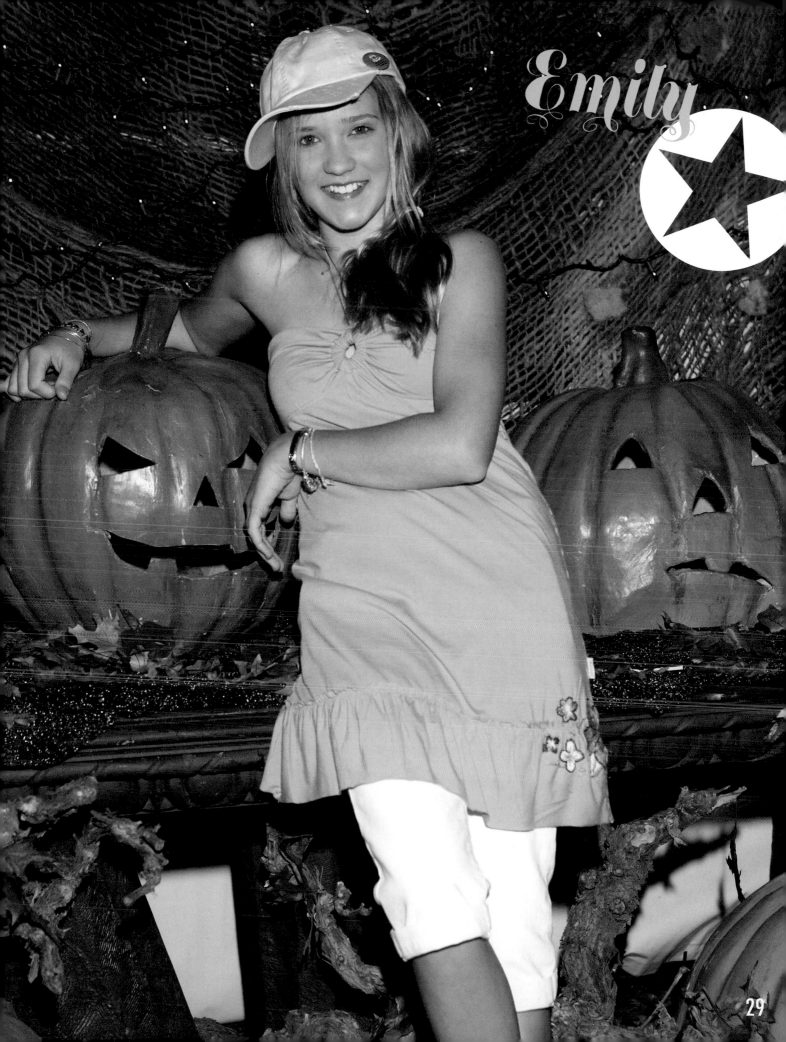

Emily

29

Jason's dressing room is the smallest, but is the perfect place for him to be alone and practice the guitar. (One of the stickers says, "Don't sit on cactus!" and the other shows a monkey eating hot soup out of a Jacuzzi he's *sitting* in!) The *National Treasure* movie poster holds special meaning—Jason played an ancestor of the Nicolas Cage character in that hit movie!

Mitchel's always surrounded by girls on the set. He joked to *Popstar!*, "At some points you'll think that *I'm* a girl because I'm with Emily and Miley talking about all the same stuff. Sometimes they'll be like, 'What in the world?' Like, we talk about the most crazy stuff, maybe not for, like, *girls* it's crazy, but for *me* it's like, 'Wow! I don't really want to be a part of this!' Lots of conversations where they're like, 'Ohhh! He's so cute!' Blah blah blah! And they're all about guys right now. So I get stuck in between it."

"When I get up in the morning, I never eat anything at home because they have the greatest food on [set]," Mitchel told Tiger Beat Celebrity Spectacular. "Emily and I will always meet up at the same time, and as soon as we get there, we go to craft services. They'll make us pancakes or waffles or bacon and eggs. We'll sit and eat, and later we'll play basketball or Ping-Pong."

Mitchel

Here, Mitchel shows off Jason's fave part of the set—Rico's Surf Shack!

Emily recently vowed to give up candy . . . but this photo catches her right in the middle of her candy-corn days!

Miley and Emily study their lines. Notice their scripts are pink? The pink pages reflect last-second changes—the cast may only have a day to learn these new lines before filming in front of a live studio audience!

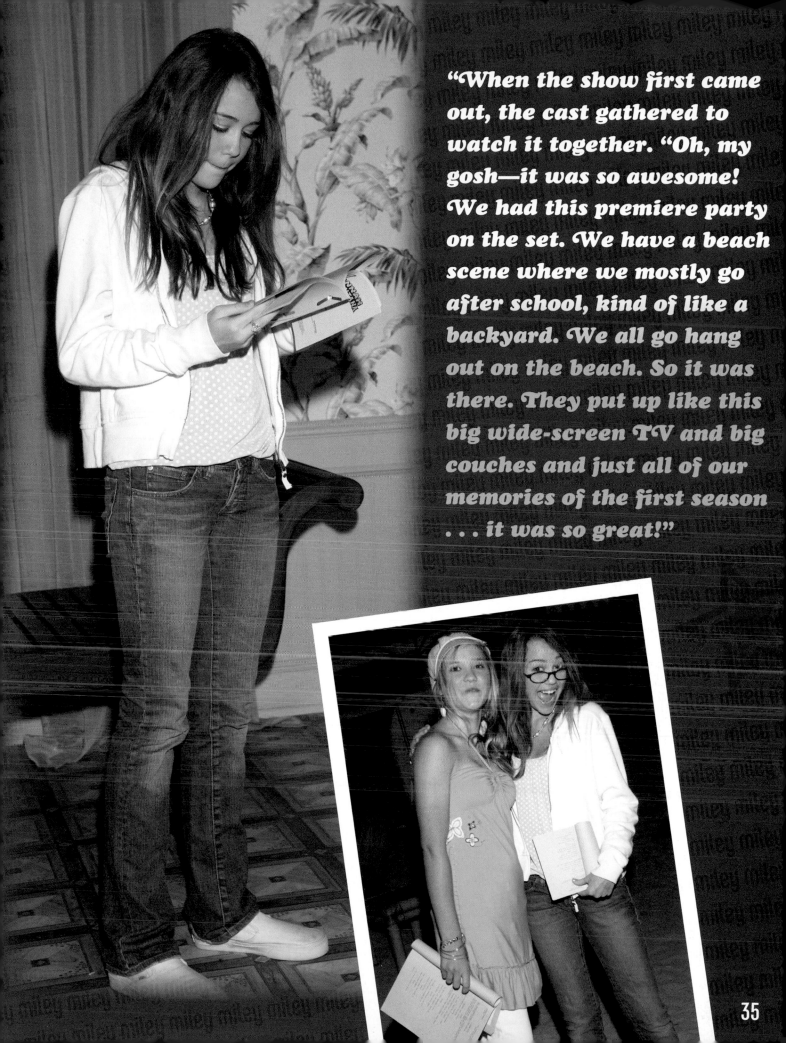

"When the show first came out, the cast gathered to watch it together. "Oh, my gosh—it was so awesome! We had this premiere party on the set. We have a beach scene where we mostly go after school, kind of like a backyard. We all go hang out on the beach. So it was there. They put up like this big wide-screen TV and big couches and just all of our memories of the first season . . . it was so great!"

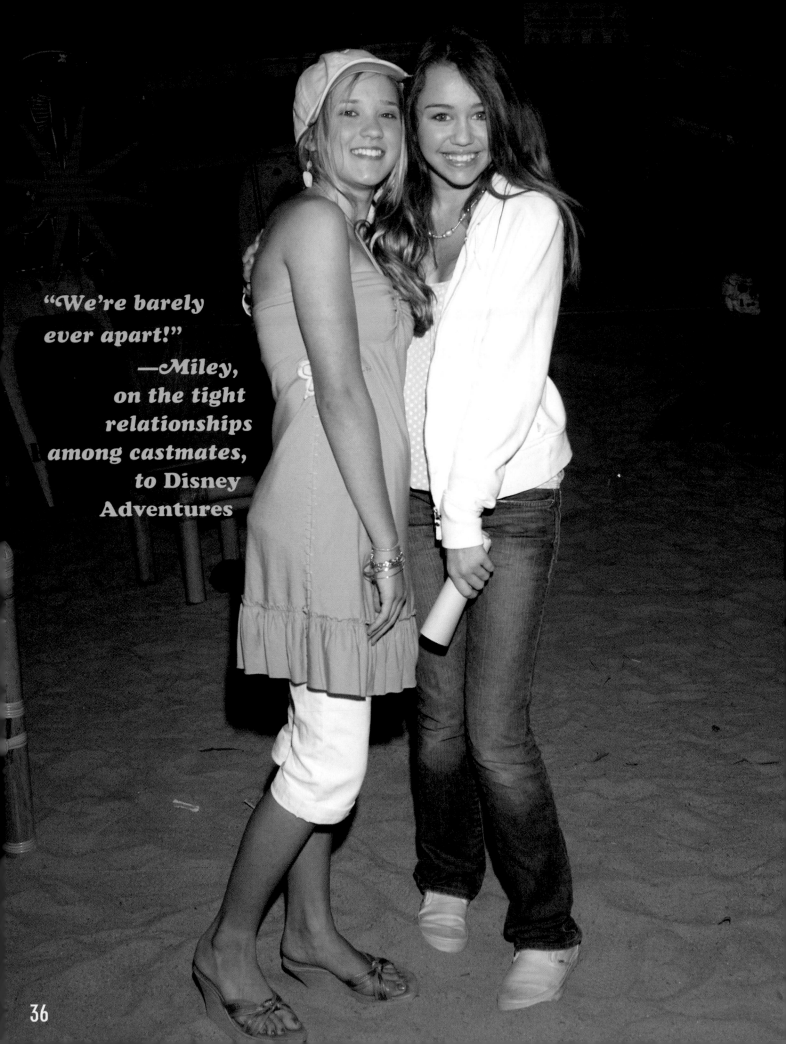

"We're barely ever apart!"
—Miley, on the tight relationships among castmates, to Disney Adventures

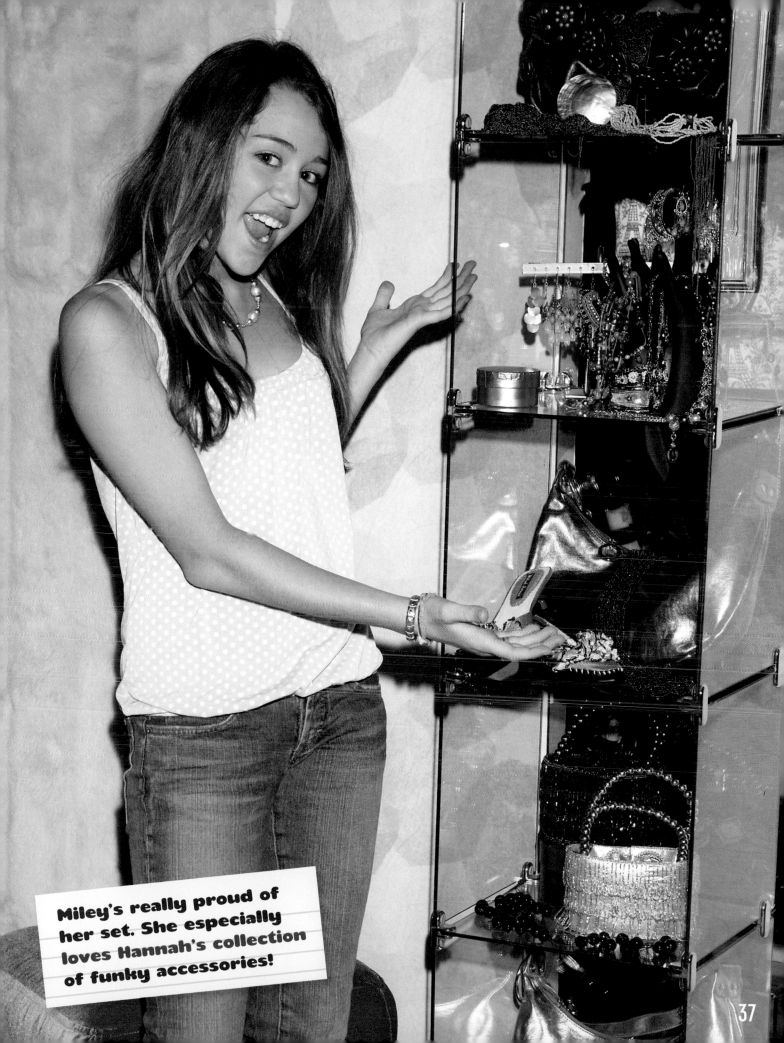

Miley's really proud of her set. She especially loves Hannah's collection of funky accessories!

Miley in Hannah's outrageous room!

38

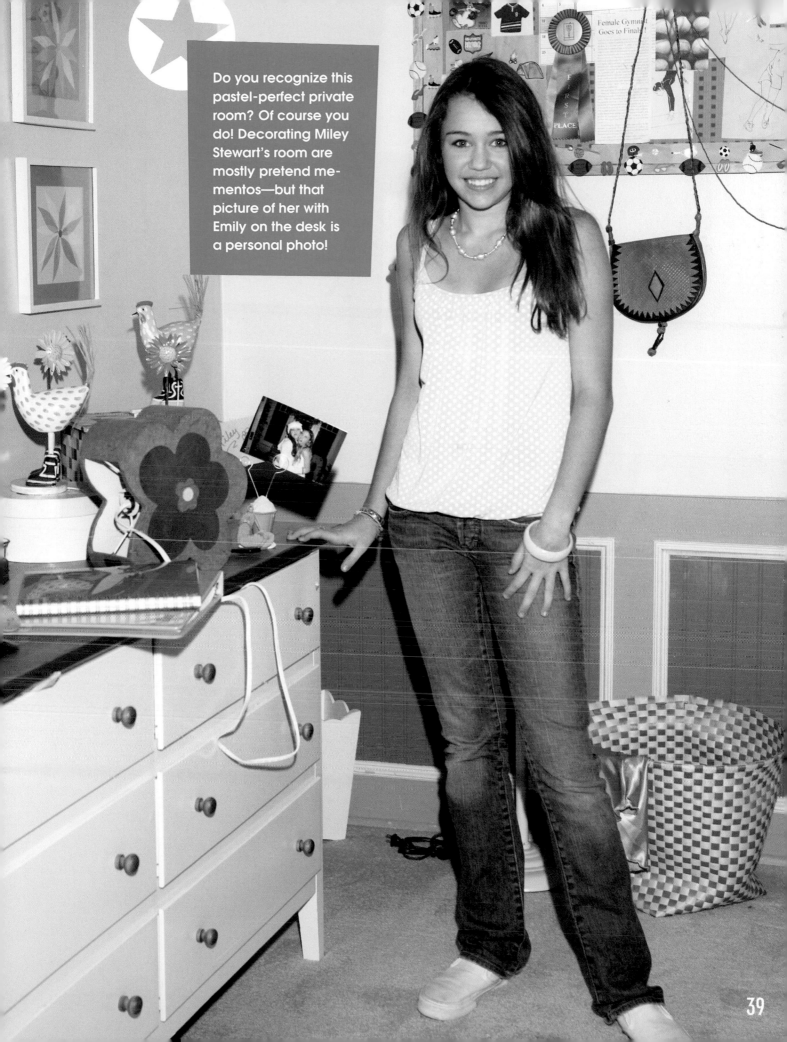

Do you recognize this pastel-perfect private room? Of course you do! Decorating Miley Stewart's room are mostly pretend mementos—but that picture of her with Emily on the desk is a personal photo!

Miley's a big Halloween girl—she loves to dress up and she loves candy. But one of her favorite holidays is Christmas, because she usually gets to spend it with her family. They don't even need gifts—being together is treat enough.

> *"My room's like the party room. The radio's always on and the music's blasting. No one knocks—they just fling open the door and get ready to party!"*
> —Miley, Bop

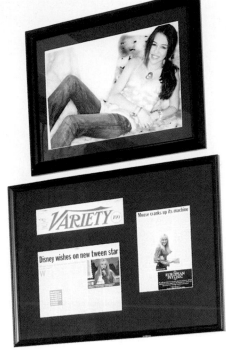

Miley's private dressing room is connected to Billy Ray's, but is separated by a curtain. Her space is pretty neat and tidy, but the walls are covered with collages Miley made (she calls this her "inspiration wall"), a framed photo from one of her first photo shoots, the first big *Hannah Montana* article that appeared in *Variety*, and . . . a framed photo of her with Nick Jonas that says, "Nick HEARTS Miley." Wonder if that's still there???

Bye! Don't you just love this cute, funny-faced pic of Miley? She's so hilarious. And you won't see a picture of her wearing glasses almost anywhere else but in this very book!

41

Jason Earles is the most seasoned member of the youth cast on *Hannah Montana*, quite a bit older than Jackson, the teen he plays. His maturity shows when he speaks of his first big role, as he did to *Popstar!* magazine in 2006.

"I enjoy coming here every day and hanging out with everyone and working, but the actual *fame* part of it is not what I'm really interested in. It's more just doing the work. And Jackson on the show is the one that's kind of the outsider when it comes to show business. He gets to see it from the outside and kind of enjoy being on the fringe of it. I feel that's kind of what my personal experience with this show has been so far, too."

Jason Daniel Earles was born on April 26, 1977, in San Diego, California. As a kid growing up in Hillsboro, Oregon, he was drawn to serious, dramatic acting in spite of his natural sense of humor. After graduating from Glencoe High in 1995, he attended Rocky Mountain College in Billings, Montana, where he gained experience on the stage. Jason's talents were put to the test as he was called on to appear in productions as diverse as *The Crucible*, *One Flew over the Cuckoo's Nest*, and *The Dresser* . . . he's even done many Shakespeare plays! He worked in shows based in Oregon (at the Glencoe Theater) as well as in Montana, where he was a part of The Illustrious Virginia City Players.

As important as his theatrical education was Jason's introduction to his future wife, Jennifer, a pretty blonde who now works as a horse trainer.

"The first thing I notice about a girl is probably her eyes, and I think it's just because, like, as an actor, you are sort of taught that the eyes are the window to the soul," he told popstaronline.com. "I think you can tell if somebody is kind or if they're sort of mean just in that first impression you get from their eyes." Not surprisingly, Jennifer has beautiful eyes!

As an insight into Jason, take note that he's been asked lots of lovey-dovey questions by teen magazines unaware he is most definitely "taken," and his answers show him to be a real sweetheart!

When trying to impress a girl (Who's his celebrity crush? Christine Taylor, Ben Stiller's wife!), he's more likely to come up with something homemade, like a poem or a card. He also might sing a girl a song—getting better on the guitar has been a goal of his for the past couple of years.

"I spend a lot of time playing video games and I probably shouldn't! I would *really* like to spend more of my free time learning how to play the guitar."

After Jason and Jen got married, it wasn't long before they relocated to Los Angeles, where he hoped to make it big.

Jason's early résumé from before he landed *Hannah Montana* boasted the ability to look younger than his age (no kidding!); to do dialects such as Standard British, Russian, Indian, and Texan; and to mimic a person with a stutter. His special skills were said to include snowboarding, dancing the jitterbug, athletics, and horseback riding.

On top of all that, he could act!

While trying to get his dream role, Jason had a bunch of really, really annoying jobs!

"I used to work for this wrecker, like an automotive wrecker junkyard sort of place. It was a sum-

"We poke at each other," Jason told popstaronline.com. "There's very much a brother-sister relationship with the whole cast. We defend each other, but we also kind of pick on each other."

Jason

really well. Jason always speaks very highly of his costars, particularly Miley.

"She's an adorable, energetic fourteen-year-old girl. But she's crazy, like every fourteen-year-old girl," he told *USA Today*. "She could be awful if she wanted to be. But she's not. She's about as sweet a person as you could want."

Jason's definitely enjoying his success and his ability to play such a fun, physical role as Jackson. He's said he enjoys getting free clothes from the show occasionally and loved filming a *Disney 411* spot in Orlando's Walt Disney World.

"Disney actually sent me to Disney World—they took care of my airfare and put me up in the Animal Kingdom Lodge—and while I had to work while I was there, there were a couple of days where I got to play in the park and you have a little guide who takes you around," he told *Popstar!*. "It's probably the coolest way to do the park—you get to see *everything*! This is probably why it was the coolest experience: it was before the show had aired yet, so we'd shot fourteen or fifteen episodes, but there was no public anything, so you just got to go and do whatever!"

Right after the show began airing, he was able to do red carpets at events such as the premieres of *Eight Below* and *Pirates of the Caribbean: Dead Man's Chest*, experiences he found exciting but a little strange!

"I still feel like, 'Why would anyone want *me* to go to an event?' It's like how I have a hard time thinking of myself as a heartthrob. 'Cuz I know *me*, and I'm just a regular guy doing my regular thing. I think it's really cool and I'm very excited about it— if you wanna be an actor, it's probably something that you always dream about, getting to see these things from behind the scenes and I really enjoy it. But I think I'm still sort of in that ugly-duckling phase, where I can't quite come to grips with the fact that I'm actually *there*. I feel more like an observer than a participant. I'm way more interested in hanging out on the set every day. I don't think

mer job and I would wash the wreckers after they used them, which wasn't too bad, but they also had an automotive shop where I had to clean out their subsystem. So I would actually have to vacuum out this sludge from the floor panels and it looked like I was rolling around in crude oil by the end of the day. And I did that like *every day*. It was an awful job!"

But bad experiences can build character, and can give actors lots to draw on when they're auditioning. It wasn't long before he was winning over the Disney Channel and being handed the part of Jackson, the obnoxious big brother whose sister is leading a double life.

As I told you before, the cast always got along

I would ever be the type that had to hit *every* red carpet and wanted to be at *every*thing. That's not really the part that interests me."

Jason never wanted to be a leading man. He told *Popstar!*, "I would love to have a career sort of like Jeremy Piven's. He's not necessarily the lead actor in anything, but he always works, and whenever you watch him, you go, 'Yeah, the lead was good, but the guy who played the best friend was *so funny.*' He always ends up being your favorite part of the movie even though he's not the headliner. And probably up until *Entourage*, it was, 'I love that *guy* from that *thing*,' so he was able to have a little bit of anonymity in his personal life. I'd love to have some sort of career path like that."

Jason is a bit embarrassed to be considered a potential pinup for some girls. "All of that stuff is really hard for me to kind of wrap my brain around 'cuz I've always been the goofy guy. On the show, I'm sort of the comic relief—that's the role I embrace on the show. So for anyone to take that and turn it into a heartthrob . . . makes me kind of chuckle."

But despite any misgivings in that area, he loves when fans do a double take and try to convince themselves he really is that guy from *Hannah Montana*. One thing's for sure: Jason's one of the nicest stars you'll ever meet, and you shouldn't be shy to approach him if you spot him.

"I encourage anyone, if they ever see me and they wanna take a picture or have me sign something to just come up because I'm *more* than happy to!"

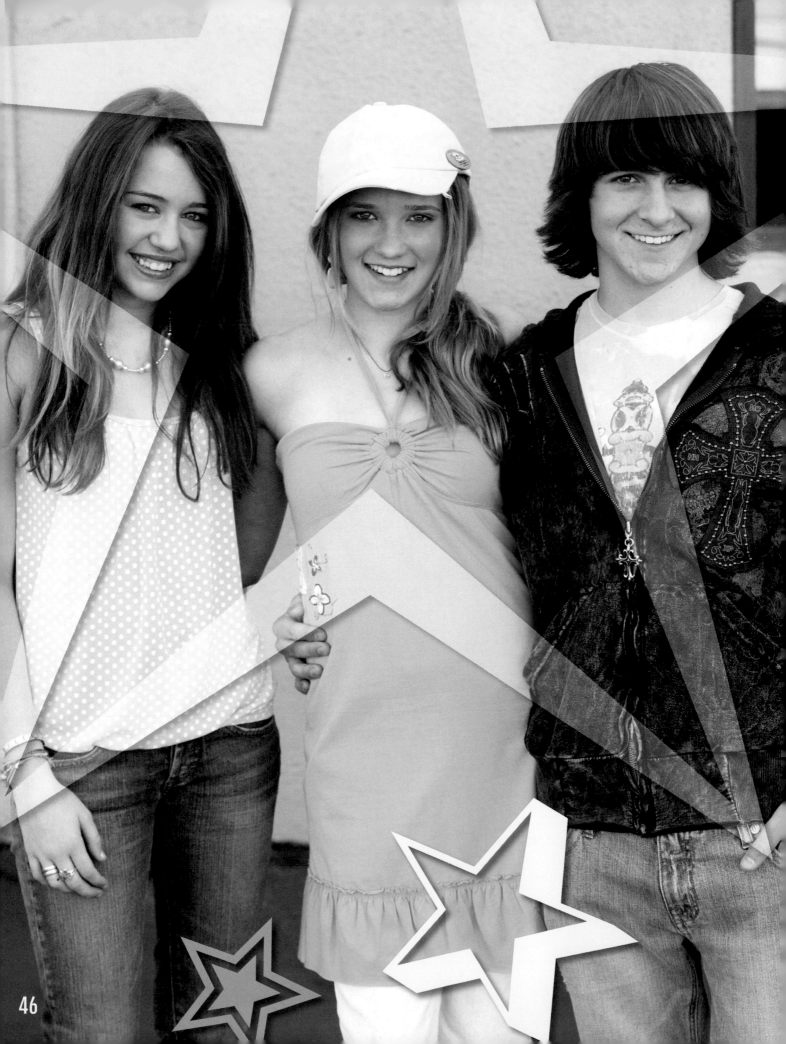

When *Popstar!* asked the stars of *Hannah Montana* to identify which of their castmates is *most like* and *least like* his or her character . . . the answers were surprising!

Miley!

MOST! "Mitchel is the *most* like his character because Mitchel's character is very obsessed with girls and kinda has his own thing. He thinks he's so smooth but everyone is like, 'What are you doing? You're so weird!' But very funny, very cute about it!"

LEAST! "Jason's the least like his character, I think. Jason has fun playing his character because he gets to go kinda crazy, but Jason's serious. He's funny and jokes around and keeps a straight face when he does it. But he's more mature than his character. But he loves gettin' to go out there and run up and down stairs and stuff—it's fun for him."

Emily!

MOST! "Personally, I think *I'm* most like my character. Because I'm thinking, like, Miley? She's not a dork at all and she's played off as this big dork kid who's not popular at school but *she's really not*, she's not a dork at all."

LEAST! "Jason, I think, is the least like his character because he's just *sooo* mature and this second father we have on set sort of because he's older than us and we always look to him because he always does the right thing and says the right thing. He's just so not his character because his character is goofy and weird and hates his sister and he's just the nicest, most lovable guy."

Mitchel!

MOST! "Oh, boy. Most like their character. Either Miley or me. Because Oliver is all about girls, of course, and *I* am *all* about girls. And of course the whole in-love-with-everything-he-sees thing. And he thinks he's cool; some people think he's cool and some people don't. And then Miley because she's a singer, she does all the same things as Hannah, as far as that goes, she does everything the same. So it's kind of a tie."

LEAST! "I gotta tell you, *definitely* Jason. He's the most *unlike* his character. He plays this crazy, annoying, funny, out-of-the-blue kid. He doesn't do stuff like that, but he's so good at his part it just looks like he does. But truly, he's just this *awesome* guy who gets all the girls and stuff. Jackson doesn't get the girls and stuff. Jason—he's so *not* nerdy. He's cool and stuff."

Jason!

MOST! "Miley really *is* like her character. She does sort of lead this dual life. She's from the South and she's got this great family background but she tries to stay normal, but then on top of that she's on TV and she's got all the music stuff so she's dealing with all the stardom. Her personality is—sometimes she's crazy, sometimes she is moody, they take a lot from her personal life and put it on the show."

LEAST! "I would say Mitch is probably the *least* like his character on the show because he is kind of goofy and stuff on the show and he's a little bit more of a ladies' man in real life—he does really well with the girls and he always seems to strike out on the show. And he's a skater, so he's a little bit more alternative and they kind of preppy him up a little bit in the show. So he would probably be the most different."

"It's fun to get dressed up every day!"
—Miley on becoming Hannah

becoming a character is an actor's favorite challenge, but it can be difficult to inhabit that character's look—especially if she's a flashy pop star and you're a down-home Tennessee girl with a simple style.

For Miley, it was especially odd to see herself as a blonde, one of the requirements of her role on *Hannah Montana*.

"When I saw myself [as a] blonde, at first I was like, 'I'm not sure about it.' I couldn't decide if I liked it!" she told *Popstar!*. "But now it's really cool. It's really cool to see myself different!"

The wig is actually one of the physically hardest parts of the show for Miley—it can take a couple of hours to get into, and there's no guarantee it'll stay there once it's in place!

"At the Macy's [Thanksgiving] Day Parade, it was raining and I had a hat on, but the water came through and the wig messed up really badly! And from the wig being messed up, my hair underneath came out! So if you ever see a replay of that, there was brown hair coming out from under the blond wig!" Miley confessed at the *New York Times* Sixth Annual Arts & Leisure Weekend.

Not a cute look!

But Hannah *does* have many cute, stylish outfits, even if they're not always the first things Miley would choose to wear herself.

"We went from dresses to skirts to high heels to flats to no shoes to cowboy boots to hats," Miley says, noting that she was asked to help create Hannah's glam style. Having so much input helped her get into character. "You can really tell when things are going wrong," she said of Hannah's outward appearance, "but through it, she's always really happy and outgoing, so her clothes are really bright and sparkly and really cool!"

MOM "NO'S" BEST!

Question: Why isn't Miley's real mom on the show, too?

Answer: First, the TV character Miley Stewart's mom died when she was little, so there isn't really a "Mom" part for Tish to play! (though Mrs. Stewart does occasionally appear in fantasy sequences, as a guiding spirit played by Brooke Shields). But there's another good reason why Tish Cyrus hasn't appeared on *Hannah Montana*: she hates to act! At the Disney Channel Games in 2007, Miley told popstaronline.com, "I wish my mom would do it," but unfortunately, "my mom does not act or get onstage or in front of cameras *ever*. So 'No, thank you!' She was on *Doc* one time—my dad's TV show—and she was, like, *sooo* nervous she ended up not even doing it. She was like, 'You can't put it on TV!'"

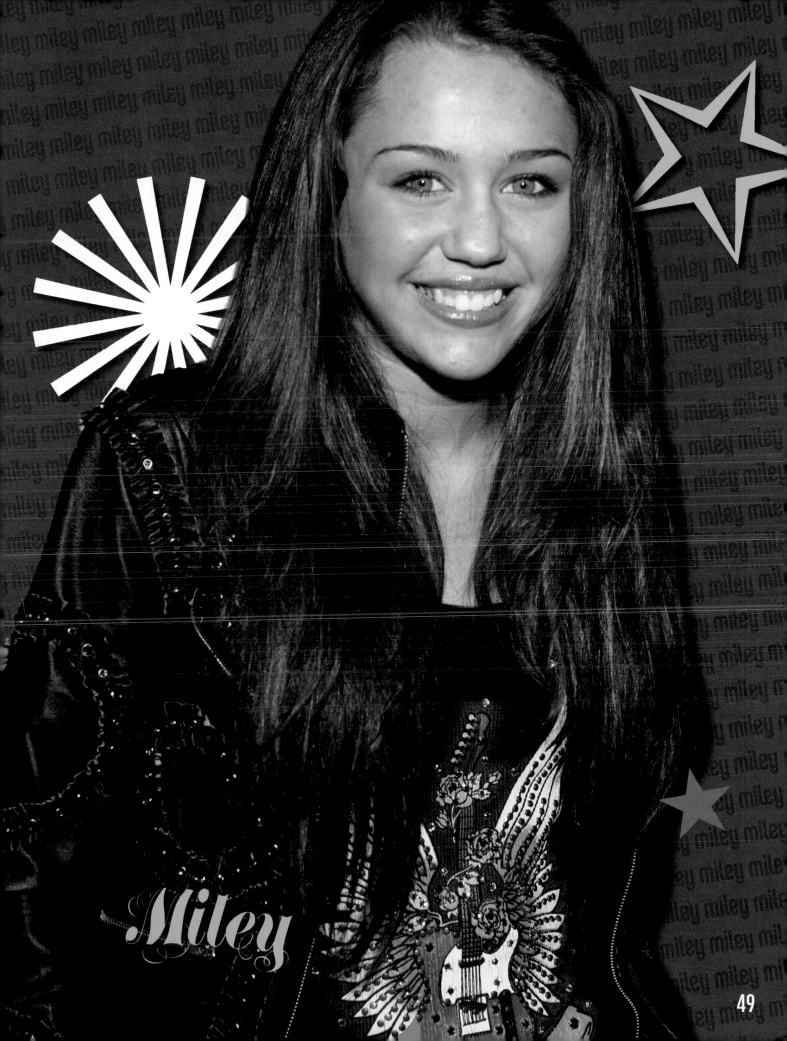

Miley

49

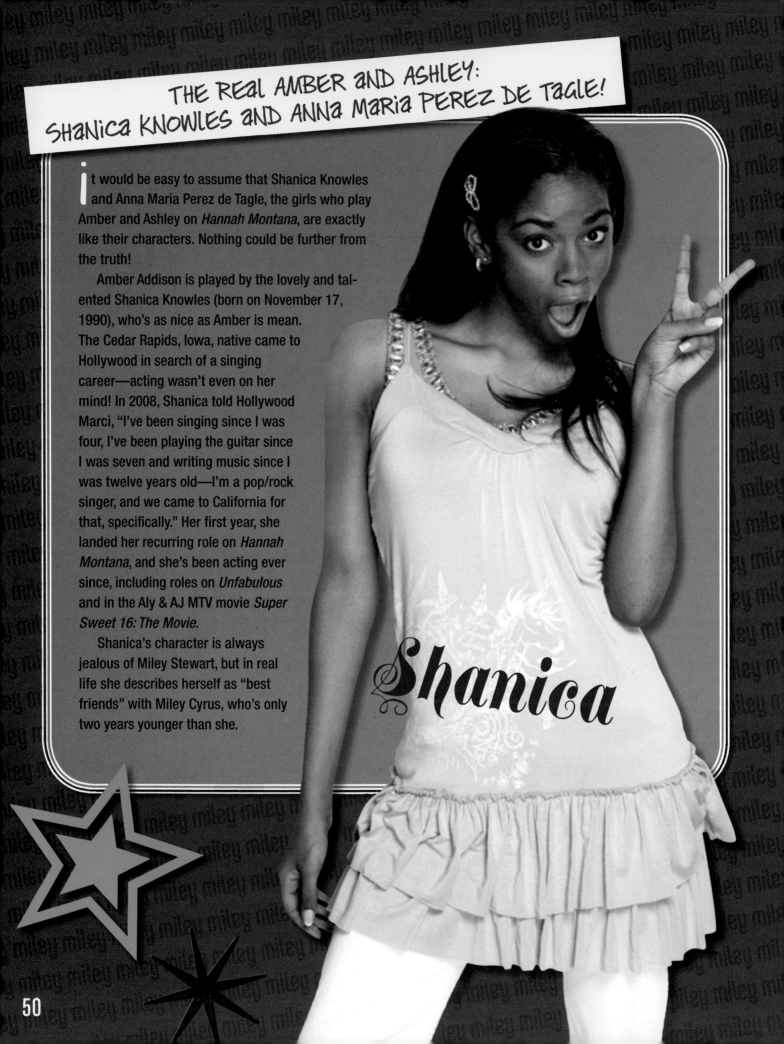

THE REAL AMBER AND ASHLEY: SHANICA KNOWLES AND ANNA MARIA PEREZ DE TAGLE!

it would be easy to assume that Shanica Knowles and Anna Maria Perez de Tagle, the girls who play Amber and Ashley on *Hannah Montana*, are exactly like their characters. Nothing could be further from the truth!

Amber Addison is played by the lovely and talented Shanica Knowles (born on November 17, 1990), who's as nice as Amber is mean. The Cedar Rapids, Iowa, native came to Hollywood in search of a singing career—acting wasn't even on her mind! In 2008, Shanica told Hollywood Marci, "I've been singing since I was four, I've been playing the guitar since I was seven and writing music since I was twelve years old—I'm a pop/rock singer, and we came to California for that, specifically." Her first year, she landed her recurring role on *Hannah Montana*, and she's been acting ever since, including roles on *Unfabulous* and in the Aly & AJ MTV movie *Super Sweet 16: The Movie*.

Shanica's character is always jealous of Miley Stewart, but in real life she describes herself as "best friends" with Miley Cyrus, who's only two years younger than she.

Shanica

Filipino-American Anna Maria Francesca Perez de Tagle (born on December 23, 1990) is from San Francisco, where she got her start modeling and singing as well as following her dream of becoming a nationally recognized actress.

A competitor on *Star Search 2* back in 2003, Anna Maria (who dropped Francesca from her already memorable name) made a big impression singing "Somewhere" from the classic film *West Side Story*. This led to her decision to audition during the pilot season in Los Angeles, which is when she landed the role of Ashley Dewitt on *Hannah Montana*.

One of the most challenging things about playing Ashley (aside from having to be adversarial with her real-life pal Miley) is that Anna Maria has to pretend she's a bad singer. In real life, she has an amazing vocal gift that will surely lead her to a recording career. Already she put her voice to good use in the Disney Channel original movie *Camp Rock* alongside the Jonas Brothers and Demi Lovato. Anna Maria told *Popstar!* of her experience with the Jonases, "They are gentleman——they'll open the door for you or pull out your seat and push it in for you or they'll sometimes text you 'Good night—I didn't get to say good-bye.' They are so gentlemanlike!"

Fashion-conscious Anna Maria is also well known to be a collector of everything from Barbie dolls to cool shoes. There might be a little, tiny bit of Ashley in her after all!

Maria

MEET MOISES!

hannah Montana's pint-sized bundle of energy (and barrel of laughs) Rico is brought to life by Moises Arias. Born on April 12, 1994, in New York, Moises was raised by parents who'd immigrated to the United States from Colombia. Fluent in Spanish and an excellent student, Moises and his brother Mateo both embarked on acting careers that began with lots of commercial auditions and classes at the Barbizon School of Modeling and with Bill Greeley's agency in Atlanta, Georgia.

When Moises moved to Los Angeles, his acting prospects picked up with a role on *Everybody Hates Chris.* Everybody loves the hilarious and good-natured Moises, so it wasn't long before he landed his first Disney Channel part, as Randall on an episode of the Cole and Dylan Sprouse series *The Suite Life of Zack & Cody.*

While Moises has had the privilege of starring in major motion pictures such as *Nacho Libre* and *The Perfect Game*, his main claim to fame is as Rico on *Hannah Montana*, a part that has afforded him many acting opportunities—everything from cracking people up to break dancing and rapping to kissing Hannah Montana on the lips!

Despite his small stature (he stands four feet, eleven inches), Moises has proved to be a *huge* favorite among other Disney Channel stars, with everyone from Emily Osment and Jason Earles to Lucas Grabeel citing him as one of their favorite people. That may be why he was hired for *Dadnapped*, Emily's first Disney Channel original movie.

COULD YOU BE
an Undercover Celeb?

quiz!

You can trust me with secrets!
A. false B. true

I'd do anything to look unique!
A. true B. false

I'm cool under pressure!
A. true B. false

I love to gossip!
A. true B. false

I'm good at doing impressions!
A. false B. true

I'd love to be famous!
A. true B. false

HOLLYWOOD

No!
You might have talent and star quality, but you'd have too hard a time hiding your identity. You have no choice but to be *openly* famous!

Yes!
You're a great actor, you're good under pressure, and you know how to steer people clear of topics you want to avoid. Hats (and sunglasses) off to you!

53

this is the life: meet

the real miley cyrus!

The Fame Game!

Nearly everyone dreams of being famous at some point in our lives, but do we truly appreciate the stresses and strains of the fame game? Miley Cyrus has experienced them firsthand, and she has mixed feelings about being America's sweetheart.

Miley first began appearing in teen magazines such as *Popstar!*, *Tiger Boat*, and *Bop* at about the time *Hannah Montana* hit the air in March 2006. Until then her main experience with fame was through her well-known dad.

She almost wasn't prepared for the overwhelming amount of newfound attention.

"Everything has been totally crazy—it was just like, one extreme to another!" Miley told popstaronline.com at a pediatric AIDS benefit shortly after her star began to rise. "It was just, you know, totally normal and then BAM! Everything is different—it was so weird, but I'm having a blast."

One of her first fans turned out to be her little sister Noah, who confessed to Miley that she had entered a contest on the Disney Channel Web site to win passes to a *Hannah Montana* taping.

"You *live* with me!" Miley exclaimed to her sister, as she later recalled at a *New York Times* event. She then made sure (jokingly) to warn Noah not to steal anything from her room to sell on eBay. That's the powerful effect fame has on people—you hope to win a contest to meet your own famous sister!

Aside from this lapse by Noah in the beginning, her family has been—for the most part—totally devoted to keeping Miley's feet on the ground.

"When they're with me, they realize it's a lot harder being under the glare than they thought," she told *New York Newsday*'s *Kidsday*.

"My brother doesn't really care about anything and he doesn't even know what's going on . . . he's really into basketball. They are all doing their own thing, and both the older and younger sisters have been on the show a couple of times."

Part of the pressure comes from all eyes being on Miley's personal conduct.

"All these little girls are looking up to me," she told *J-14*. "I've looked up to other stars, but now I'm someone who girls look up to. It's all eyes on me, and any choice I make may not be the best one—I'm scared of that."

Miley is very aware of the temptations that have caused some of her peers to fall from grace, and feels strongly that she will not let you—her fans—down.

"There are a lot of young people in Hollywood who are underage and drinking and smoking. That's not going to really affect me. I have been really good about always saying no."

And it's not only inappropriate behavior that Miley has to watch. She also has to think twice before opening her mouth.

After a concert in 2007, she told popstaronline.com, "Just always think before you speak. I think some things can be taken out of context and it's not exactly what you meant to say. I've had that happen to me before where there will be things that I've said that get kind of turned around, so I think just be smart about what you say and think before you talk."

But for Miley, along with the high standards she sticks to as she upholds her position as a role model, she's also worried about doing anything that will embarrass her! Imagine how embarrassing it would be if someone took your picture as you were falling down, and then posted it all over the Internet. Not fun.

Miley told *PBS Kids*, "I think just having a camera on you all the time gets kind of frustrating, because if you make a mistake, like if you say or do something really stupid, the whole world knows about it. It's not just your family or friends. Sometimes I'll watch something back and think, 'What am I doing? I'm like the biggest geek!' Sometimes my friends will call me and say, 'Did you see that commercial? You were such a nerd!' And I'm like, 'Thanks, guys, I love you, too!' "

Miley is now one of the most familiar faces in the country—she ranked second in AOL's 21 Under 21 survey of 2007 (right behind Rihanna), to which she said (via AIM):

"i love hearing things like that, it makes me so happy to know the response it's a lot of pressure, but it helps me strive to be a better person."

When you're the biggest star in the world, you've also got the zaniest fans. Some of Miley's crazy-fan stories are hilarious!

At a Disney Channel press event, Miley confirmed that fans often write to her and ask her to get Hannah Montana's autograph—which is confusing since not only are they the same person, Hannah Montana doesn't actually exist! Not that fan mail ignores the real Miley. "Miley Cyrus gets a lot of mail, but then again, you know, Hannah Montana gets a lot of, like, comments about her songs and stuff. So it's kind of—it's equal!"

In *Popstar!*'s August 2006 issue, Miley recalled a time when her fans couldn't separate her from her alter ego! "I was at Universal Studios and there were like five girls and they were like, 'Oh, my gosh—what's your name?' and I was like, 'Mii-iley,' and they were like, 'It's Hannah Montana!' and I was like, 'Oh, my goodness!' So then all these people were like following me. It got kind of creepy, but then again, I was like, 'Oh, gosh, this is so cool! Awesome!' "

On *Regis & Kelly*, Miley recounted a tale of chaos she once caused . . . without even trying! "My mom and me were shopping the other day . . . there was this big sale and I signed a couple of autographs and it was cool. Then we go upstairs to the kids' department for my little sister's stuff . . . then it turned into a complete mess. The manager was looking at me like, 'Get out of my store, you're really causing a scene!' "

Suddenly having fans recognize her at every turn leads to some sticky situations . . . but Miley's fine with that. "I'll be out with my friends and I'll get recognized. . . . For, like, all of my life I've just been working for this. I've wanted this so much. Now that it's here, I'm really—like, that part is just

another, you know, a part of this lifestyle. It's really not a bad thing, you know. . . . It's really cool to get to see all the people that are out there supporting you." She adds, "When you get to see the people like when you're out working and there's something hard that you're doing—it's so worth it to see all these young kids looking up to you. It's really awesome."

Sometimes she has to think fast, though, to keep fan encounters from going wrong. During an exclusive interview, Miley told popstaronline.com's editor that several months after *Hannah Montana* became so popular, she and her friend Sierra were at a mall in Los Angeles. While Miley was trying on makeup, Sierra walked outside, where she saw some young boys staring at Miley. They asked if she was Miley, and Sierra replied, "Does it look like her?" to which they said, "Yes." "Does she talk like her?" she asked. "Yes!" they answered. "Well, then it's probably her!" At that point, the boys asked if they could get an autograph as Miley came out, and Sierra told them Miley would only do it for a dollar apiece! "I was like, 'Sierra! What are you doing?' She's like, 'Yeah, the boys are gonna go get us a dollar so we can do that dollar machine and get our pictures taken!' I was like, 'You don't ask that!' " Miley thought the whole thing was hysterically funny, but she also knew it could sink her with fans if word got out. "I walked over to the boys' moms and was like, 'I am *so* sorry. I will *totally* take pictures and do autographs for these boys. They do not have to give me a dollar!' They were probably like, 'Okay, she's on Disney Channel and she's asking my boy for a dollar??? What is *with* this chick?' That was a really weird story!"

"...it's so worth it to see all these young kids looking up to you."

Kids all know Miley's face from TV, but they're also becoming acquainted with her from the enormous number of official *Hannah Montana* products on the market. "It's weird. I was playing the video game and they made my hair like eight sizes too big," she told MediaVillage.com. "I'm like, 'Is *that* really what you guys think of me? You really think of me with this enormous hair?' It's really crazy to see all the things they have out. It's really weird to see in stores but it's really fun, too."

She generally enjoys being recognized all the time—it's just those times when she feels she doesn't look her best that she cringes! She told MediaVillage.com, "When I look horrible and see people I'm like, 'Oh, no, they're going to be scarred for life. They're never going to think of me the same way.' But it's fun meeting new people."

One thing's for sure: a part of being famous that never bothers Miley is autograph requests!

"It's just a quick way to make them smile," she generously told *Life Story*, explaining that it's fun to sign for kids. Billy Ray's best advice to Miley—repeated by her in nearly every interview—was, "If you ain't havin' fun, it ain't worth it." And so far, even with the high price of fame, Miley's still having fun!

> **"When I look horrible and see people I'm like, 'Oh, no, they're going to be scarred for life. They're never going to think of me the same way.' But it's fun meeting new people."**

THE BUSINESS OF BEIN' MILEY!

Miley belongs on any list that includes successful young people, but even *she* was surprised to find herself on *Forbes* magazine's list of the Twenty Top-Earning Young Superstars! On the list, which ranked the income of athletes and performers under age twenty-five for the year 2007, Miley came in at number seventeen, with $3.5 million. She was in good company: basketballer LeBron James was number one, Mary-Kate and Ashley Olsen were number five, Hilary Duff ranked number seven and Carrie Underwood was number eleven. And things are only looking better for the future—that list came out *before* Miley had a sold-out concert tour or a hit movie!

Although she's a star beloved by millions, Miley does have her share of antifans. This is a common thing that all famous people deal with—for every member of the public who loves you, there is another person who can't stand you.

At a press gathering, Billy Ray Cyrus said, "You know, for every reaction, there's an equal and opposite reaction. If you do something that's really, really good or you do something that people really, really like, there's going to be somebody that really, really hates it. That's just the laws of life, you know? That's just the way it is. So we just try to do what the fans of the show want us to do and be the people that we feel—the best people we can be on this earth while we're here, hopefully do what makes us happy."

Tish subscribes to her husband's theory, according to Miley, who said on *Good Morning America*, "My mom always says for every, you know, ten thousand people that love you, there's going to be another handful of ten thousand people that don't. And it's like, there's nothing that you can change. So, that's all right."

If you're a fan of Miley's, you've probably experienced some pushback from her antifans, people who don't understand why you admire her so much. Why? It's hard to say with Miley, but much of it probably has to do with jealousy—and that's something she has gone up against in the past.

"Before I was on *Hannah Montana*, I went to regular school back in Tennessee," Miley told *M.* "I used to get picked on all the time because my dad was a famous country singer. Mean girls would say, 'Oh, she thinks she's better than us.' But I didn't! I just wanted to fit in. What I learned was to try and be friends with the haters."

That's the best advice ever—and it applies to nonfamous people, too. "My goal is to just do what I need to do and help others and make others happy . . . The truth is there's always going to be someone to, you know, criticize or whatever, but you can't really take that personally. You make all your choices and you take it and you don't use it, you know, in a bad way or, you know—you know, you just have to take it and kind of do what everyone wants. You know, take the criticism, make it happen, and give them nothing to complain about."

The next time anyone hassles you for liking the great Miley Cyrus, remember: Miley herself can handle the negativity, so don't let it distract you from enjoying her music, her acting, or her amazingly upbeat attitude!

> "My mom always says for every, you know, 10,000 people that love you, there's going to be another handful of 10,000 people that don't. And it's like, there's nothing that you can change. So, that's all right."

Miley Cyrus has to be one of the world's busiest teenagers—but you'd be surprised how much one of her days sounds like yours!

She told *Popstar!* in 2007, "This morning I got up at eight—well, I was supposed to get up at eight and shower [but] I didn't. So I got up at nine, got here at nine-fifteen, did two hours of school, got hair and makeup done. Went out and did a Disney Channel interview-type thing. Went back, got cookies and a granola bar. I came here and now I'm doing interviews. The food, that's repetitive. That's what I do every day!"

See? Just like you—well, except for the free hair and makeup and those fabulous interview opportunities!

But Miley is a hard worker who knows how to use her downtime to truly relax. At her famous Hollywood & Highland outdoor concert to launch *Hannah Montana 2: Meet Miley Cyrus*, she confessed that her ideal day is spent "shopping, shopping, and more shopping!"

More seriously, a day without a lot of Disney Channel press is much more school-focused than you might expect.

Like many of her famous peers (but not costar Emily Osment, who's been known to attend public school), Miley has spent all of her recent school years learning on the set or at home, via tutors and other home-schooling options.

This was a big change for her after attending Heritage Middle School until sixth grade back home. Leaving that school was very hard for Miley, but it was necessary to help keep her exploding career on track.

Miley can spend about three hours a day (including weekends) devoted to school, including independent-study projects she may be doing and also regular homework. This kind of focus allows her to absorb subjects more easily, and led her to discover that—hey, who'd have guessed it?—she's really into math!

> **"I have a teacher there and people are always saying, 'Oh, I bet he gives you an easy time because of your situation.' No way!"**

"Just working in the business, you need to know how to take care of your money," she explained to *Life Story* regarding her interest in math after many years of hating it. Language remains her fave subject—no big surprise, considering she's definitely got the gift of gab!

Miley's main, in-person schooling came from an organization called Options for Youth.

"I have a teacher there and people are always saying, 'Oh, I bet he gives you an easy time because of your situation.' No way! He's more hardcore! He's like, 'Everyone's watching me because of you, so you'd better get it done!' It's intense," she told *PBS Kids*. "My shooting schedule is easy compared to what I do at school. This was the rule, that acting and singing is my 'side stuff.' If you came to my school you'd see a whole different side of me. There I'm like, 'Okay, it's time to get down and study.' "

In an interview with *Parade*, Miley further explained that her hours of schoolwork usually are not all at once.

"There's a tutor on the set, but it's difficult. I may act for forty-five minutes, then do an hour of school and go back to acting. That makes it hard to concentrate on either acting or schooling."

Still, Miley has shown herself to be a bright student who's dedicated to learning new things. You don't become the most famous teenager in the world by blowing off the need to constantly grow, change, and learn new things.

On December 14, 2007, Miley appeared on the Canadian show *Much on Demand* to premiere her "Start All Over" video. The hosts had her play word association . . . and here are some of the more telling answers she came up with!

Smile	"Guys"
Frown	"Hard questions"
Laugh	"Will Ferrell"
Scent	"Vanilla"
Bores	"School"
Irritates	"My brother"
Afraid of	"The dark"
Envy	"Nicole Richie's style"
Can't do without	"I can't do anything without my puppy, Roadie!"
Rewarding	"Getting to travel all over the world after working so hard!"
Biggest disappointment	"My dad's Christmas presents!"
Favorite item in my room	"My blanky. It's Eeyore from *Winnie the Pooh*. It says 'Gimme a hug' on it. . . . I love it!"

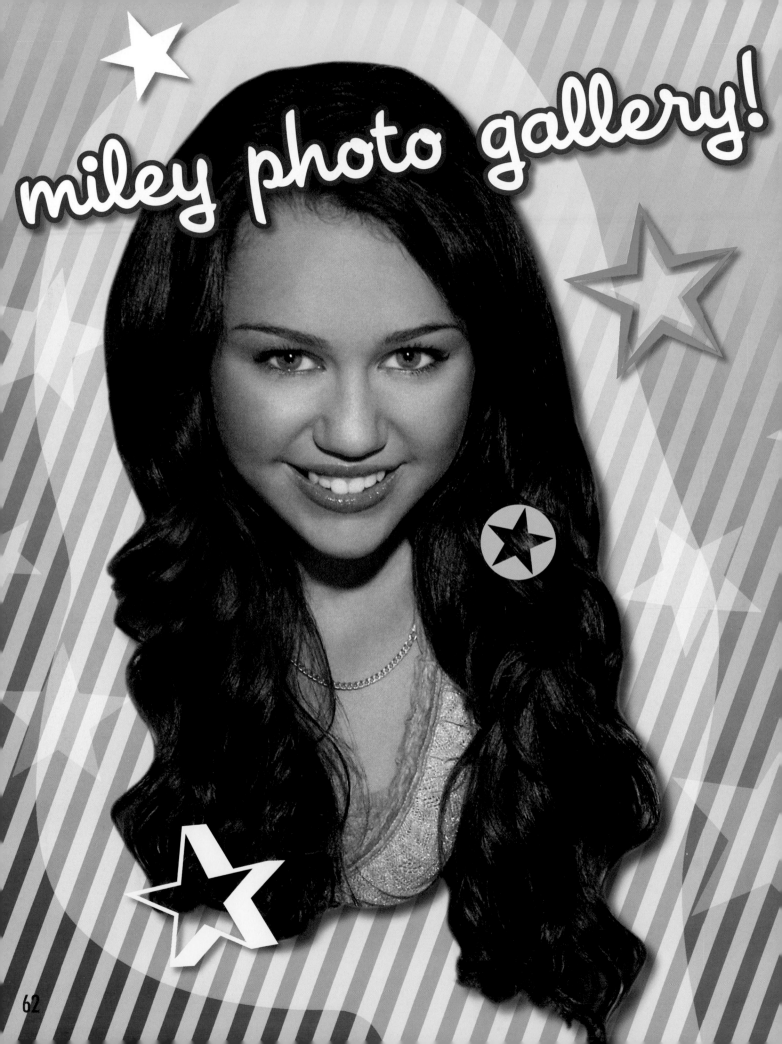

miley photo gallery!

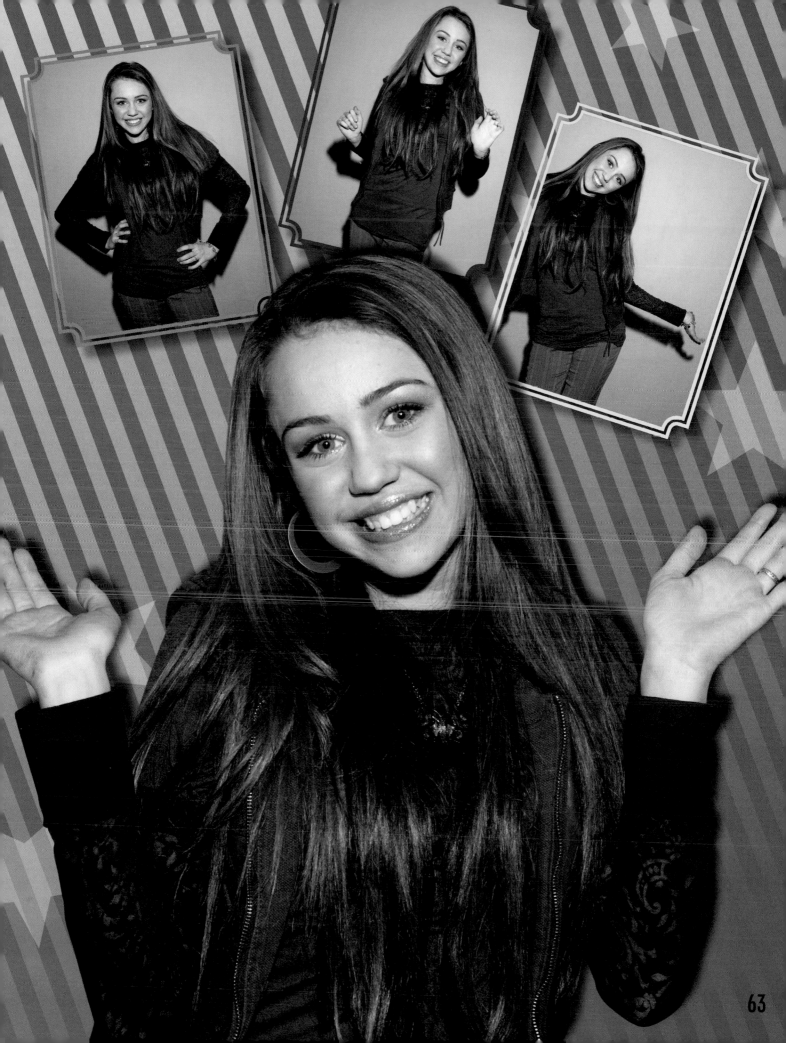

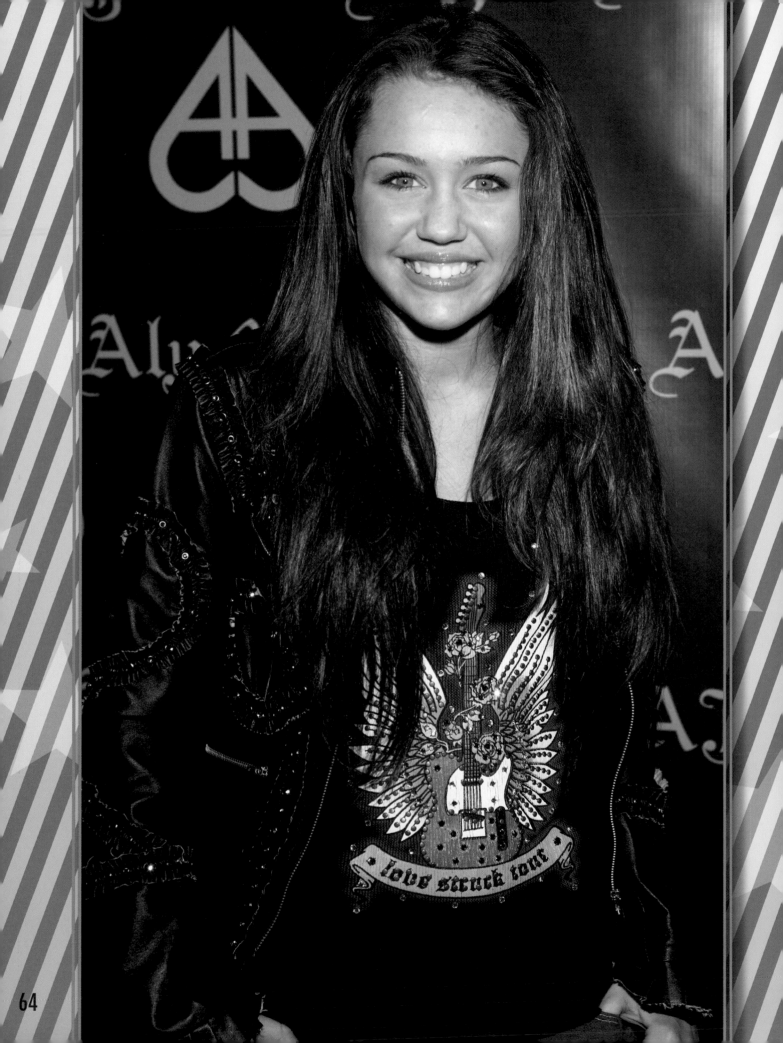

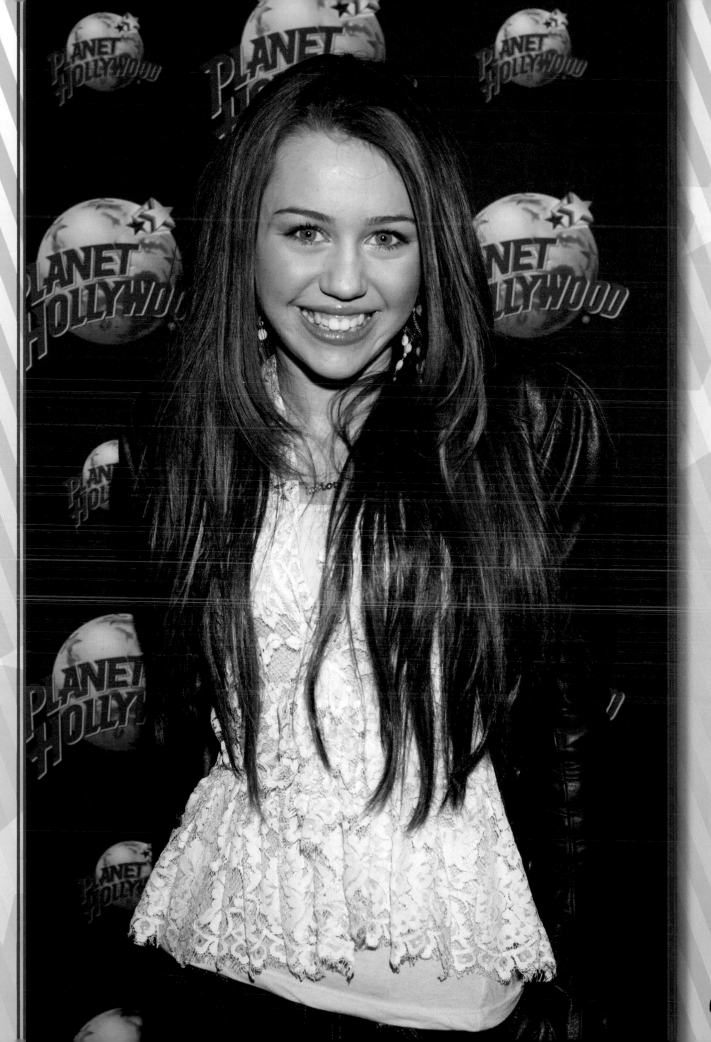

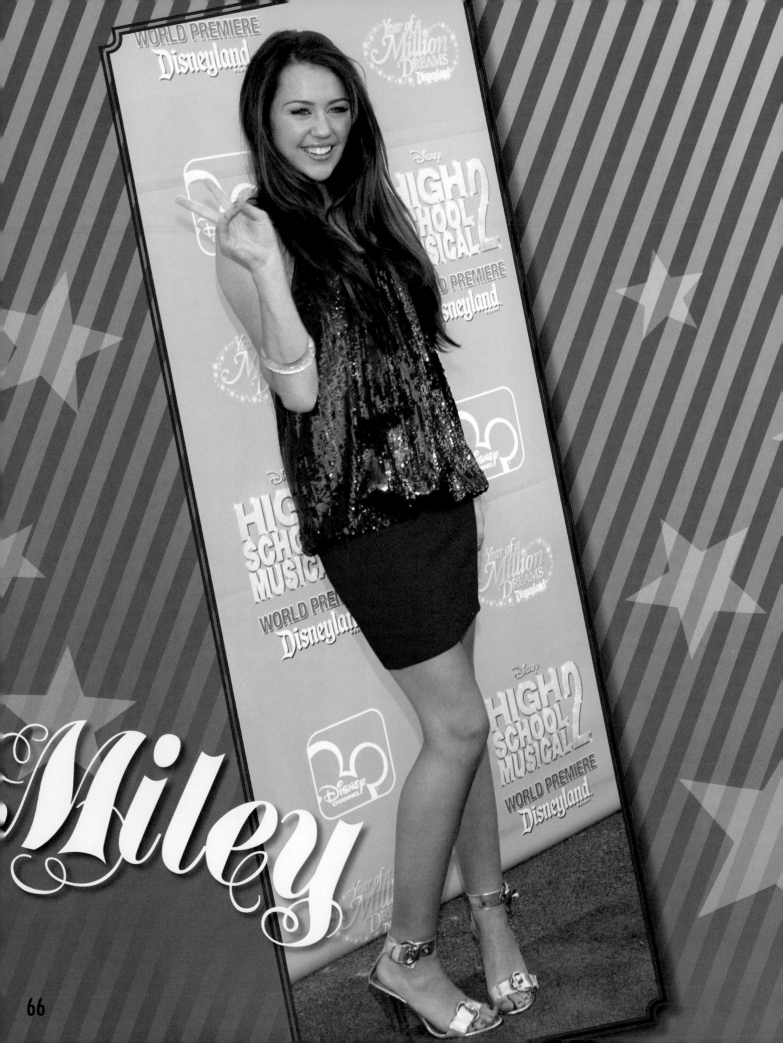

Miley

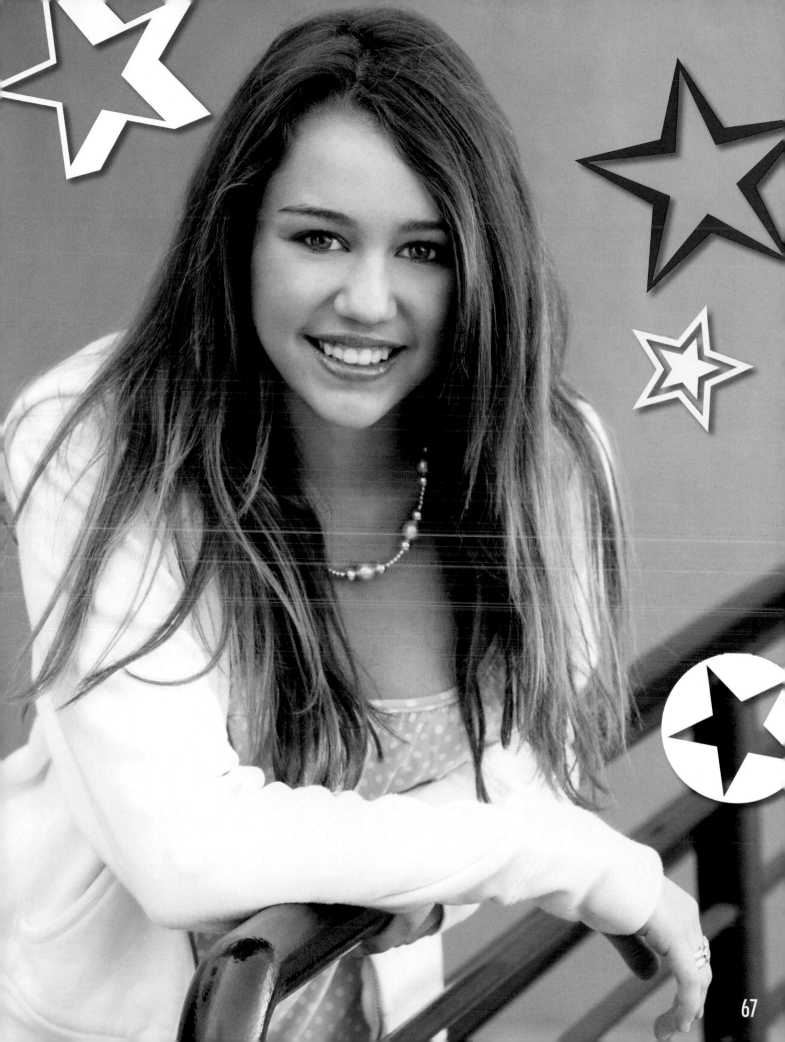

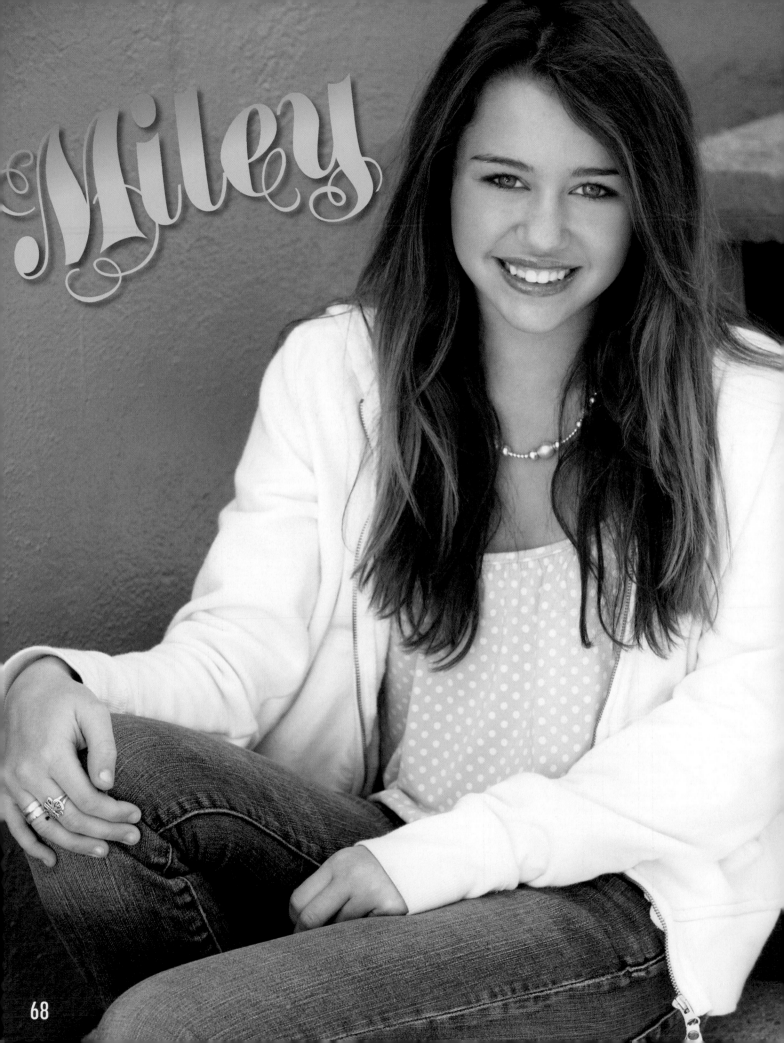

Miley

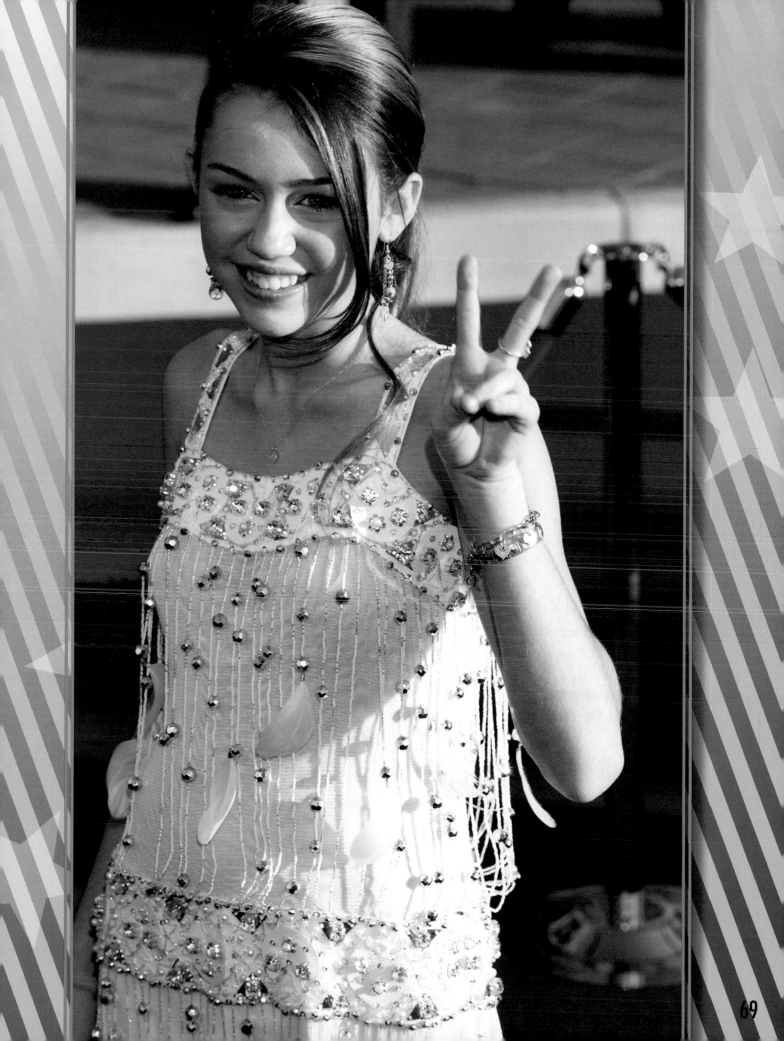

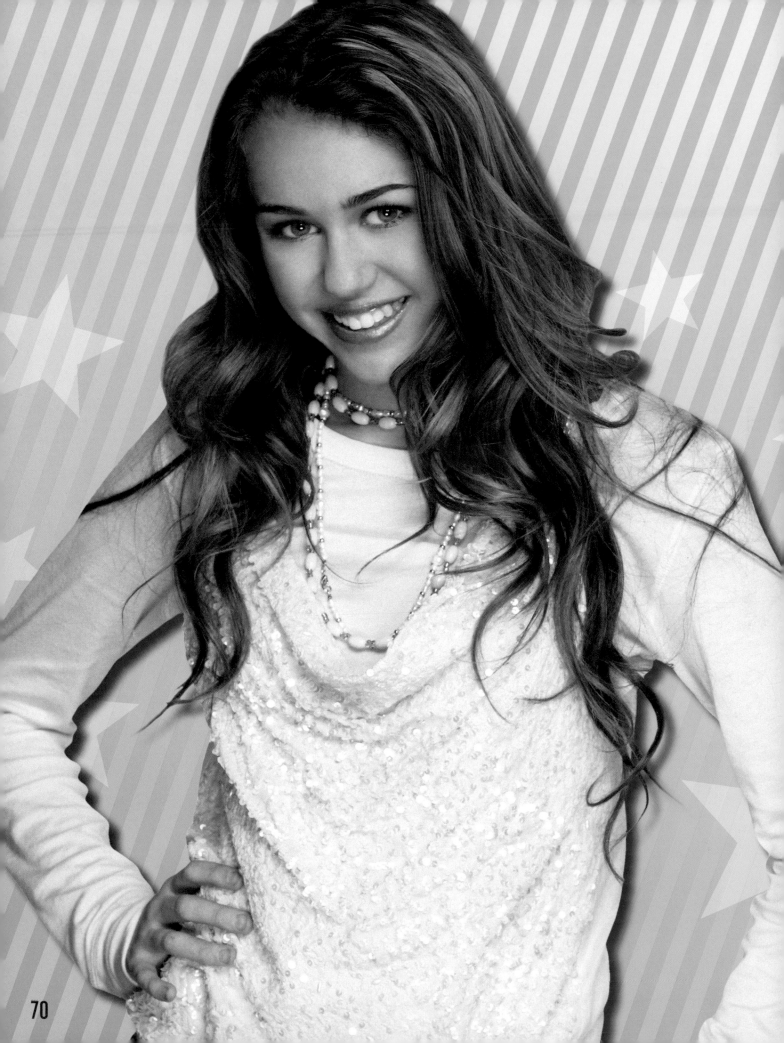

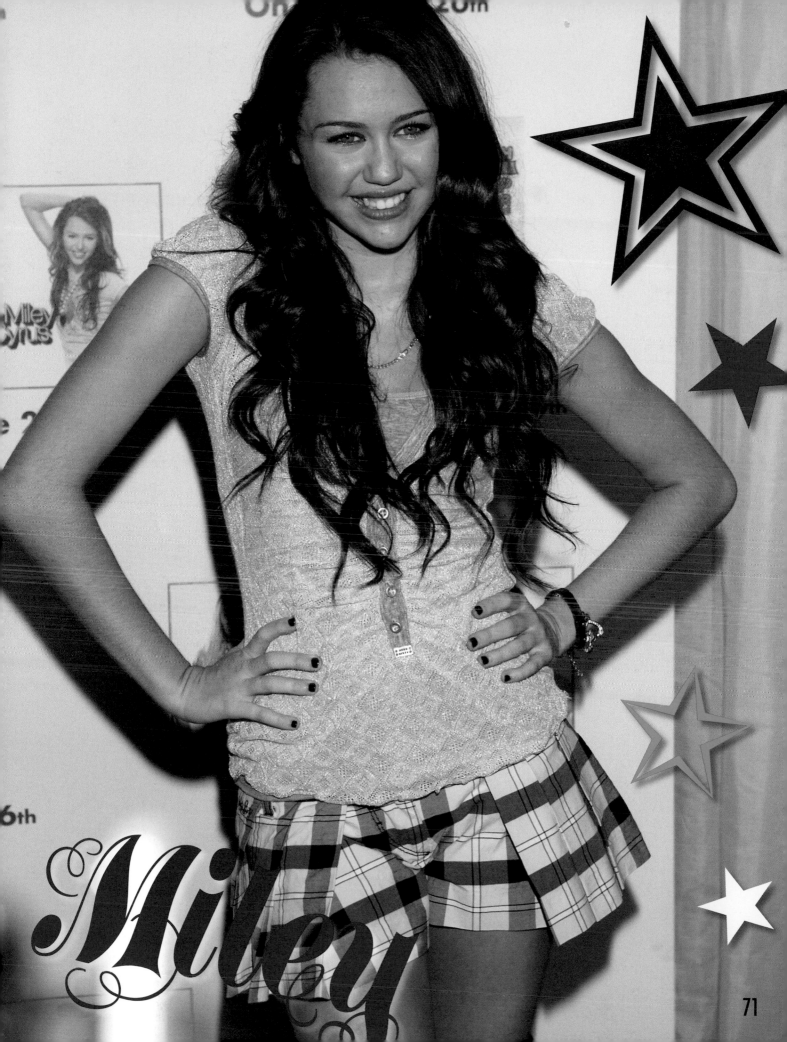

71

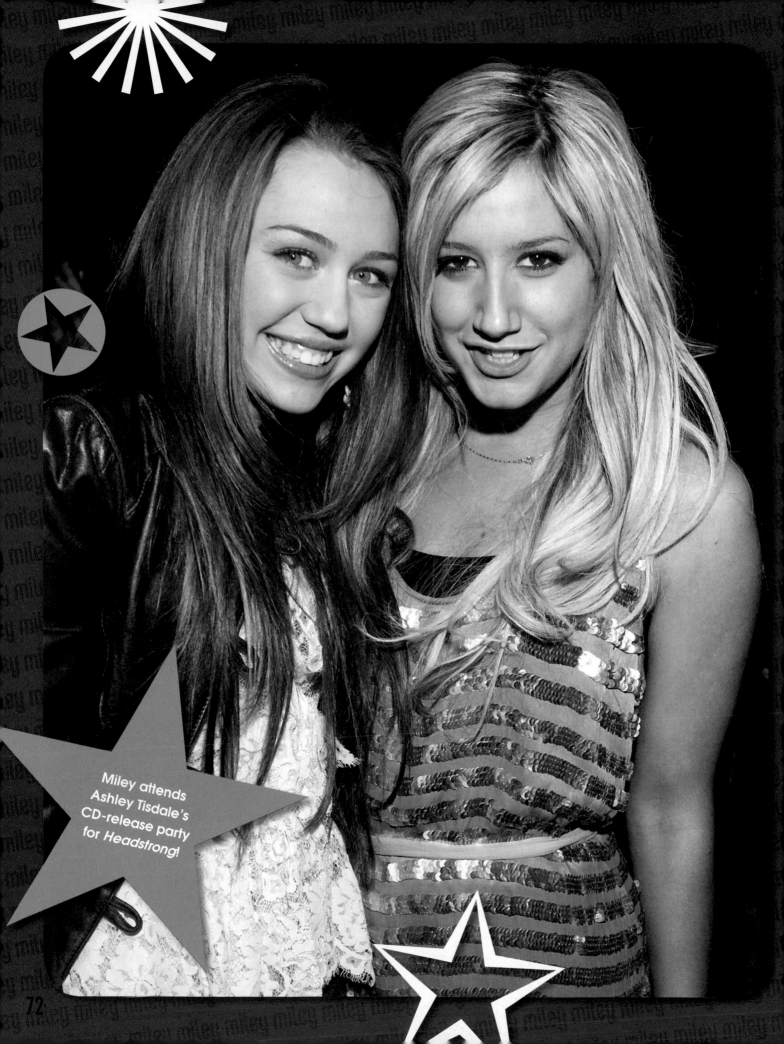

Miley attends Ashley Tisdale's CD-release party for *Headstrong*!

true friend: miley's VIP BFFs!

Miley knows how to make friends wherever she goes—even in Hollywood! She values their support, as she told *Popstar!* magazine after her Hollywood & Highland concert on June 26, 2007. "All my close friends are especially supportive, which is really nice—to actually have people care and love you."

Check out this list of her BFFs. Could you be among them one day?

"I actually have a song called 'True Friend.' I think a true friend is someone who's there during the ups and the downs. There have been a lot of positive things in my life, but there have also been some negative parts, too. There are things that aren't so fun to deal with, not just for me but for my friends. So I think that's what makes a true friend: being there and listening through everything."

—Miley, PBS Kids

Tish and Brandi Cyrus

Yes, Tish is Miley's mom, but she's also her friend—and one of her closest confidantes.

"My mom and sister are my best friends and are always there for me," Miley said to *TigerBeat*.

Vanessa Hudgens

The glamorous star of the *High School Musical* series is a good friend of Miley's. Miley told the *Minneapolis Star Tribune*, "We, like, stay up the whole night talking. We go shopping. When we're not together, we iChat each other!" The reason for her connection with Vanessa might be in the stars—Miley told *M*, "Vanessa and I are both Sagittarius, so we can just talk forever!"

The girls have even made hats for each other—Miley's says "XOXO Nessa" and Vanessa's says "XOXO Miley."

And Miley's a true friend, no matter what. When embarrassing photos of Vanessa were leaked, Miley's response was simply, "Mistakes happen and I'm just happy I can be there for her as a friend, which is what she needs more than anything."

And that's *exactly* what she's got in the loyal Miley Cyrus!

"Vanessa and I are both Sagittarius, so we can just talk forever!"

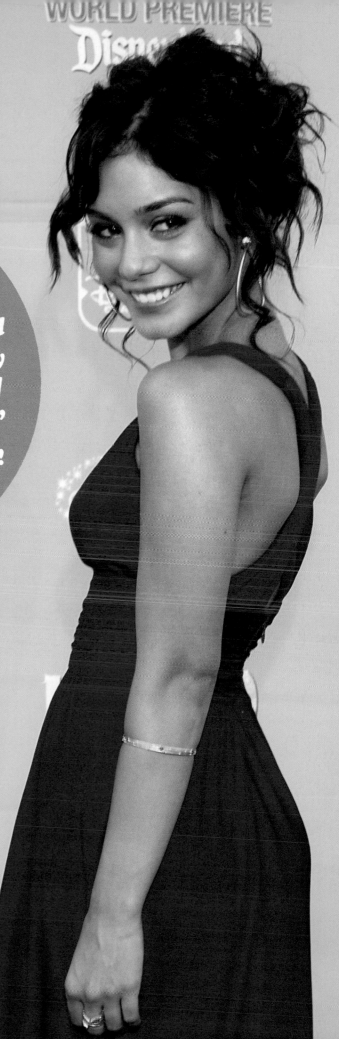

Vanessa

"Ashley, Vanessa and Corbin are like my closest friends [who] aren't on my show!"

—Miley, Popstar!

Aly and AJ

"I am very close with Aly & AJ . . . we run into each other all the time!" Miley told *Life Story.* She shares a lot in common with fellow Hollywood Records act Alyson and AJ Michalka—a reliance on faith, a strong sense of fun and devotion to making music!

"We're big sleepover people! We always go over and write music!" Miley told popstaronline.com.

The girls all got along so well that Aly and AJ were added to Miley's 2008 tour when the Jonas Brothers finished their contribution!

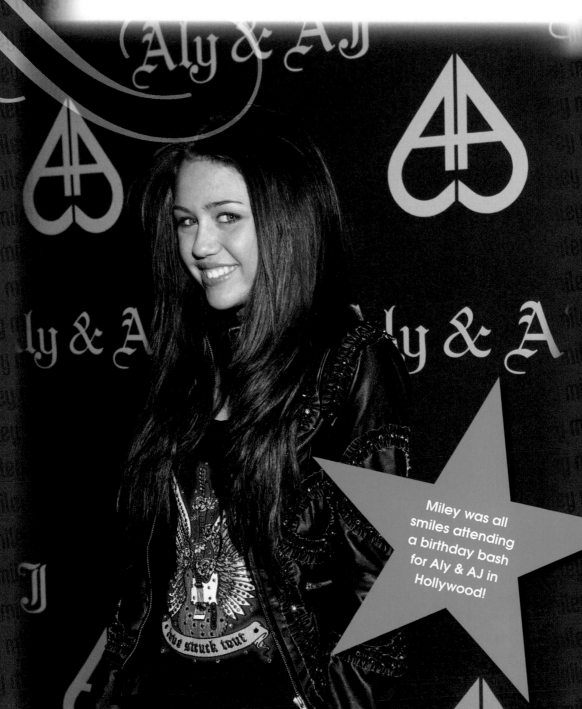

Miley was all smiles attending a birthday bash for Aly & AJ in Hollywood!

Lesley

Bubbly blonde Lesley—who has been immortalized in the Top 10 hit "See You Again" as the pal who says, "She's just bein' Miley!" when Miley freaks out over a boy—has known Miley since they were six years old back in Tennessee. The girls both aspired to be cheerleaders and bonded from the moment they met.

Lesley is one of Miley's friends who lends her support in all areas of life.

Miley told *J-14*, "She's been so supportive of me. She went though the whole auditions process with me. She talked me through it. We've all stayed in touch and Lesley comes out to L.A. a lot, so it's cool. I realize now that you can't be afraid to lose people, and that's the thing I was afraid of the most. You can't lose somebody if you always hold on to them."

Lesley has also helped to keep Miley grounded, reminding her not to let fame and fortune go to her head.

"Even though I may be a celebrity to the kids now or whatever, Lesley is still like, 'Miley, you're just a normal person,' " Miley told popstaronline.com. "(We were) used to seeing each other every single day, because after school, we'd always hang out and go to cheerleading together, and now I barely get to see her at all. It's so sad. We'll always be online talking or on the phone. We're like, 'I just miss you so much!' We're sitting there crying. This is lame, but we can't live without each other. She's a really good friend!"

Over the years, Miley's flown Lesley to be with her for some important moments, including making sure that Lesley was front row at Miley's first ever concert! And Lesley's never far for other reasons—Lesley's mom also works for Miley's godmother . . . who happens to be world-famous country singer Dolly Parton!

Mandy

One of Miley's best pals is Mandy, who in 2008 launched a YouTube channel with Miley at youtube.com/mileymandy, where they upload episodes of *The Miley and Mandy Show*. They've imitated the Jonas Brothers and Aly & AJ on their wacky show!

Ashley

Ashley Tisdale

"She's one of my best friends!" Miley declared to *Tiger Beat*. When Ashley Tisdale held a small, exclusive record-release party for her album *Headstrong* at Planet Hollywood Times Square, Miley Cyrus made sure to be there. The girls hugged and gossiped and had a blast— that's because they're like two peas in a pod!

As Miley related to popstaronline.com, working for Disney Channel is a wonderful bond the girls share.

"A lot of the Disney stars— we've all got so many different things that I think you wouldn't know about. Ashley and all of them are so cool and down to earth. Some people are like, 'I bet they'd be so cocky in person!' But . . . I haven't met a bad person *yet*, so I'm not planning on it anytime soon."

Taylor Swift

One of the top-selling acts of the past couple of years, country princess Taylor Swift probably has a lot to talk about with pop princess Miley. She was invited to Miley's '80s-themed fifteenth birthday party, where she hugged and chatted with her hostess.

Selena Gomez

The star of Disney Channel's *Wizards of Waverly Place* told *Popstar!*'s May 2008 issue that Miley's "so sweet, she's really fun. She made me feel really welcome!" She was referring to her performance as a rival pop star on *Hannah Montana* before *Wizards* launched and before she was a huge star herself! "When I went there, she made me feel really good. I think we level each other out because she's the girly-girl and I'm the tomboy—I text her all the time!"

Selena

Tory

Tory is another of Miley's best friends, a longtime supporter who helps Miley relax and enjoy being a normal teenager when she's not performing.

"My friend Tory looks exactly like (Alexis Bledel from *Gilmore Girls*) and I'm not even kidding!" Miley said, talking about how she wanted the two of them to have their own TV show together. "It would be so perfect! We'll come out with our own *Gilmore Girls*!"

"I hung out with a small group of friends I've known all my life because I went to the same school my whole life," Miley told *J-14*. "I was in the same school since kindergarten." That stability led to long-lasting friendships, like the one she enjoys with Tory (who looks like Rory!).

In 2007, Tory accompanied Miley on her very first trip to London, riding a double-decker bus with her and waving to fans along the way.

You and Me Together: The Jonas Brothers

miley has plenty of guy friends, too, and none are closer to her than the Jonas Brothers! Kevin, Joe, and Nick have been huge fans of Miley since meeting her a couple of years ago at a charity event, spending time with her at her house, going on Pinkberry runs, and touring together in 2007 and 2008.

Miley enjoyed her time with them so much she invited them to guest-star on *Hannah Montana* in what wound up being the best-rated episode ("Me & Mr. Jonas & Mr. Jonas & Mr. Jonas") in the show's entire run! More than ten million kids watched the show when it debuted on August 17, 2007, following the premiere of *High School Musical 2*.

"It was amazing," Nick Jonas told *Life Story* of the *Hannah Montana* taping. "That was our first sitcom experience and it was really fun. For us it was a whole new animal and so different from concerts. It was pure fun getting in front of the camera and doing the lines. By the time it came to film, we had memorized our lines and weren't worried about that anymore. What we needed to focus on was the delivery of our lines!"

The guys liked the experience so much it led them to their own Disney Channel show, *J.O.N.A.S.*

"*Hannah Montana* is filmed with a live audience, but our pilot (*J.O.N.A.S.*) was shot single-camera and there was no live audience. That was different, because there was no one there to laugh or cheer. We liked doing both. And Miley is a great friend of ours," Kevin Jonas confided to *Life Story*.

Joe Jonas also has had a lot to say about appearing on *Hannah Montana* with Miley. In *Life Story* he confessed, "Onstage when you're performing, you can't say, 'Cut, let's do it again.' If you mess up a lyric or guitar line, you can't just go back and do it all over again." Despite fears they'd mess up, things went well, to say the least!

The match was musical as well—the Jonas Brothers and Miley (well, "Hannah"!) even recorded the song "We Got the Party with Us" together for the episode!

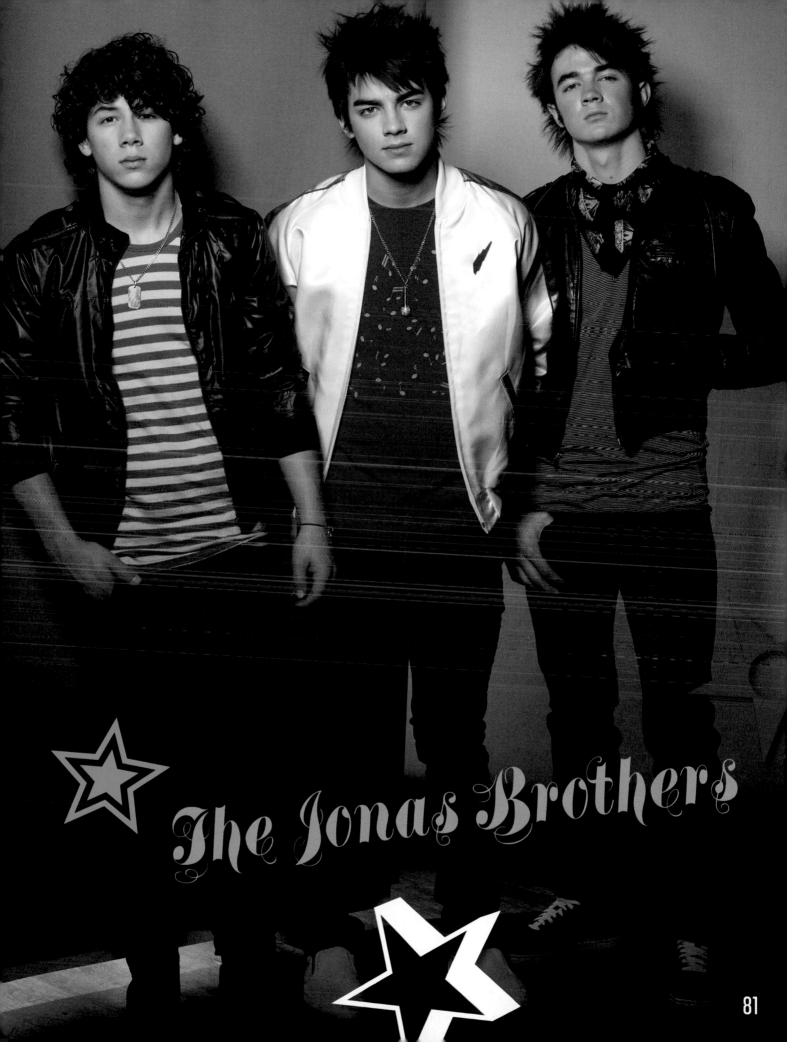

The Jonas Brothers

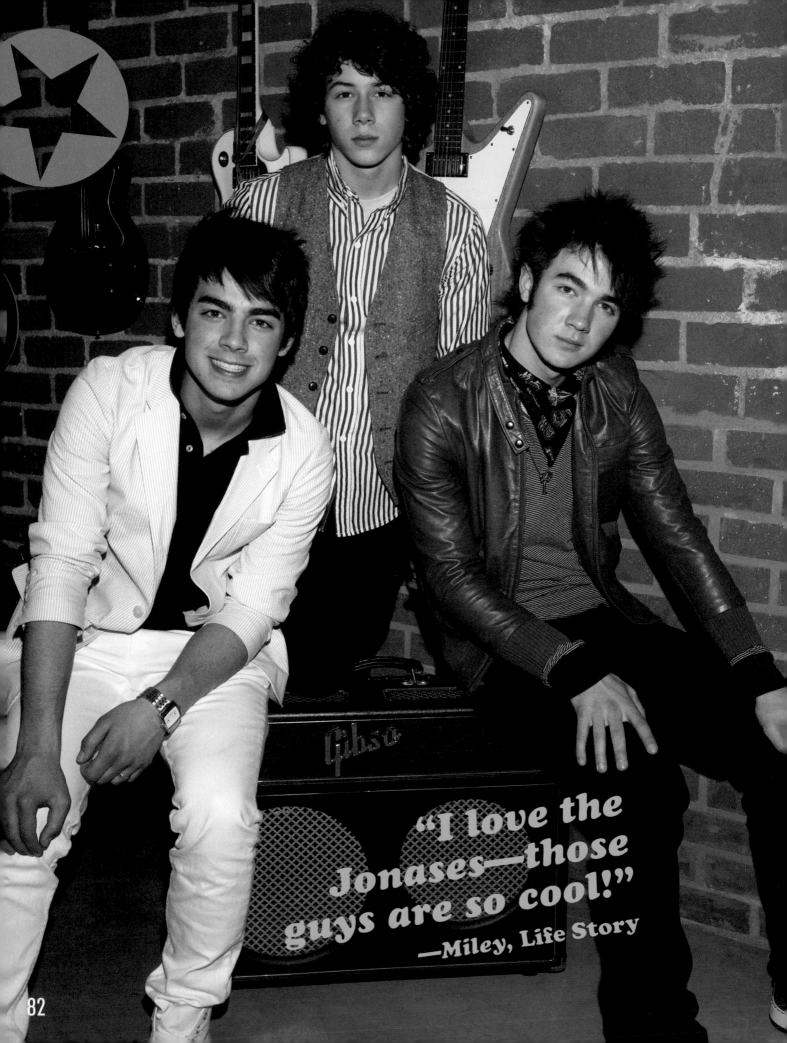

"I love the Jonases—those guys are so cool!"
—Miley, Life Story

82

What does Miley share with the guys? Well, she definitely appreciates their love of music. When *Hannah Montana 2/Meet Miley Cyrus* was still months from being released, she told *Popstar!*, "I've played it for two people. I've played it for Moises Arias, who plays Rico (on *Hannah Montana*), and Nick Jonas. I was listening to theirs and they were listening to mine so it was really cool to get to listen to our albums together!" (When Nick played her tracks from *Jonas Brothers*, their future hit album, Miley told the magazine, "It sounds really great. It sounds really, really good. I was really happy for him!")

Joe Jonas confirms that the feelings of friendship are mutual, telling *M*, "Miley's one of my best friends. She works so hard all the time. She'll go onstage and play two sets, as Miley and as Hannah—altogether, it'll be, like, thirty songs! It's crazy."

"Miley's like my little sister; we're like family. I just think she's great—she's like a little ball of energy," Kevin told *M*.

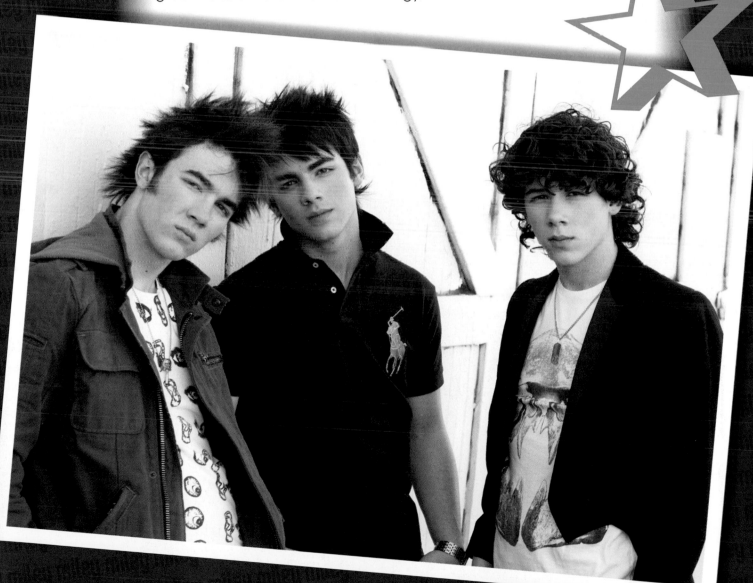

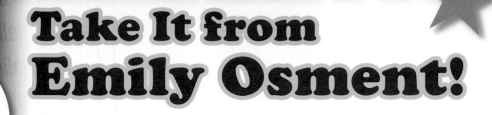

Take It from Emily Osment!

if Emily Jordan Osment (born on March 10, 1992) identifies with her offbeat character Lilly Truscott, part of the reason could be just how much she likes and admires her close pal Miley, just like Lilly does!

"The first time I met Miley was the final audition for *Hannah Montana*," she told *Teen*. "She'd already gotten the part, and the producers were auditioning Miley with other actors to see how well we'd fit together. She was just really loud and crazy. I thought, 'Wow, she's really out there!' Since then, she's been a great friend of mine." Prior to joining *Hannah Montana*, Emily was already a showbiz pro, unlike newcomer Miley. Emily had appeared on many TV shows (from *Friends* to *3rd Rock from the Sun*) and two of the *Spy Kids* movies, and had been afforded a close-up view of the industry thanks to her big brother Haley Joel Osment's experience shooting to fame as the ghost-spotting kid in *The Sixth Sense*. She also had her dad to thank for getting her into acting at such a young age.

"I know I can tell her anything, and if I ask her to not say something, I know she won't. She's a really good, trustworthy person and really fun to be around."

—Miley on Emily,
Tiger Beat

"My dad has been, he's been a play actor for years, since, like, college, high school," she told *Popstar!* during a break at the DC Games. "He got my brother into it. He was like, 'Hey, you want to do this?' and my brother was like, 'Yeah, sure, okay.' So he kept doing it and I remember I was really, really little—I must have been like four or five—and he'd be practicing lines and I'd be like, 'That looks really fun. I want to do that!'"

Emily recalls that her early-years performing came with no strings attached, and absolutely no pressure. Maybe that's why she's remained grounded enough to be cited by ABC's *20/20* as one of the most well-adjusted kids in Hollywood, despite her escalating fame.

Em never suspected that *Hannah Montana* would be quite as big as it's become! "I think at first I was like, 'Oh, this'll be cute.' But since I've never been involved with something that's so out there and so big right now . . . I think it's all been sort of new for all of us."

When she first shot the pilot, she recalls everyone telling her it would be big. "I was like, 'Oh, yeah, okay, whatever!' and now it's really happening and I was caught by surprise, I think!"

Em wasn't really sure she had hit the big time until one particular moment made it all crystal clear.

"It didn't hit me until I did a signing back in Pennsylvania and there were seven thousand people waiting outside the mall," Emily remembered on the show. That kind of double life reminds Emily a lot of her day job on *Hannah Montana*!

"I think we're *all* sort of experiencing some Hannah-ism in this," she's said, referring to the double-life aspect, with one life being that of an instantly recognizable star. "We're doing this right now three weeks out of the month and we're sort of living what Hannah is living. She's being this pop star, then she has to live this normal life as Miley Stewart, and I think we're all doing that on hiatuses and things."

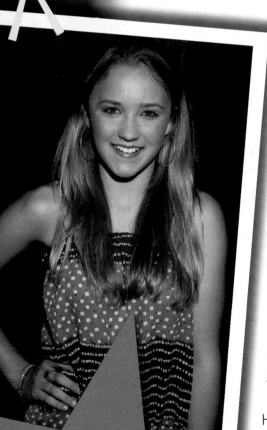

Emily loves making her own clothes— she did this dress with a little help from her mom!

As Emily told *USA Today*, her mom even started noticing kids imitating the *Hannah* gang soon after the show first aired!

Bonded by sudden fame, Miley and Emily get along like best friends, or even like family members.

"When we first met," Miley told *Teen*, "Emily and I were automatically really, really close. When we're together, we're never quiet because there's so much to talk about and there are so many stories. Every day it's something new for us. And when you're with someone all the time, it's more than just being friends—we're sisters now—we love each other like sisters and we fight like sisters."

Along with sister territory come sisterly squabbles. Emily described how she and Miley sometimes fight, "Like, 'No, I did that first!' 'No, you're totally copying me!' and, 'What are you doing???' She'll come in one day and we, like, *won't talk*. For ten minutes. But then it never lasts and we're like, 'Okay . . . this is stupid!' We'll fight over dumb stuff like brothers and sisters do—we love each other just like a family."

Emily told *Popstar!* that the girls frequently have sleepovers. "Miley will be like, 'You wanna come over?' and Miley will come spend the night

A FEW OF EM'S FAVORITE THINGS!

★ Retro TV such as *M*A*S*H, Full House, Taxi,* and *The Cosby Show*.

★ Music from the '60s and '70s, such as AC/DC and the Beatles.

★ Classic, no-nonsense clothes from stores such as Abercrombie & Fitch and Old Navy.

★ Candy and doughnuts to satisfy her sweet tooth, even though she's trying to cut back on those snacks.

★ Soccer. "I love soccer!" she told popstaronline .com. "I've been playing soccer forever, since I was like six years old. And it's so much fun and my whole family's in on it, so we all go to soccer games!"

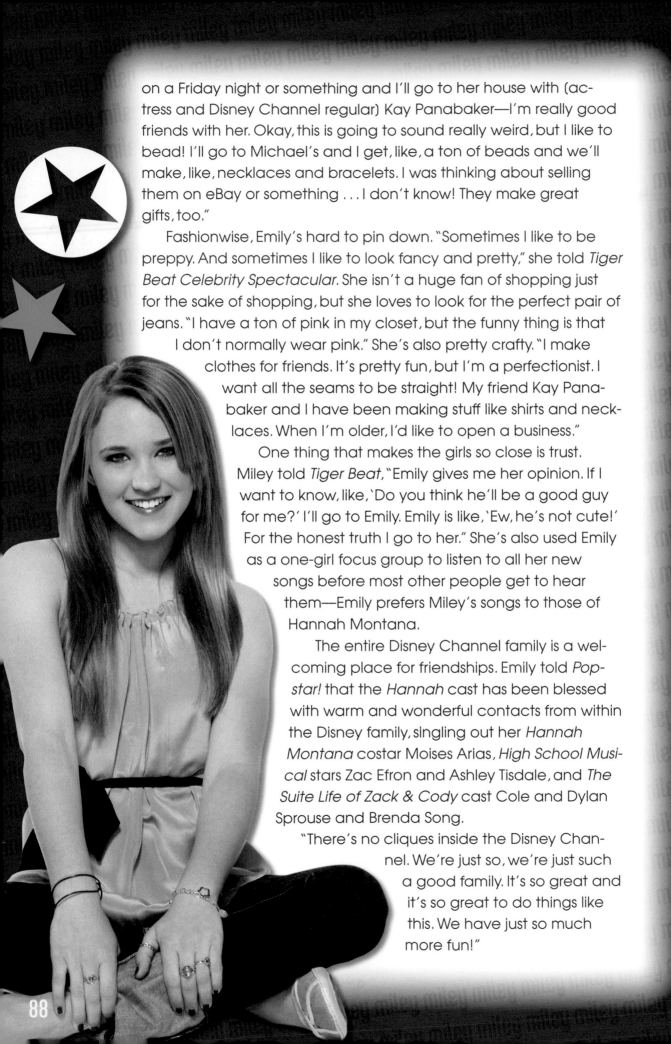

on a Friday night or something and I'll go to her house with (actress and Disney Channel regular) Kay Panabaker—I'm really good friends with her. Okay, this is going to sound really weird, but I like to bead! I'll go to Michael's and I get, like, a ton of beads and we'll make, like, necklaces and bracelets. I was thinking about selling them on eBay or something . . . I don't know! They make great gifts, too."

Fashionwise, Emily's hard to pin down. "Sometimes I like to be preppy. And sometimes I like to look fancy and pretty," she told *Tiger Beat Celebrity Spectacular.* She isn't a huge fan of shopping just for the sake of shopping, but she loves to look for the perfect pair of jeans. "I have a ton of pink in my closet, but the funny thing is that I don't normally wear pink." She's also pretty crafty. "I make clothes for friends. It's pretty fun, but I'm a perfectionist. I want all the seams to be straight! My friend Kay Panabaker and I have been making stuff like shirts and necklaces. When I'm older, I'd like to open a business."

One thing that makes the girls so close is trust. Miley told *Tiger Beat,* "Emily gives me her opinion. If I want to know, like, 'Do you think he'll be a good guy for me?' I'll go to Emily. Emily is like, 'Ew, he's not cute!' For the honest truth I go to her." She's also used Emily as a one-girl focus group to listen to all her new songs before most other people get to hear them—Emily prefers Miley's songs to those of Hannah Montana.

The entire Disney Channel family is a welcoming place for friendships. Emily told *Popstar!* that the *Hannah* cast has been blessed with warm and wonderful contacts from within the Disney family, singling out her *Hannah Montana* costar Moises Arias, *High School Musical* stars Zac Efron and Ashley Tisdale, and *The Suite Life of Zack & Cody* cast Cole and Dylan Sprouse and Brenda Song.

"There's no cliques inside the Disney Channel. We're just so, we're just such a good family. It's so great and it's so great to do things like this. We have just so much more fun!"

When she's not working, Emily's a normal girl. If you see her, don't be shy to ask her for her autograph—she has said she understands that she owes her success to the fans, and she'd never refuse to sign an autograph unless she had absolutely no choice.

One of Em's biggest pleasures comes from being a role model. "I think it's pretty cool," she told *Popstar!*. "It's a big responsibility because you always have to have your head on straight and you gotta know what you're doing. We have to do everything right and be polite and dress nice. We just wanna be the best that we can be."

And that sums up Emily perfectly—she's a great person to look up to, and a perfect pal for Miley to look to whenever she needs support!

> *"I don't go clubbing. I'd much rather have a sleepover or go bowling with girlfriends."*
> *— Miley,* **Tiger Beat**

ROCKiN' ROLE MODEL: HiLaRY DUFF

Miley is an obvious successor to the legacy created by *Lizzie McGuire*'s Hilary Duff—not only the star of her own Disney Channel show, a singer and touring pop star, but also a one-girl brand!

"I am, like, a big Hilary Duff person," she told *Life Story*. "My family loves her. And it's cool, because she started *Lizzie McGuire* at the same age that I started *Hannah Montana*, so the way that I am doing the business and everything is kind of following her footsteps."

When asked how it feels to be compared to Hilary, Miley says, "Oh, my gosh—it's . . . *scary*! Because Hilary Duff has been my role model forever. I went to her concert, like, *right* when her concert started coming out when I was probably like *eleven*. I went, and I was just amazed by her. So now, to be compared to her, it's like . . . holy moley, it's so cool."

Before meeting Miley, Hilary had this to say when *Popstar!* asked her for her thoughts about Disney's newest princess looking up to her as a role model: "I kind of just learned about her, but I know how hard she's working now. It's really sweet, you know? It's *really* flattering!"

The similar songbirds met on September 27, 2007, at the Spirit of Life Awards gala hosted by Hollywood Records honcho Bob Cavallo, where they happily posed for pictures. Even stars get star-struck!

Hilariously, Hilary called in to *Much on Demand*—a Canadian show on the music channel MuchMusic—posing as a fan named "Hailey" from Vancouver, British Columbia. After asking Miley a question, Hilary revealed herself with these kind words for Miley, "It's been really cool just to get to watch someone that I know admires me and see them grow up and be so successful and do things that they love and have fun."

Miley's words to Hilary? "Thank you for making it cool to be a good girl!"

WOULD YOU BE AN F.O.M.?
(FRIEND OF MILEY)

I already know you're Miley-minded, but see which F.O.M. most closely mirrors you!

1. When I think about the friends who mean the most to me, the ones with whom I share the best memories, I realize I'm more likely to have friends who are . . .

A. similar to me!

B. like big sisters!

C. more adventurous!

2. Shopping is a way of life for some people. I'd have to say my personal outlook on outlets is that they're . . .

A. fun to do in groups!

B. my life!

C. A-okay if they have the right stores!

3. If I hear an unbelievable rumor about someone my BFF and I both know, I'm most likely to share the news with her (and compare notes if we think it's true) by . . .

A. talking on the phone together!

B. getting together for lunch!

C. texting the shocking dish!

4. Friendship is what life is all about. Being "best friends" with someone is a bond that can last a lifetime. In general, I *need* to see my BFF . . .

A. every once in a while!

B. all the time!

C. whenever she's free!

5. When meeting new people and deciding if we click as friends, the most important deciding factor is if he or she has . . .

A. kindness!

B. wisdom!

C. loyalty!

6. When friends fight, it can be worse than when sworn enemies square off. If my BFF and I fight, I usually . . .

A. need her to say "sorry" first!

B. end up asking her to forgive me!

C. laugh about it with her later!

7. The most important "big picture" outlook I have that makes me the person I am is . . .

A. thinking about others!

B. staying true to myself!

C. making my mark in the world!

Mostly A's
SELENA GOMEZ

You're most like *Wizards of Waverly Place* star Selena Gomez! Selena, who worked with Miley on *Hannah Montana*, has a similarly tomboy-ish personality. She's known for always having her cell with her and describes herself as being thoughtful in regard to other people. You and she would make a perfect pair of pals.

Mostly B's
ASHLEY TISDALE

Your ideal lunch buddy would be "Sharpay" herself, Ashley Tisdale! Ashley is a big-sister figure to Miley, doling out wisdom about boys, shopping, and fashion. Ashley's a positive person, someone who is impossible to stay mad at and a girl who tells it like it is. You'd be peas in a pod.

Mostly C's
VANESSA HUDGENS

You'd have the most fun with dazzling *High School Musical* star Vanessa Hudgens! Vanessa is the kind of friend who's always fun to be with, but who isn't around 24/7—and that's exactly what you're looking for. You'd hit it off with her, you'd have fun hitting up only the trendiest stores, and your texting would soon become so familiar it would look like a new language.

i can't wait to see you again:
dating and boys!

"I've got high standards when it comes to boys. As my dad says, all girls should!"
—Miley, M

Something all her fans know about Miley is that she's a big flirt! She used to send and receive "love notes" at age seven that she now stores in a special box her mom, Tish, got for her, and she's always been one to wear her heart on her sleeve, confessing in interviews to crushes on Nick Jonas (whom she may or may not have dated . . . more on him later!), Cody Linley, Ryan Cabrera, Orlando Bloom, Jude Law, and Chad Michael Murray.

She told *Girls' Life*, "I will forever like Ryan Cabrera, but my number one is Chad Michael Murray. He's the hottest!"

She's also quite fond of none other than Ashton Kutcher! "If I could just meet him, I don't care how. I would meet him wherever, whatever time of day—he can take my dad's place (on the show)! . . . If Ashton could be here every day, I would be so happy!"

Miley's very outgoing, and is more comfortable with guys than a lot of girls her age—she hangs out with them as friends, and that allows her to decide which she has crushes on.

"Most of my friends are all guys," she told *Popstar!*. "Now that I moved into a new neighborhood . . . one of my best friends lives like three houses down and Sierra lives like four houses down and then like this guy named Dylan across the street, he's one of our friends and he has all the hot friends so we're kind of hangin' out with him

like, 'Yeah, we should all go skateboarding with your friends!' . . .
I got on, like, a shuttle, and so I was riding on this little shuttle down
the little road . . . and they were skateboarding there so we went
and I was like, 'Yeah, hi, I'm Miley!' so we went and ate food with
them. So all day yesterday I got to hang out with all the guys and
have so much fun. So mostly, I'm just hanging out with all of them."

Miley tells stories like these mostly to let people know she prefers
not to date one-on-one, but instead to hang out with a group
of friends.

Part of the reason for this comes from Billy Ray and Tish. Miley's
protective mom told *Life Story*, "I would never let her go out on a
car date *ever*. To have a boy over to the house or them going to
the movies, I will let her do that. I would also let guys go to the set
when I was there."

Even costar Jason Earles gets in on the protective act. "Every
time we have guy guest stars, I eyeball them if they get too close to
her," he said at a Disney Channel press conference. Miley confirms
this, saying, "Yeah, he comes up and I'll be like, sitting here and I'll
be like flirtin' up a storm. And he'll walk up, 'So Miley, those nachos,
they're real good, huh?' He steps in the middle and is like, 'How you
doing, dude?' And I'm like, 'Yeah, Jason, you're real nice. We'll talk
later.' "

Miley tries to avoid crushing on people she works with—but
it can be hard! "It's kind of nerve-racking because you're kind
of nervous," she told *M* recently. "You think, 'What if he says "No"
straight to my face?' And then you have to see him every day."

She did have a crush on Jesse McCartney when she asked that
he be a guest star on *Hannah Montana*. She told *Life Story*, "I wrote
a song for Jesse (McCartney) on my album. It's called 'He Needs
Me,' because I had a serious crush on him before I met him. I told
my mom and she said, 'Sorry, he has a girlfriend.' So I wrote a song

> **"I would never let her go out on a car
> date ever. To have a boy over to the
> house or them going to the movies, I
> will let her do that. I would also let
> guys go to the set when I was there."**
> **—Tish, Life Story**

about him!" The song's title was later changed to "As I Am," and is one of her most beautiful slow songs.

When Miley does have her heart set on one boy, she often turns to friends and family for their advice. Older brother Trace is a reliable source of wisdom.

"No boy is ever good enough for me! Trace will be like, 'He's a really nice guy, I like him, but not for you!'" she told *Bop*.

Miley told *Life Story* that her first kiss was in kindergarten. "His name was Austin. He gave me a necklace, and I dropped it in the toilet! I didn't mean to. It was really nice. It had really pretty crystals and a big heart." What kinds of boys win her affections? Vanity will get them nowhere with Miley!

"You should see these guys at my school who carry around a mirror," she complained to *Bop*. "It's like, 'Dude, *I* don't even carry a mirror. Seriously!' I'm not *that* girly and I'm an extremely girly girl!"

She's also against cocky boys, as she told *Popstar!*.

"Cockiness—when they think they're the man. I'm like, 'Oh, please! You're such a nerd. You're still sitting by the phone waiting for me to call so stop acting like you're this (player)!' Actually, my guitar player yesterday, I was like, 'It's so unfair. Guys don't even care!' He was like, 'No way, we just act like that. We sit by the phone and we're like, "Is she going to call?"' So I believe that—I think guys aren't really that cocky, but I hate when they put on that act."

Even though Miley hates being asked for boy advice ("I'm probably not the best person to ask about guys. I'm very slow in that department!" she confessed to *M*), she's full of experiences that range from helpful to hilarious.

She told *Tiger Beat*, "I made the mistake of falling for this guy on the first day (of school). And he turned out to be a jerk! Everyone was like, 'You like him! You like him!' Don't tell anyone until you're really sure that you like him and you talk to him. Be casual and cool, and see if he looks at you—if there's chemistry between you. If it's there, it's there. You can't just make it."

More good advice came from her interview with *J-14* magazine, in which she cautioned her fans never to try to force a guy to like you. If it's not working, it's not working.

So what kinds of boys does Miley like? "In general, I like guys who are musicians or into music like I am. I need a guy who's calmer than I am because I'm hyper, and my mom tells me I need one who has a T-Mobile cell plan, like mine, so my phone bill won't be outrageous! Looks are a bonus, but it's not all about that. A boy has

to be able to make me laugh, because I love to joke around. I think he needs to be able to tell me to bring it down, but at the same time to have fun!" she told *Life Story*.

She also expects guys to be gentlemen.

"He'd better turn on that charm," she told *PBS Kids*. "I'm from the South and I'm all about Southern hospitality. Our family is so funny because we're really set in our old traditions from Tennessee. Like when we walk in the house—shoes off! I'll be like, 'Mom, nobody does that,' and she'll say, 'That's the way they do it back home and we're not changing for anybody!' We're all about fun most of the time, but we're also about respect, with, 'Yes, sir,' and that kind of thing. Common courtesy is important to us. I think a guy should be able to turn on the charm and not be fake about it!"

"I'm from the South and I'm all about Southern hospitality."

Stories vary about the craziest thing Miley's done to get a boy's attention, but one story she shared with *Twist* seems to be about as daring as it gets!

"I was at summer church camp. When I got there, I saw this guy, and I was like, 'Oh, my gosh, he's so cute!' He was doing backflips off the diving board, and he said to me, 'Oh, you should try it.' Oh, my gosh, I was so nervous! But I kept telling myself, 'Just go, just go,' so I did. I did a double backflip!"

Miley's best advice for dating is—like most of her beliefs—rooted in the desire to express herself and never to sell herself short.

Otherwise, she warns, if you're not being yourself and "you start dating for a long time, then you have to put on that act every day. That's so lame! I did that with one guy I was kind of 'talking' to. I started changing and acting all nervous, shy, and quiet. I am not nervous, shy, or quiet. . . . I think a guy should like me for being loud, crazy, and not really girly . . . I am totally tomboy."

As Miley says, in matters of crushing, always be yourself, and no matter what happens, you'll always know it was meant to be!

When it comes to boys, one central to Miley's life is the irresistible Nick Jonas!

But were they always "Just Friends" (as the Jonas Brothers song goes), or did they date? Let's figure this out together.

One thing we know about Miley and Nick is exactly when they first met, face-to-face.

"I met her June 11, 2006," Nick said to *Twist*. "We were at a pediatric AIDS event." That would be the A Time for Heroes event held annually by the Elizabeth Glaser Pediatric AIDS Foundation. In 2006, Miley and the Jonas Brothers were among dozens of A-list teen stars who came out for this worthy cause, including Kristin Cavallari, Devon Werkheiser, and Vanessa Hudgens (whose secret boyfriend Zac Efron sneaked in without doing any press).

By all accounts, Nick and Miley struck up a special friendship. They got *so* tight *so* fast that Miley brought Nick along with her to a June 20, 2006, appearance on MTV's *TRL* . . . which first caused Jonas fans' love radar to ping!

Some fans of both wondered how they'd work out as a couple, considering their personalities are so different—Miley's outgoing, and Nick's more reserved. Nick himself added fuel to the fire with descriptions of the kind of girl he goes for.

Speaking with *Life Story*, Nick said, "I like all types of girls, and it's sometimes hard to know which girl I'll notice. . . . I think the first thing I'll notice is a girl's smile, if she looks like a happy person, because a beautiful smile can really tell you a lot about what's inside a person's heart." This certainly applies to Miley—who was *named* for her big smile!

"If I feel relaxed around her, I know she's the right one. We're always running around, always moving and traveling. A girl would have to be able to understand that and support me, and that's not an easy thing." Well, Miley would certainly have firsthand knowledge of how hard it is to tour and work and maintain friendships.

more →

"I think the first thing I'll notice is a girl's smile, if she looks like a happy person, because a beautiful smile can really tell you a lot about what's inside a person's heart."

Miley and Nick played it cool, avoiding too much talk about their budding friendship. Miley threw cold water on rumors by saying it was just that—a friendship. "We're best friends. I got him a polo that says 'Best Friends Forever,' " she told *Bop*.

But they spoke of each other in ways that led fans to believe they might be secretly dating. For example, Miley told *Twist*, "I like to do cute things. I went to Nick's house as a surprise once and I left a card on his door that said, 'Take two steps forward. Take two steps to the side. Turn around ten times.' And when he turned around, I was there!"

With both of them being so secretive, fans went nuts guessing if they were or were not a couple, finally giving them the combined name "Niley."

Finally, both of them hinted that their relationship was, at best, off and on. Nick—who rarely spills the beans about his private life—told *Twist*, "I had a big, total crush on her. We talked for a while and it was cool . . . it was a summer thing. We're just friends now and it's all good!"

Backing this up, when speaking of breakups, Miley mentioned to *Life Story*, "Nick and I are still best friends and I think it is really cool. Just be cool with each other!"

But things seemed to heat back up when the Jonas Brothers officially relocated to Los Angeles to continue their recording and acting careers under the Disney brand.

"We're really good friends—he's actually my neighbor and so we're just really close!" Miley beamed to *Popstar!*, but Nick told *Twist*, "We have one of those things where it's always just kind of there."

Every time Miley was around the Jonas Brothers in public—such as the time when she made a surprise appearance to introduce them at their Six Flags concert in Valencia, California, in June 2007—she was next to Nick or even hugging him. This closeness fanned the flames of rumors, as did Nick telling *M*, "Yeah, she's awesome. Miley's just a really cool girl. She's down to earth, and she's really important to me."

When Miley added the Jonas Brothers as an opening act on her massive tour, it was understood that this was when Niley were at their strongest. They spent countless hours together on the road, and those hours definitely—trust me!—led to formal dates.

"I'm really excited to be on tour with Nick. He's like my best friend," Miley mooned to *Twist*. "Yesterday, I got up and went to see him at seven-thirty in the morning just because I really wanted to see him! Whether we're together or

not, no matter what, we're really close friends and that's what I love."

Urged by handlers not to go public (girl-friends are bad business for teen heartthrobs such as Nick, whose fans sometimes resent them), Miley told *M,* "I am *not* going out with Nick. I love him to death and of course he's so hot! But we are too close of friends for anything to happen. One thing's for sure—any girl who does end up with him is really lucky. He's adorable and sweet—just a really great guy."

But by this time, Billy Ray Cyrus had inadvertently exposed their dating in a *People* interview, and hosts Ellen DeGeneres, Ryan Seacrest, and Oprah Winfrey all ambushed the duo with questions about their romance. It was officially the worst-kept secret in entertainment!

Sadly, Niley broke up around New Year's Eve 2007. Costar Mitchel Musso confirmed the split in *Popstar!*'s April 2008 issue, saying, "From what she said, it was just kind of maybe a tim-ing thing, you know? They have all this time that they're not together. The boys are gonna go on their own tour, and they never get to see each other. I don't think that there were any problems, 'cause they're both really cool people. I never got from her, like, that there was something wrong."

Another reason for the end of Niley might have been Nick's reluctance to treat his relationship with Miley as just a fun dating situation. For him, when he crushes, he crushes hard!

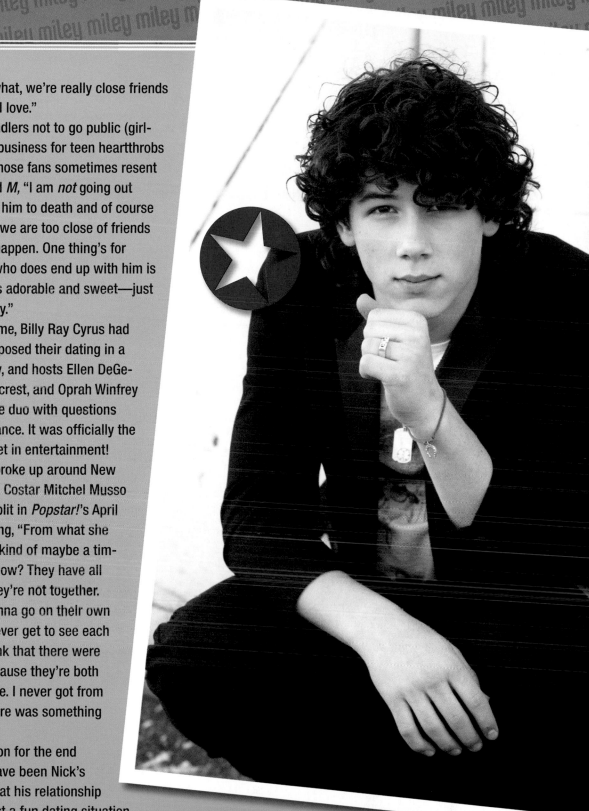

"I know I've been in love," he told *J-14* (maybe about Miley?), "but I waited a long time before I used the word 'love' to a girl other than my mom. Love to me is more than just a word."

Sadly, "Niley" is just a word now, no longer a teen power couple. But the good news is that they remain great friends. They appeared on *Dick Clark's New Year's Rockin' Eve* together, letting fans know that while their dating may be off—their friendship is still on!

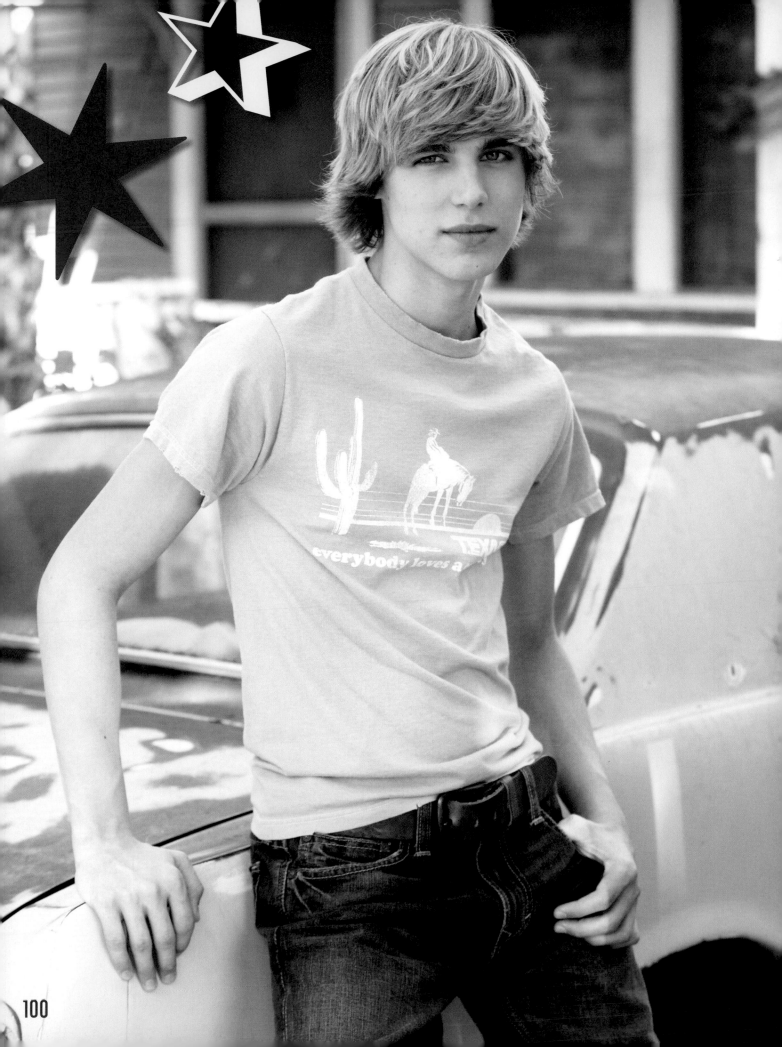

PUMPIN' UP THE PARTY WITH CODY LINLEY!

What does Miley think about her *Hannah Montana* costar Cody Linley? "That's my favorite subject!" she gushed to MediaVillage.com in 2007. "Do you think he's cute? . . . I have a total crush on him but he doesn't like me, but I don't really care because he's so fun to look at. I love being on set with him. He's really a cool guy. He's really fun and down to earth and he's hot. [The kissing scene] was my favorite!" She went on to confirm he was a good kisser. Great kisser? "Yes, it was perfect. His lips are like velvet. He's so totally cute!"

This crush started when Cody Linley—born in Texas on November 20, 1989—was cast as Jake Ryan on *Hannah Montana*. His role calls for him to be a showoffy pop star who wins Miley Stewart's heart . . . but the real-life Cody won Miley Cyrus's!

"He's so perfect! Too bad he doesn't like me. I wish he did," she lamented to *M*. "I did get to kiss him for the show, though. Best kisser in the entire world!"

But not many fans know that Cody came to Miley recommended by Mitchel Musso! Yep, Cody and Mitchel were already friends, so Mitchel was able to vouch for him to Miley, to let her know he is a good guy.

"Cody's so cool!" Mitchel told *Popstar!*. "I've known him for like four years or something. I've known him from Texas, like I knew him just from seeing him—we never hung out. And then when I saw him out in L.A. we started hanging out."

The teen press, unaware that Nick Jonas was Miley's secret boyfriend, tried to encourage Miley and Cody to be more than friends. At the Disney

> ## "At one point they weren't filming anymore, but I made Cody think they were so I could kiss him one more time!"

Channel Games in 2007, they asked Miley about Cody because he'd just admitted to breaking up with a longtime girlfriend!

"Yeah, he is [single now]. What a coinkydink. So am I," Miley said playfully. "He just so happens to be on set all the time. I've been trying to look extra-pretty every day and I don't think it's working for me. I'm like, 'Come on, Cody, come on.' Boys don't get what it looks like when girls take time. I'm like, 'I curled my hair today, isn't it pretty?' And he's like, 'You did?' And I'm like, 'You freak, I usually have like rings, now I have twirls. It's totally different!' "

You'd think Miley being so up front about her crush would make things a little awkward on the set, but Miley told *Teen* magazine that the opposite was true!

"Was it awkward kissing Cody Linley [on *Hannah Montana*]? No! It was like the best ten seconds of my life. I was like, 'Oh, my gosh, he's like an angel!' At one point they weren't filming anymore, but I made Cody think they were so I could kiss him one more time!"

A typical day on set with Cody and Miley was anything but awkward—it was fun and relaxed. For all her crushing, Miley seemed to keep things pretty professional and friendly.

"When I was on the set of *Hannah Montana*, Miley Cyrus, Emily, Mitchel Musso, and i would have lunch in Miley's dressing room (Miley's was the

fun fact!

Did you know that "Jake Ryan" was also the name of the heartthrob Molly Ringwald pines for in the classic '80s teen movie *Sixteen Candles*? Ask your mom—I bet *she* remembers!

more ⟶

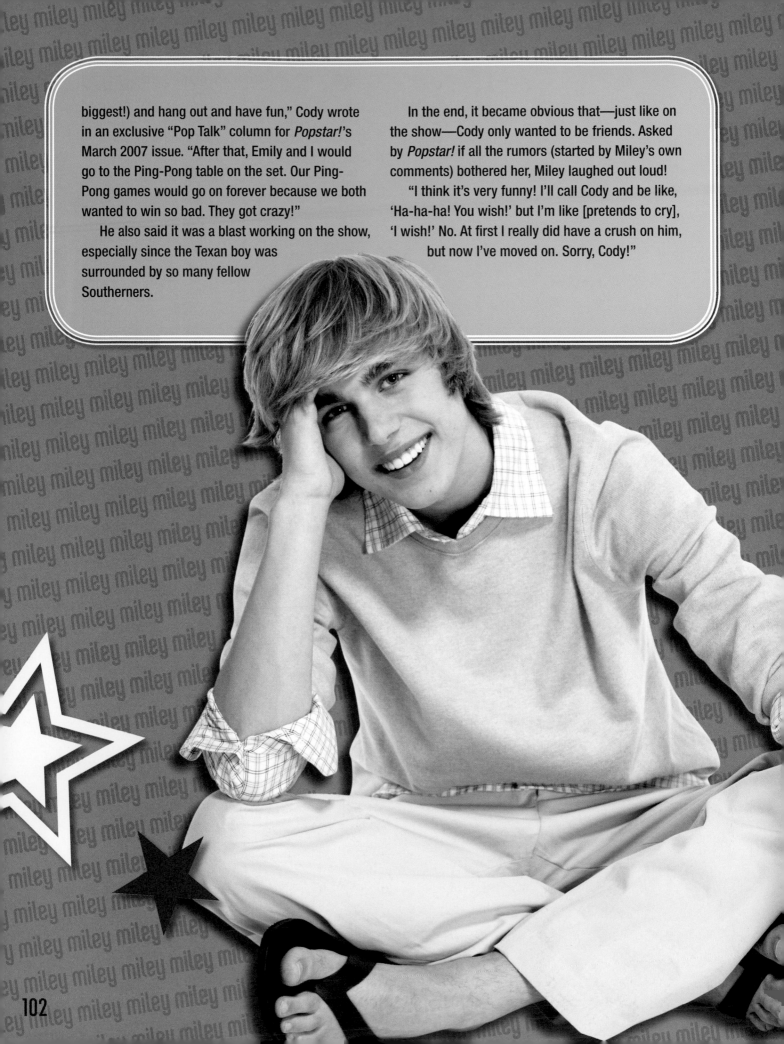

biggest!) and hang out and have fun," Cody wrote in an exclusive "Pop Talk" column for *Popstar!*'s March 2007 issue. "After that, Emily and I would go to the Ping-Pong table on the set. Our Ping-Pong games would go on forever because we both wanted to win so bad. They got crazy!"

He also said it was a blast working on the show, especially since the Texan boy was surrounded by so many fellow Southerners.

In the end, it became obvious that—just like on the show—Cody only wanted to be friends. Asked by *Popstar!* if all the rumors (started by Miley's own comments) bothered her, Miley laughed out loud!

"I think it's very funny! I'll call Cody and be like, 'Ha-ha-ha! You wish!' but I'm like [pretends to cry], 'I wish!' No. At first I really did have a crush on him, but now I've moved on. Sorry, Cody!"

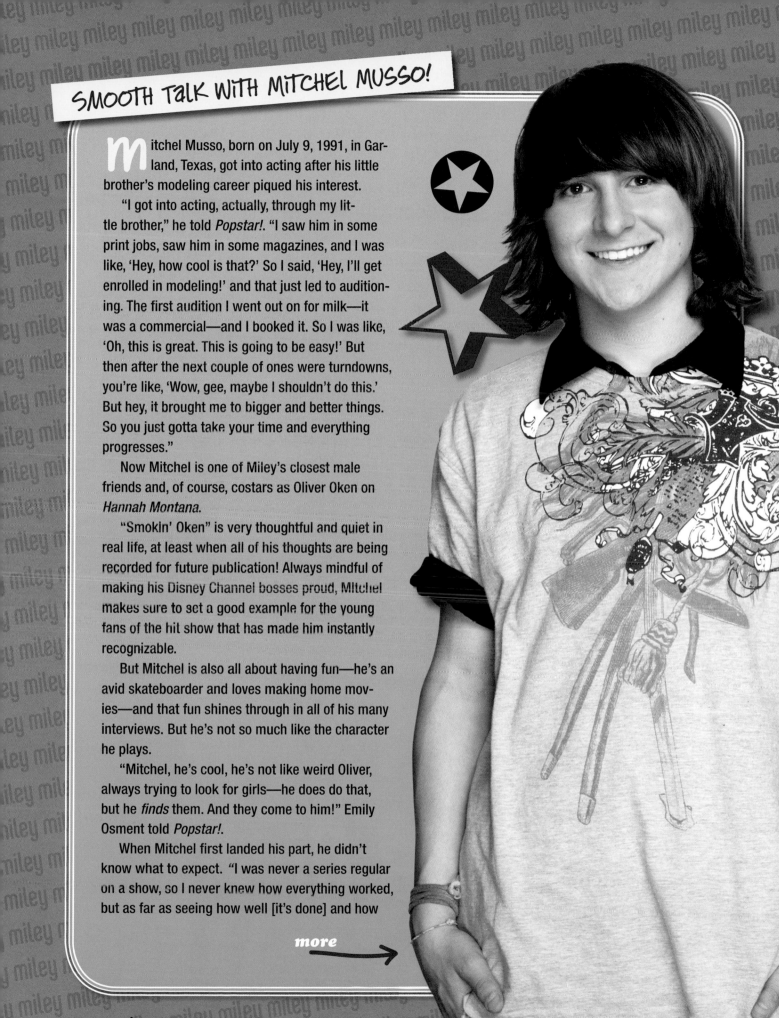

SMOOTH TALK WITH MITCHEL MUSSO!

Mitchel Musso, born on July 9, 1991, in Garland, Texas, got into acting after his little brother's modeling career piqued his interest.

"I got into acting, actually, through my little brother," he told *Popstar!*. "I saw him in some print jobs, saw him in some magazines, and I was like, 'Hey, how cool is that?' So I said, 'Hey, I'll get enrolled in modeling!' and that just led to auditioning. The first audition I went out on for milk—it was a commercial—and I booked it. So I was like, 'Oh, this is great. This is going to be easy!' But then after the next couple of ones were turndowns, you're like, 'Wow, gee, maybe I shouldn't do this.' But hey, it brought me to bigger and better things. So you just gotta take your time and everything progresses."

Now Mitchel is one of Miley's closest male friends and, of course, costars as Oliver Oken on *Hannah Montana*.

"Smokin' Oken" is very thoughtful and quiet in real life, at least when all of his thoughts are being recorded for future publication! Always mindful of making his Disney Channel bosses proud, Mitchel makes sure to set a good example for the young fans of the hit show that has made him instantly recognizable.

But Mitchel is also all about having fun—he's an avid skateboarder and loves making home movies—and that fun shines through in all of his many interviews. But he's not so much like the character he plays.

"Mitchel, he's cool, he's not like weird Oliver, always trying to look for girls—he does do that, but he *finds* them. And they come to him!" Emily Osment told *Popstar!*.

When Mitchel first landed his part, he didn't know what to expect. "I was never a series regular on a show, so I never knew how everything worked, but as far as seeing how well [it's done] and how

more →

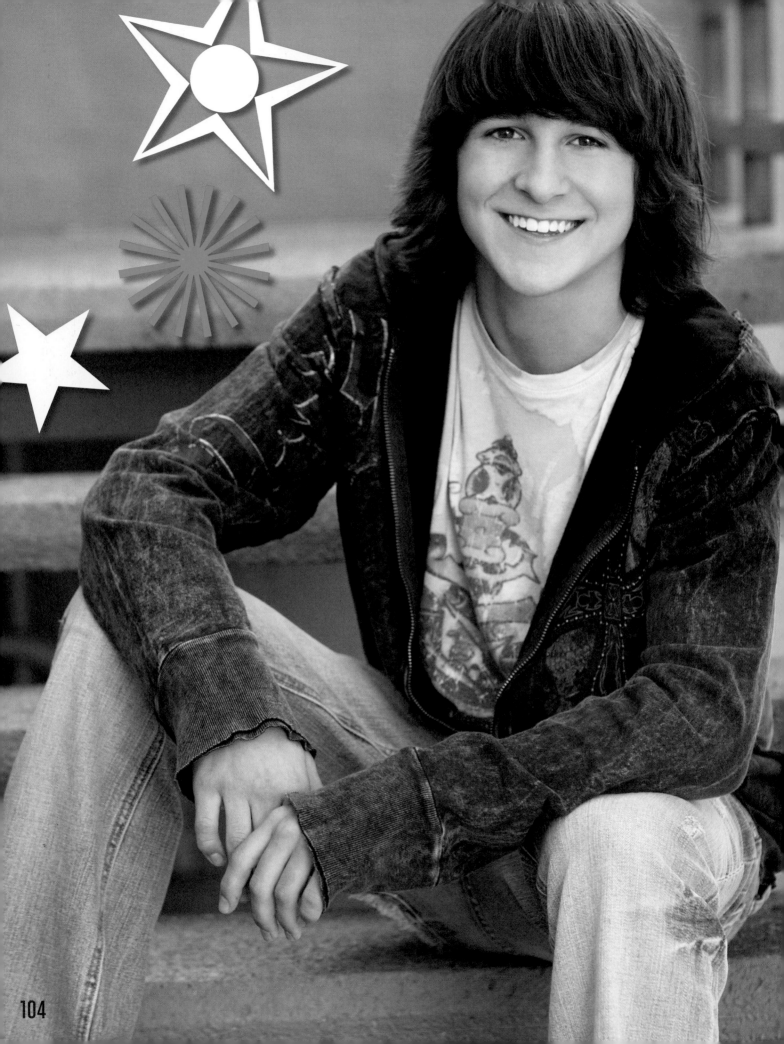

everybody's just loved the show, it's blown me away. Never, never . . . sure, everybody was amazing on the show and it was like, 'Oh, this show's *great*—of *course* it's gonna get picked up!' but it's done wonders for everybody."

Mitchel got used to his newfound fame before anyone else on the show.

"The first time I got recognized for being on the show, I was at Valencia Mall—it's always a mall! It's always a mall!—it was like four or five girls. They walked past me. This was after like four episodes had shown—just *four*—they walked past, took a glimpse at me, looked back, turned, they talked, then they walked right over, *inches* from me, screamed, and ran away. Seriously, *nobody* approaches me. I just walk around and get these stares like [gasps] and "click!" their picture phones, they'll click their cameras. They know who it is, but they're scared of me! They won't walk up to me. They're afraid to ask me who I am."

Mitchel's much more humble than Smokin' Oken. His favorite part of the show has been his fans. "I *love* having fans. That's my *favorite* thing for people to come up and say, 'Hey, can I get an autograph?' On Fridays [live taping days], when everybody's screaming and hollering to meet you—they're so supportive. It just pumps everything up and takes off my career because of all these fans. You can't do it without these fans, and that's what I've figured out. It's all about them and how supportive and how they're *there* for *you*!"

When it comes to girls, Mitchel loves a girl with a great laugh and thinks of bowling as an ideal first date. He's the first to admit he's *close* to girl-crazy, and he loves a girl with a great laugh. Quizzed by *Popstar!* about what kinds of girls he's all about, Mitchel's answer was typically sweet and funny. "Any girls that are about *me*! It's kinda hard to like a girl that doesn't like you back—it's a tad bit difficult, isn't it? If a girl likes me, I like her. It's easier that way—I promise—than *trying* and *trying* and *trying*."

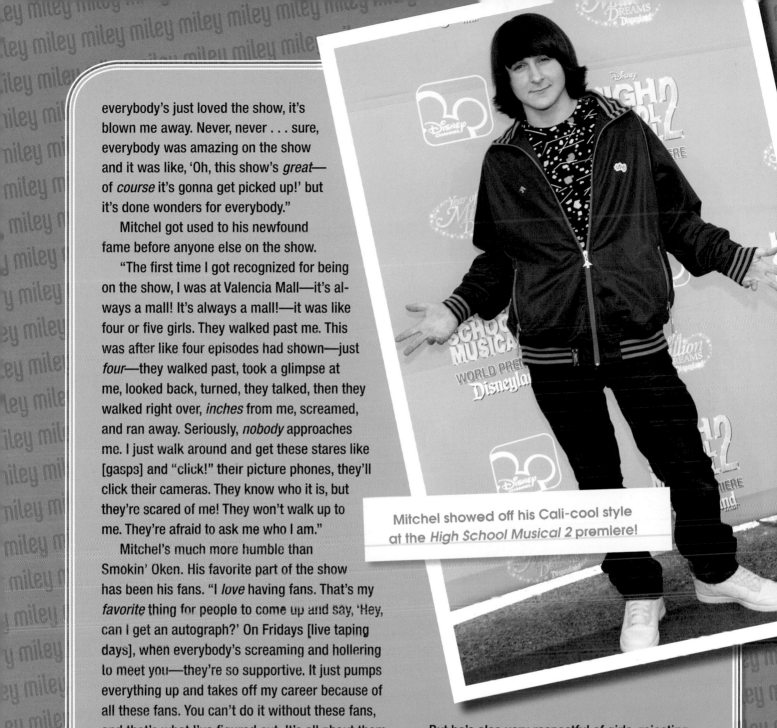

Mitchel showed off his Cali-cool style at the *High School Musical 2* premiere!

But he's also very respectful of girls, rejecting the idea of an ideal "line" to use to make a girl fall for him. "I don't know if there *are* any 'surefire' pickup lines! I don't think there are. Girls are just out there. They're in their own world! . . . You can't just get a girl with one pickup line. You've got to show them who you are, and show her that she's going to be able to like you!"

Also, he has given his female friends lots of good advice! When one friend told him a boy had

more →

"A guy doesn't mean anything he says . . . EVER! At this age, just remember, keep in mind, if people break up with you, there's always bigger and better things!"

sent her flowers, making her think he regretted breaking up with her, Mitchel said, "A guy doesn't *mean* anything he says . . . EVER! At this age, just remember, keep in mind, if people break up with you, there's always bigger and better things!"

How did Mitchel become such a love guru? Well, he's been dating since the first grade, to hear him tell it! "I would have to say my first date was at school. It was kind of like lunch together. I'd have to say that was in, like, the first grade. I had my first kiss in first grade. It was a kiss on the cheek. And it was under a coloring table. I didn't know what was going on, though. I was like, 'Well, well! What do I do now?' That was my first date. We went to eat in the lunchroom and we had our date there and we ate PB and J or something like chicken fingers."

But Mitchel isn't all that secure around girls, at least not compared to Smokin' Oken. "To tell you the truth, Oliver is a little more cool with girls than I am! I mean, I'm not like, 'Oh, a girl!'—I'm not nervous, but Oliver's just straight up! [He] walks up like, 'Hey, I'm Smokin' Oken'!' . . . He'll walk up to any girl—he doesn't care!—and me, I mean, I'll get a little nervous. Any guy would with a girl that he really likes!"

Ultimately, any girl trying to win Mitchel's heart would be competing for it with "the love of my life—my dog, which is a yellow Lab and his name is Stitch, like Lilo and Stitch, and he's huge . . . his birthday is, I think, July 24th, and mine is July 9th, so ours are both in the summer."

Disney Channel has been very good to Mitchel—he appeared in the Disney Channel original movies *Life Is Ruff* and *Hatching Pete*, and does the voice of Jeremy on *Phineas and Ferb* in addition to his dream job on *Hannah Montana*. "Disney is so

fun about everything, like, the producers that shoot the show and everybody just knows your character so well that it's easy coming in in the morning to work, and Disney does floats for all the kids during Christmas—they make everything so easy and fun!"

Disney also has given him solid relationships with his costars, especially with Miley. He's so close to Miley that many fans of the show wish they'd date in real life!

Miley described Mitchel's appeal to popstaronline.com by saying, "Me and Mitchel, he's the one to bring the *funny* into a bad situation. We'll be sitting here crying, like, 'I don't really know what to do right now!!!' and he'll be like, 'Well . . . I got a joke.' And we'll be like, 'Okay!' "

He also plays the spoiler at times, such as when he tells boys that Miley has a crush on them! "At a concert, I'll be like, 'OMG, that guy in the front row is so cute.' Mitchel will go up to him and be like, 'Will you back up a little so Miley can stop staring?' " Miley spilled to *Tiger Beat* .

Mitchel has said that he and Miley never talk about their jobs when they speak, instead concentrating on dating stories and how their lives are going. "When we talk, we talk for hours!" he's said. "We were on the phone for two to three hours, something like that. We never hang up. We just talk about random stuff. That just kind of shows she's like my best friend who's a girl. It's just Miley to me."

Interestingly, Mitchel wrote a song called "My Best Friend," in which he sings of a girl who's his friend . . . but who he wishes were more than just a friend! Could this be a secret message to Miley? Only time will tell!

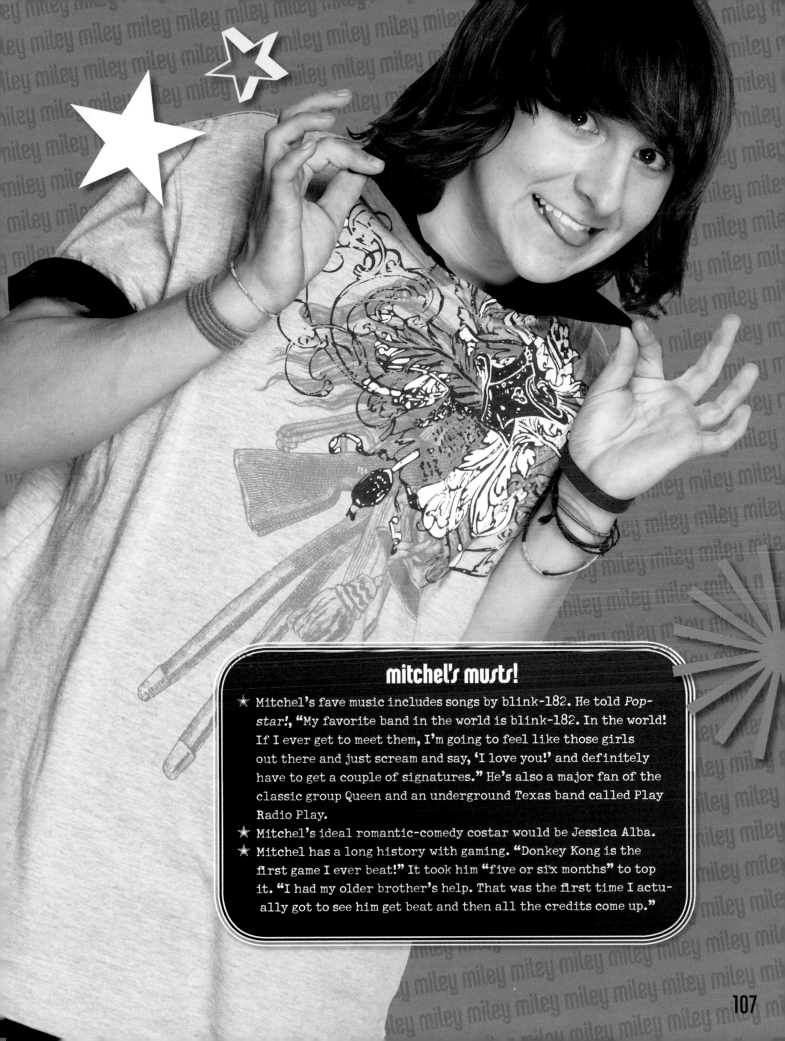

mitchel's musts!

★ Mitchel's fave music includes songs by blink-182. He told *Pop-star!*, "My favorite band in the world is blink-182. In the world! If I ever get to meet them, I'm going to feel like those girls out there and just scream and say, 'I love you!' and definitely have to get a couple of signatures." He's also a major fan of the classic group Queen and an underground Texas band called Play Radio Play.

★ Mitchel's ideal romantic-comedy costar would be Jessica Alba.

★ Mitchel has a long history with gaming. "Donkey Kong is the first game I ever beat!" It took him "five or six months" to top it. "I had my older brother's help. That was the first time I actually got to see him get beat and then all the credits come up."

WHICH *Miley Crush* WOULD BE *your match?*

1. The best way to describe my sense of humor is...
- **A.** Quirky!
- **B.** Outrageous!
- **C.** Dry!

2. A perfect dream date would be...
- **A.** Just hangin' out!
- **B.** Doing something new!
- **C.** A group date with friends!

3. Of all the hot guys in Hollywood, my idea of an all-around cutie (inside and out) is...
- **A.** Jason Dolley from *Minutemen*!
- **B.** Ryan Sheckler from *Life of Ryan*!
- **C.** Josh Hutcherson from *Firehouse Dog*!

4. If I like a boy, I...
- **A.** Am okay if people know!
- **B.** Tell everyone but him!
- **C.** Treat it like a big secret!

5. When it comes to gossip about stars or just about people I know...
- **A.** I do it sometimes!
- **B.** I love to do it!
- **C.** I'm not interested!

6. When it comes to meeting new people, I'm...
- **A.** Shy at first, then I get over it!
- **B.** Always outgoing!
- **C.** So nervous I clam up!

7. My friends would describe me as...
- **A.** Down-to-earth!
- **B.** Driven to succeed!
- **C.** In my own world!

8. My fave food is...
- **A.** Barbecue!
- **B.** French fries!
- **C.** Steak!

9. My ultimate dessert is...
- **A.** Brownies!
- **B.** Key lime pie!
- **C.** Milk shake!

10. One of the best movies ever is...
- **A.** *Catch Me If You Can*
- **B.** *Pirates of the Caribbean*
- **C.** *Finding Neverland*

11. If I had to choose one performing talent that I'm best at, it would be...
- **A.** Acting!
- **B.** Dancing!
- **C.** Singing!

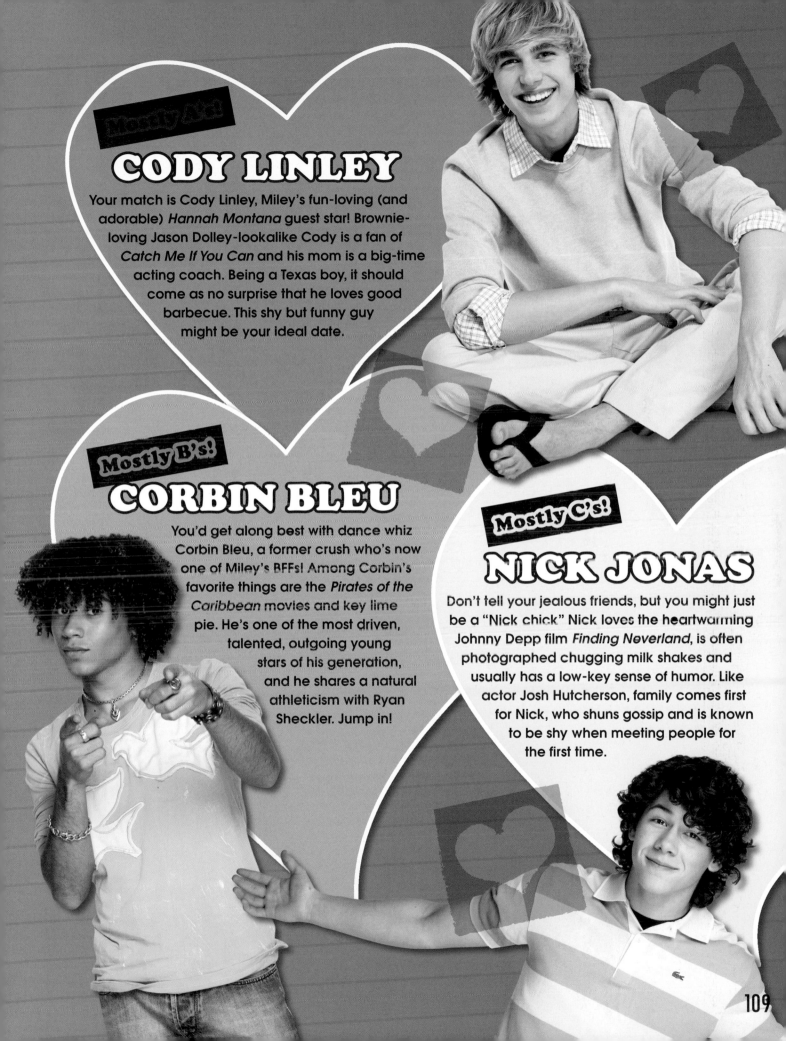

CODY LINLEY

Mostly A's!

Your match is Cody Linley, Miley's fun-loving (and adorable) *Hannah Montana* guest star! Brownie-loving Jason Dolley-lookalike Cody is a fan of *Catch Me If You Can* and his mom is a big-time acting coach. Being a Texas boy, it should come as no surprise that he loves good barbecue. This shy but funny guy might be your ideal date.

Mostly B's!

CORBIN BLEU

You'd get along best with dance whiz Corbin Bleu, a former crush who's now one of Miley's BFFs! Among Corbin's favorite things are the *Pirates of the Caribbean* movies and key lime pie. He's one of the most driven, talented, outgoing young stars of his generation, and he shares a natural athleticism with Ryan Sheckler. Jump in!

Mostly C's!

NICK JONAS

Don't tell your jealous friends, but you might just be a "Nick chick" Nick loves the heartwarming Johnny Depp film *Finding Neverland*, is often photographed chugging milk shakes and usually has a low-key sense of humor. Like actor Josh Hutcherson, family comes first for Nick, who shuns gossip and is known to be shy when meeting people for the first time.

old blue jeans: miley style-y!

"I like trying on all different types of clothes!" Miley told *Twist*, in what could be the understatement of all time! Like most teen girls, Miley loves clothes. She uses them to express who she is becoming as a young woman, to cheer herself and others up, and even as a reflection of her moods.

In this section, you'll get to check out some of her greatest looks along with getting some pointers to help you build similar looks. Don't ever be afraid to get creative with fashion. As Miley told *J-14*, "Sometimes I'll be punky, the next day I'll be preppy."

It's all about experimenting and finding what clothes make you feel best!

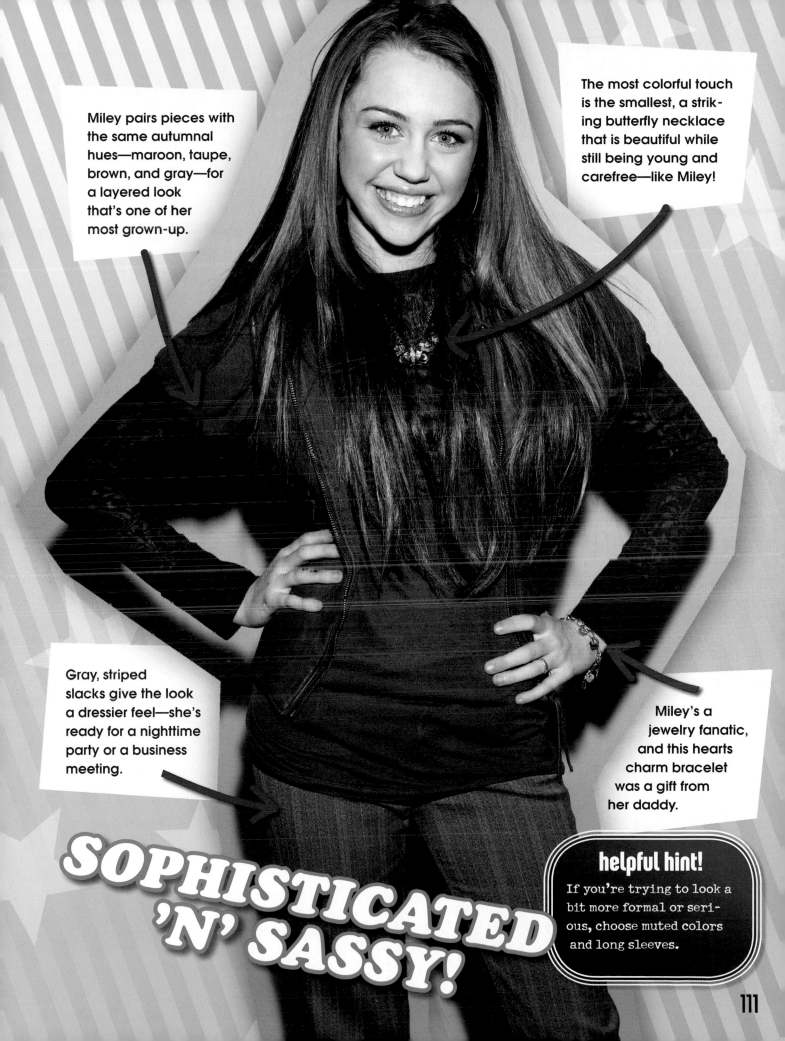

Miley pairs pieces with the same autumnal hues—maroon, taupe, brown, and gray—for a layered look that's one of her most grown-up.

The most colorful touch is the smallest, a striking butterfly necklace that is beautiful while still being young and carefree—like Miley!

Gray, striped slacks give the look a dressier feel—she's ready for a nighttime party or a business meeting.

Miley's a jewelry fanatic, and this hearts charm bracelet was a gift from her daddy.

SOPHISTICATED 'N' SASSY!

helpful hint!
If you're trying to look a bit more formal or serious, choose muted colors and long sleeves.

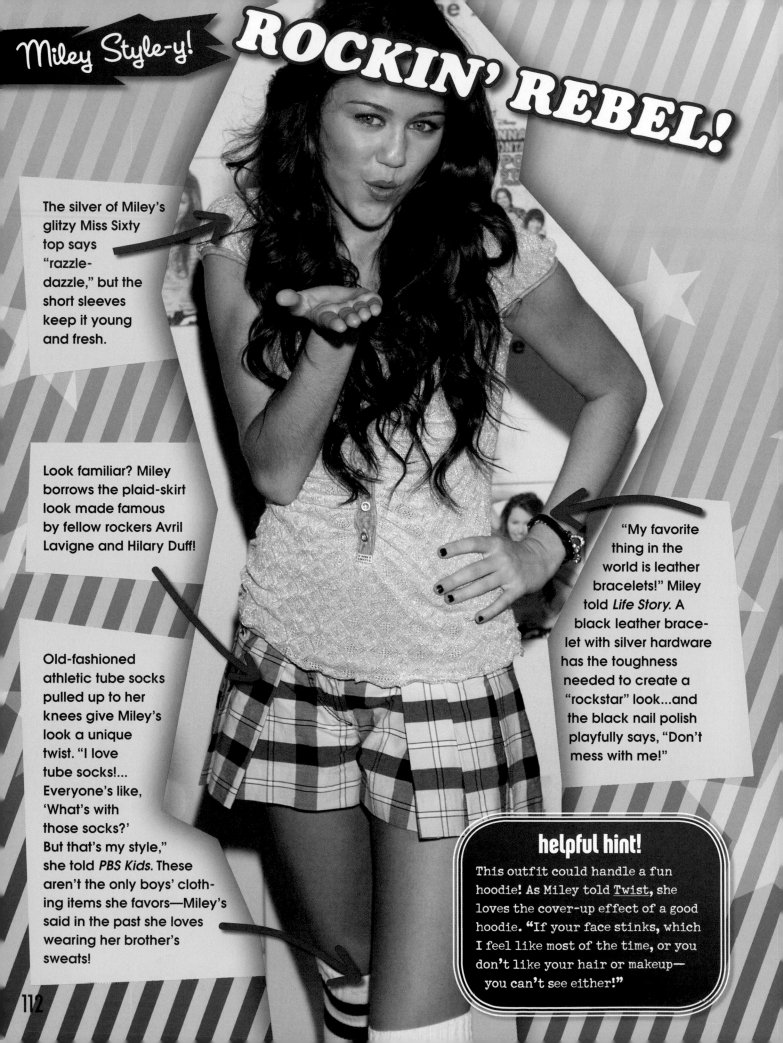

ROCKIN' REBEL!

The silver of Miley's glitzy Miss Sixty top says "razzle-dazzle," but the short sleeves keep it young and fresh.

Look familiar? Miley borrows the plaid-skirt look made famous by fellow rockers Avril Lavigne and Hilary Duff!

Old-fashioned athletic tube socks pulled up to her knees give Miley's look a unique twist. "I love tube socks!... Everyone's like, 'What's with those socks?' But that's my style," she told *PBS Kids*. These aren't the only boys' clothing items she favors—Miley's said in the past she loves wearing her brother's sweats!

"My favorite thing in the world is leather bracelets!" Miley told *Life Story*. A black leather bracelet with silver hardware has the toughness needed to create a "rockstar" look...and the black nail polish playfully says, "Don't mess with me!"

helpful hint!

This outfit could handle a fun hoodie! As Miley told Twist, she loves the cover-up effect of a good hoodie. "If your face stinks, which I feel like most of the time, or you don't like your hair or makeup— you can't see either!"

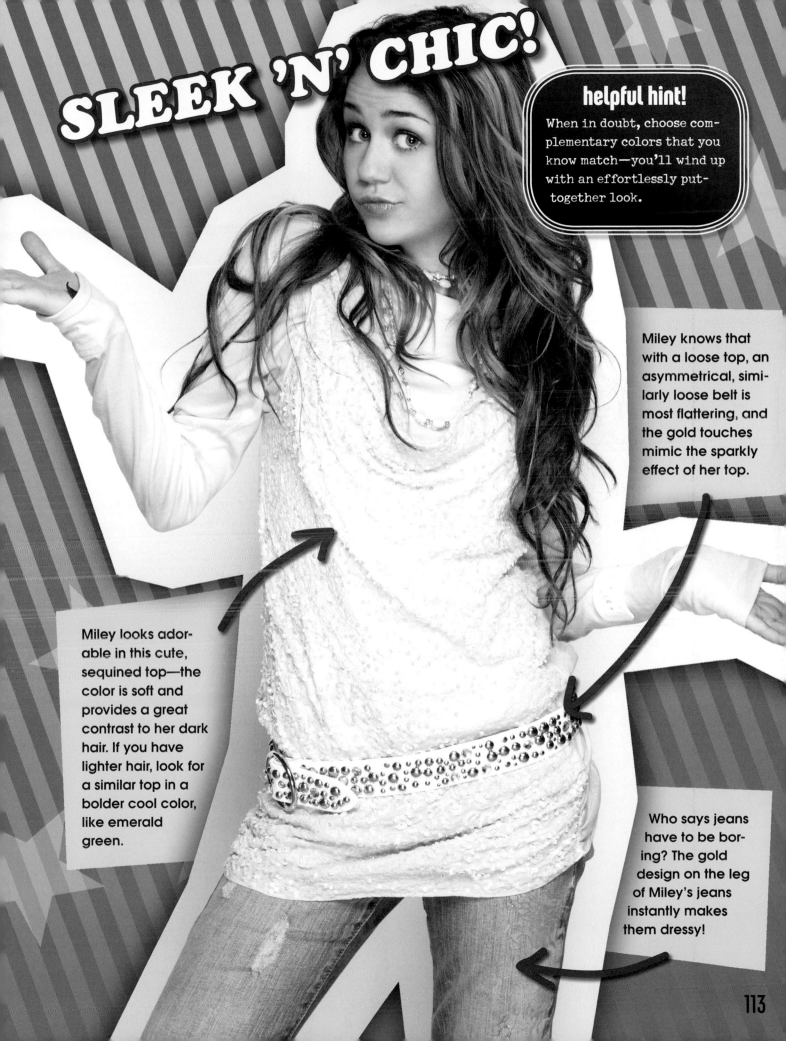

SLEEK 'N' CHIC!

helpful hint!
When in doubt, choose complementary colors that you know match—you'll wind up with an effortlessly put-together look.

Miley knows that with a loose top, an asymmetrical, similarly loose belt is most flattering, and the gold touches mimic the sparkly effect of her top.

Miley looks adorable in this cute, sequined top—the color is soft and provides a great contrast to her dark hair. If you have lighter hair, look for a similar top in a bolder cool color, like emerald green.

Who says jeans have to be boring? The gold design on the leg of Miley's jeans instantly makes them dressy!

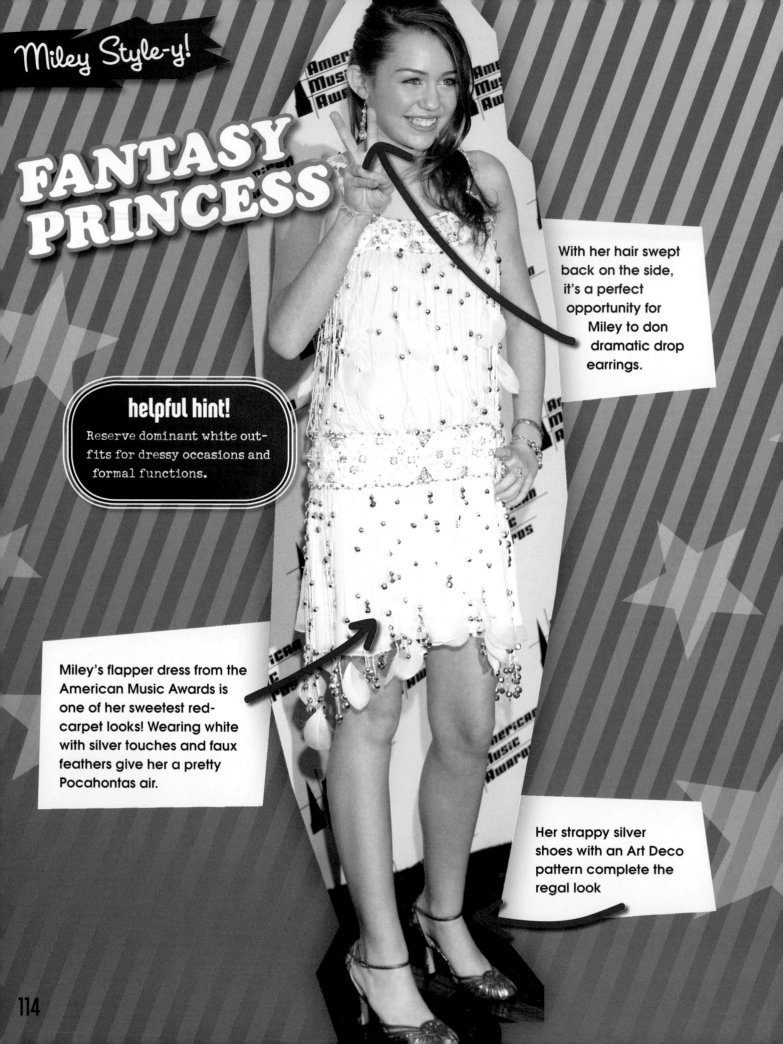

Miley Style-y!

FANTASY PRINCESS

With her hair swept back on the side, it's a perfect opportunity for Miley to don dramatic drop earrings.

helpful hint!
Reserve dominant white outfits for dressy occasions and formal functions.

Miley's flapper dress from the American Music Awards is one of her sweetest red-carpet looks! Wearing white with silver touches and faux feathers give her a pretty Pocahontas air.

Her strappy silver shoes with an Art Deco pattern complete the regal look

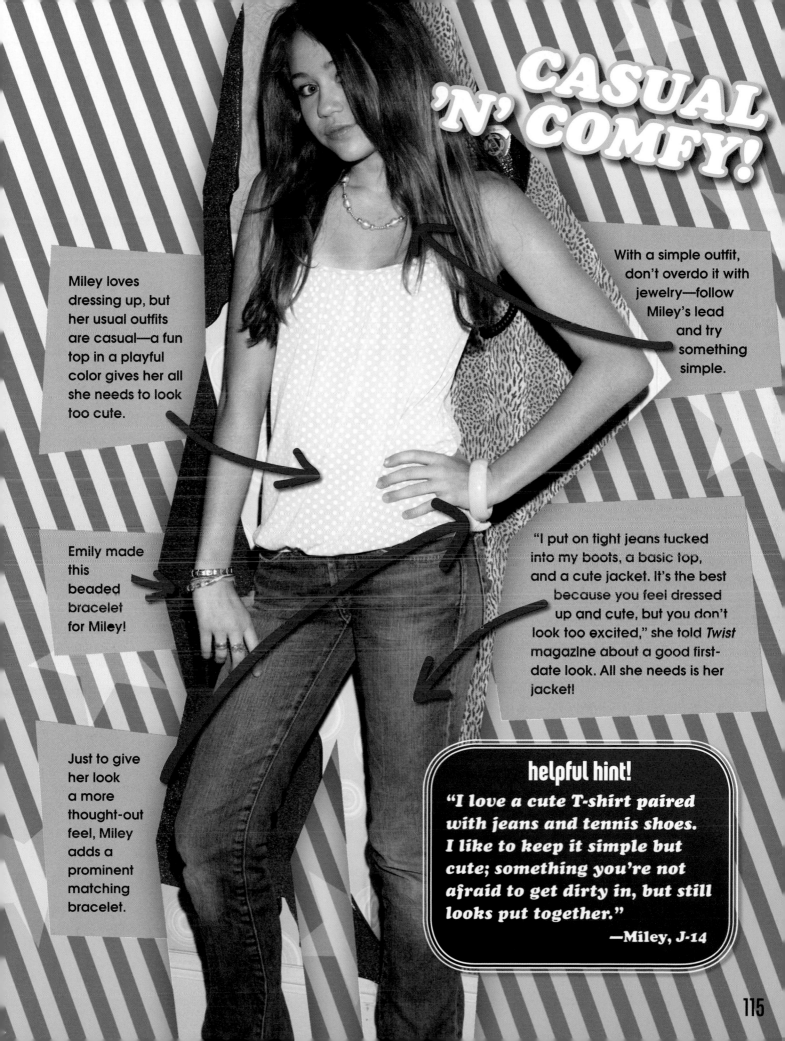

CASUAL 'N' COMFY!

Miley loves dressing up, but her usual outfits are casual—a fun top in a playful color gives her all she needs to look too cute.

With a simple outfit, don't overdo it with jewelry—follow Miley's lead and try something simple.

Emily made this beaded bracelet for Miley!

"I put on tight jeans tucked into my boots, a basic top, and a cute jacket. It's the best because you feel dressed up and cute, but you don't look too excited," she told *Twist* magazine about a good first-date look. All she needs is her jacket!

Just to give her look a more thought-out feel, Miley adds a prominent matching bracelet.

helpful hint!
"I love a cute T-shirt paired with jeans and tennis shoes. I like to keep it simple but cute; something you're not afraid to get dirty in, but still looks put together."

—Miley, J-14

One of Miley's most daring looks was from the *High School Musical* premiere—her red sequined top drew all eyes to her.

To balance out her flashy top, Miley goes with a short skirt in a more sedate tone.

The silver bracelet worn high on her arm accentuates the surprising simplicity of the look.

G-L-A-M-O-R-O-U-S 'N' GIRLY!

Those glittering silver shoes provide a perfect frame for the overall look that screams, "Hollywood!"

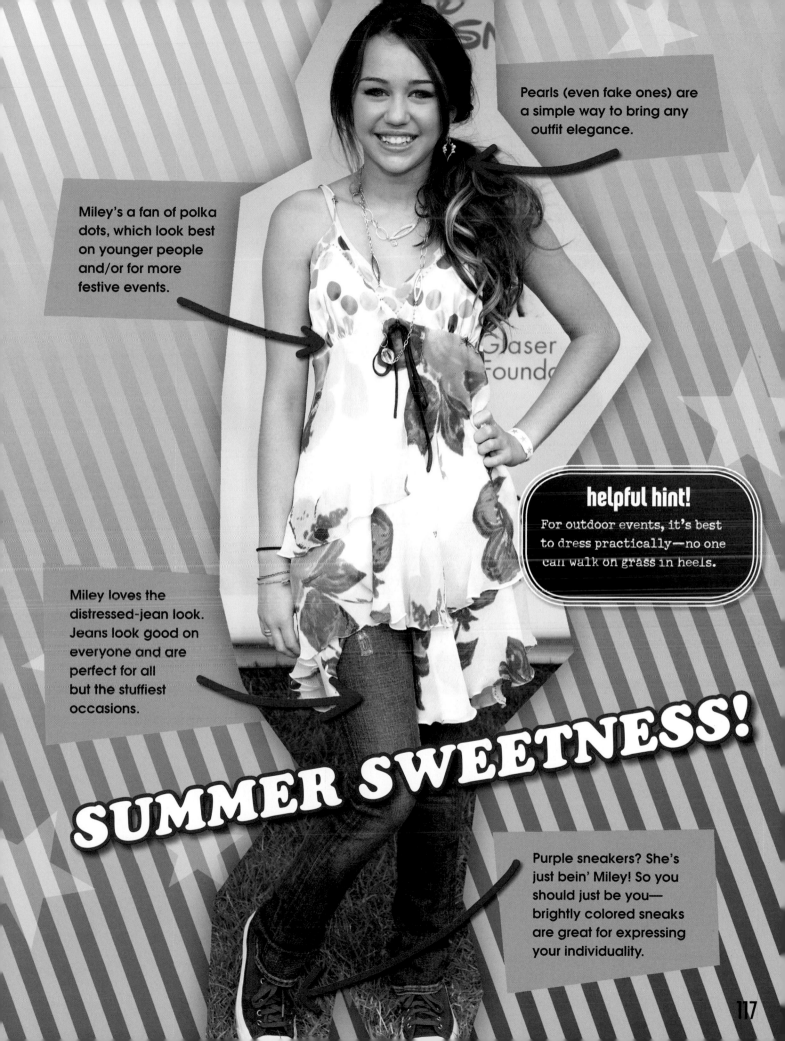

Pearls (even fake ones) are a simple way to bring any outfit elegance.

Miley's a fan of polka dots, which look best on younger people and/or for more festive events.

Miley loves the distressed-jean look. Jeans look good on everyone and are perfect for all but the stuffiest occasions.

helpful hint!

For outdoor events, it's best to dress practically—no one can walk on grass in heels.

SUMMER SWEETNESS!

Purple sneakers? She's just bein' Miley! So you should just be you— brightly colored sneaks are great for expressing your individuality.

WILD CHILD!

Nothing communicates edginess like a classic leather jacket—but Miley's, with its unique stitching, has a decidedly girly vibe.

For evening parties, you're safer with darker jeans—avoid trendy jeans that might have intentional rips.

helpful hint!

Research the theme of where you're going and dress with that in mind. At Aly and AJ's birthday bash, where the girls were escorted in on motorcycles, Miley was the only star who looked in tune with the theme!

For this nighttime party, Miley goes with black—but the design on her shirt, complete with a bejeweled guitar, definitely rocks!

One of Miley's fave colors is hot pink, and since anything goes with black, she made sure to work that color in with her cool shoes!

Miley, like all of us, questions her appearance all the time—it's only natural to be a little self-conscious, even if you're the world's biggest superstar.

"I feel like I stare in the mirror four hundred hours a day. Believe me, I freak out. I will be [looking] in the mirror saying, 'I hate my hair, I hate my nose, I hate my teeth,' " she told *Tiger Beat* magazine. Obviously she needs to get herself a better mirror, don't you agree?

Here are some helpful hints to keep in mind when copying Miley's look!

MAKEUP!

Miley is mainly known for her fresh-face approach to beauty. In fact, she told *Life Story* that her mom, Tish, encourages her to use "Dove only! Just the good old white bar!" She was not even allowed to wear mascara or eyeliner until she was old enough to wear it tastefully. "I wasn't allowed to wear makeup until the sixth grade! Finally I said, 'Mom, I really want to wear some!' And I was really clumping it on," she told *Bop*.

Avoiding the urge to overdo it is important to Miley. "I always like to wear makeup that's as natural as can be," she told *J-14*. "It's too over-the-top when you start caking makeup on. Don't do it!"

Miley uses mainly natural colors, but never leaves home without lip gloss!

She always has lip gloss with her, she told *Popstar!*. "It's the best because on set you're talking all the time. . . . I get out my little lip gloss and it's not that bad!"

more

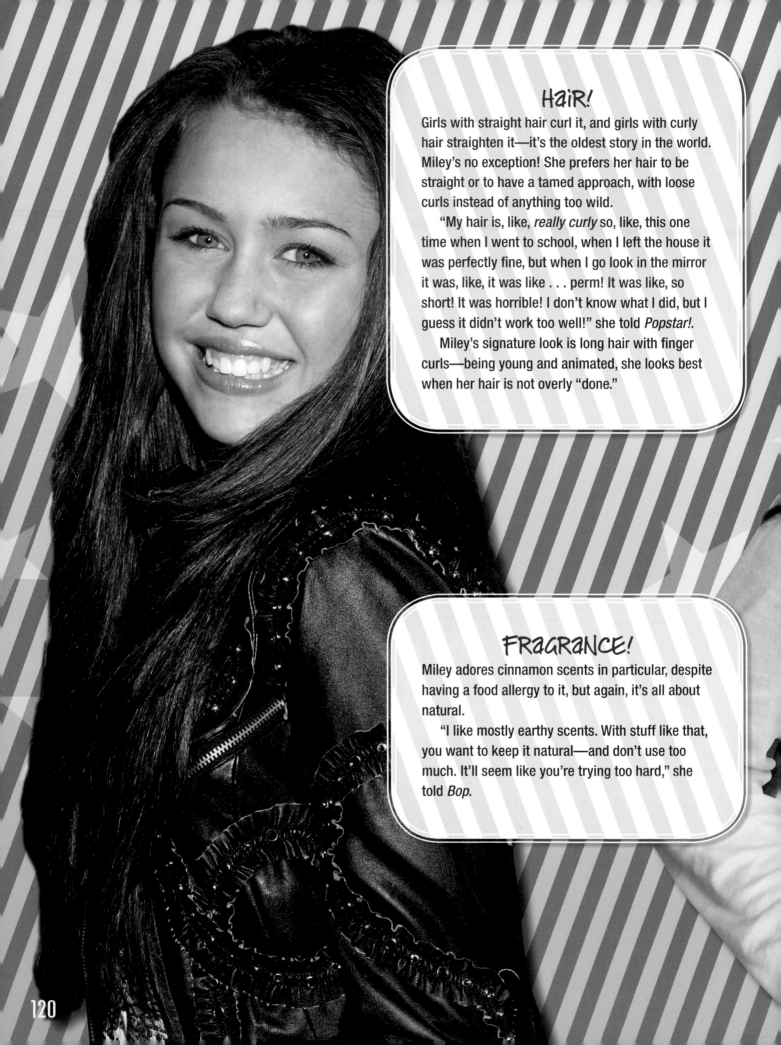

HAIR!

Girls with straight hair curl it, and girls with curly hair straighten it—it's the oldest story in the world. Miley's no exception! She prefers her hair to be straight or to have a tamed approach, with loose curls instead of anything too wild.

"My hair is, like, *really curly* so, like, this one time when I went to school, when I left the house it was perfectly fine, but when I go look in the mirror it was, like, it was like . . . perm! It was like, so short! It was horrible! I don't know what I did, but I guess it didn't work too well!" she told *Popstar!*.

Miley's signature look is long hair with finger curls—being young and animated, she looks best when her hair is not overly "done."

FRAGRANCE!

Miley adores cinnamon scents in particular, despite having a food allergy to it, but again, it's all about natural.

"I like mostly earthy scents. With stuff like that, you want to keep it natural—and don't use too much. It'll seem like you're trying too hard," she told *Bop*.

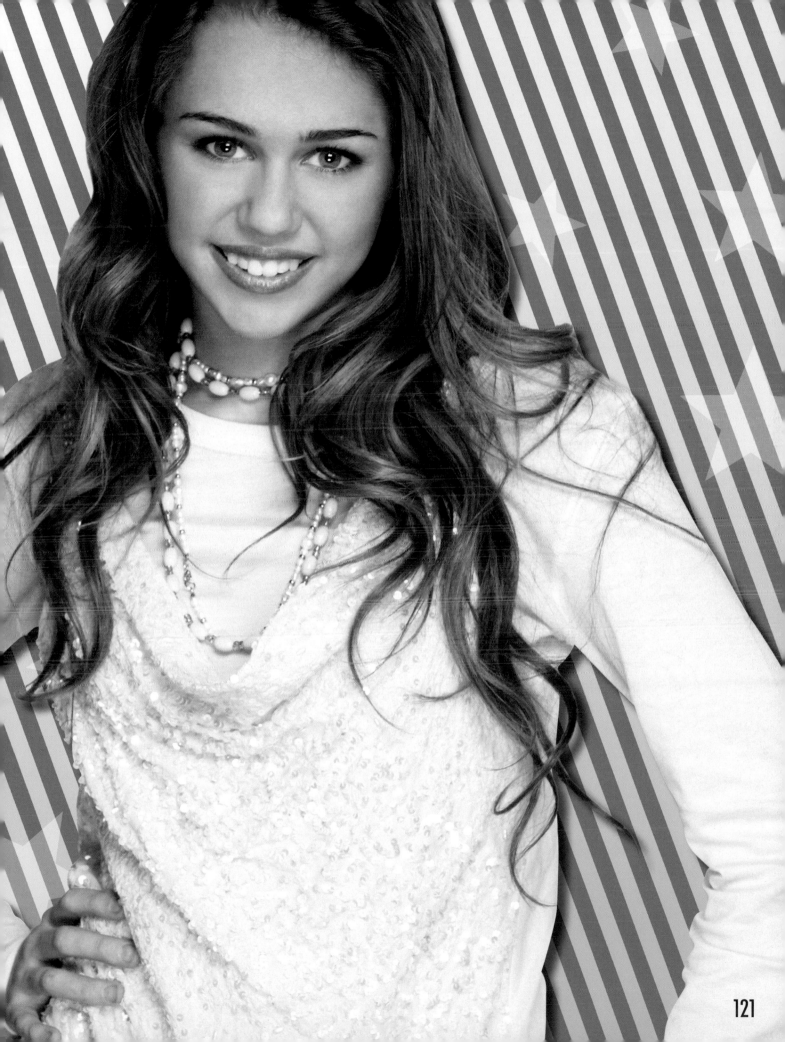

Miley might often have perfect hair, makeup, and clothes—but she's anything but Miss Perfect. And she's okay with that. Miley wants to be herself, and that includes learning to laugh at any embarrassing moments. You won't believe some of these!

"Embarrassing moments happen to the best of us and they will always happen. I just joke about it and laugh it off."

—Miley, *Tiger Beat*

"I don't want [snakes] near me, I don't want to see them. So [my brother] decides to go get this [wooden] mechanical rattlesnake and put it in my bed. He put it in the bottom of my bed and of course he's, like, put it perfectly . . . he just wanted to hear me scream!"

—Miley, *Popstar!*

"I was about to go out for the dance team. I was dancing in the hallway and I had on a jean skirt and I slipped and it ripped up and I fell flat on my face. I tried to talk it off and my face was all red and then the teacher was like, 'Are you okay?' I got to the bathroom and took a look and saw that I had a knot [on my head] the size of a softball."

—Miley, *Life Story*

"There's a boyfriend episode [of Hannah Montana] and the guy was in there, Jason and Mitchel—basically, everybody that was on the show was in my room. And Emily decides to stick her foot out to see if I could fall. Not only do I fall, I do a Superman. I go in the air . . . and my face hit the ground pretty hard, but then we had an indentation in my floor!"

—Miley, *Disney Channel press event*

"I remember one time me and my best friend, Lesley, were out in this parking lot and there was this big white van and Miley decided she'd go see if she could go sit on it. So I climbed onto the car and the alarm goes off. There were actually people in the car. They were like, 'What are you doing touching our car?' and they got so mad at me. It was so funny. I have pictures of the light blinking!"

—Miley, Popstar!

"I wore my shirt backwards to the Over the Hedge premiere, like completely backwards—and I was with Corbin [Bleu]. Me and Corbin were walking and all of a sudden he's like, 'Do you know your shirt is on backwards?' And I was like, 'Oh, crap!' And then I fell, actually, and I pulled Vanessa [Hudgens] down with me! So thank goodness for friends, right? If I wouldn't have had her it would've been all me down the red carpet on my face!"

—Miley, popstaronline.com

In June 2006, Miley appeared on Regis & Kelly, and when she came out... Kelly stepped right on her foot! Ouch!

123

WOULD YOU SHARE Clothes WITH Miley?

1.

I almost never wear . . .

A. jeans!
B. pink!
C. overalls!

5.

My style choices tend to be . . .

A. consistent!
B. loud!
C. unique!

2.

If I have a fave outfit, I wear it . . .

A. all the time!
B. often!
C. on special occasions!

6.

If my BFF wanted to share clothes, I'd . . .

A. say, "Heck, yeah!"
B. discourage her!
C. try it once!

3.

My main goal with my clothes is to feel . . .

A. comfy!
B. glamorous!
C. outrageous!

7.

My approach to bargain-hunting is . . .

A. money is no object!
B. never overspend!
C. you get what you pay for!

4.

A good place for basics is . . .

A. Target
B. Bebe
C. Forever 21

8.

Bright colors . . .

A. sometimes work well on me!
B. scare me to death!
C. are a trend I avoid!

8–16 Points!

NOPE!

You have your own, unique sense of style that probably wouldn't "match" Miley's. But you two would have a blast shopping together!

17–40 Points!

YEP!

You and Miley probably have very similar taste in clothes and would save lots of money swapping—like she does with Ashley Tisdale!

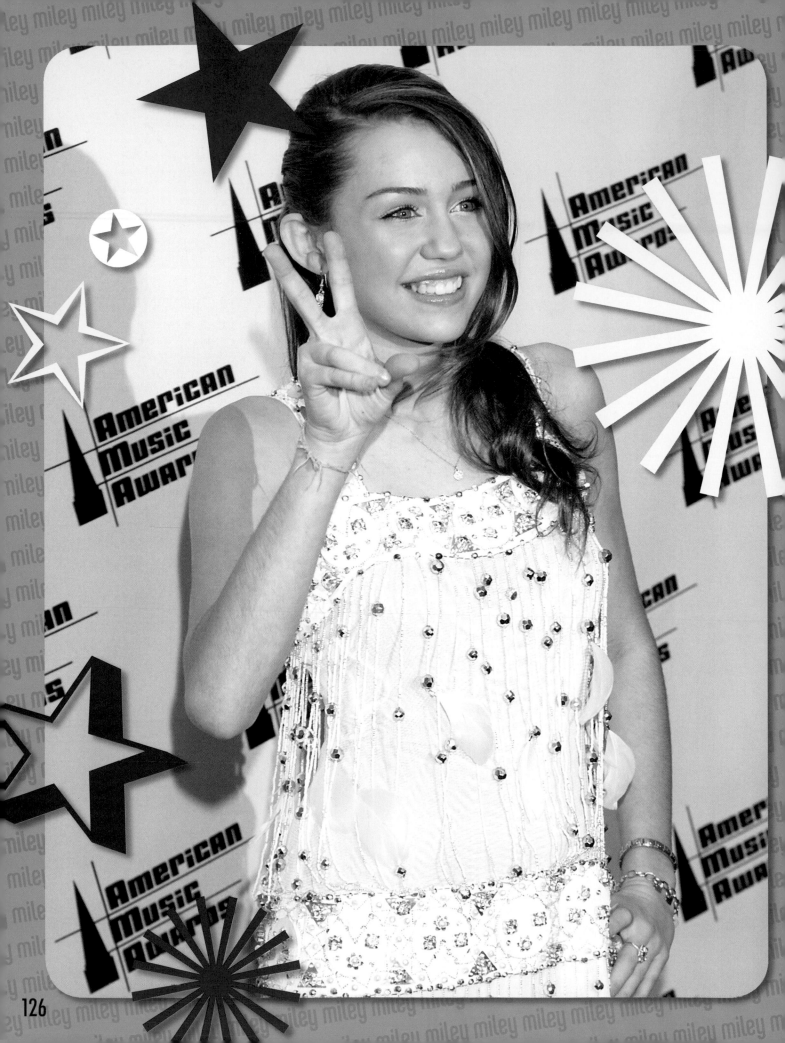

bigger than us: miley's causes!

You may not know this about Miley because it doesn't attract paparazzi and splashy magazine spreads, but she's a big believer in giving back to her fans and to the world at large. People in need have a friend in Miley!

One of the causes close to Miley and Billy Ray's hearts is Boys & Girls Clubs of America. In September 2006, the daddy/daughter dynamos spent a day with nearly four thousand youngsters, riding rides at Pacific Park on the Santa Monica Pier in California. The charity provides safe places for kids so they won't spend their formative years alone or hanging out on the streets. Father and daughter felt so strongly about the cause that they became national spokespeople for it.

Miley also has loaned her star power to the Elizabeth Glaser Pediatric AIDS Foundation. Founded by a woman (the wife of famous '70s TV actor Paul Michael Glaser) who contracted HIV (before it was even discovered) through a blood transfusion during childbirth, the foundation works to prevent HIV transmission and to provide care for children battling the virus.

In 2006, Miley arrived at the foundation's annual Celebrity Carnival fully prepared.

Speaking with WireImage.com, she said, "Me and my mom had gotten, like, online and we had looked at all the pictures and it's really great to get to see, like, all these families and all the stars and everybody to get to come together and kinda help and just be one unit."

Dressed in supercute polka dots, she happily answered all the reporters' questions before going in to head up an autograph booth, where hundreds of lucky children got up close and personal with the newly famous Disney Channel starlet!

Popstar!'s reporter asked Miley if she enjoyed such charitable festivities, to which Miley replied, "When I'm working on set, I don't get to see my family that much, but when we're getting to do, like, you know, festivals, everything fun—we get to come together. My little sister's face lights up when she gets to go somewhere, so I just love being here and being with all the cool people!"

Some of Miley's drive to give back rubbed off on her from costar Emily Osment. In Miley and Emily's opinion, giving back is one of the best parts of being famous.

"We have a little thing called phone friends. We call people in the hospital with cancer and, you know, all kinds of diseases. We call them and they get to ask us questions. It's really great to get, you know, not only get to do what you love but help other people reach their dreams, too."

DOG GONE!

Miley attracted lots of paparazzi attention in March 2008 when she went on a mission to find her aunt's missing two-pound Maltese. Armed with homemade signs she and her friend Mandy made, Miley biked around her neighborhood in search of the wayward pooch as photographers captured the whole ordeal.

In the end, the pup was returned by some neighbors who'd seen it running loose and had taken it with them to a funeral they had to attend—apparently they had no time to drive back to the Cyrus residence until after the funeral.

Luckily, the dog was safe and sound, and the Cyrus brood learned a valuable lesson about making sure all the doors are closed!

She made this kind of visit in January 2008 while busy touring, stopping at Georgetown University Medical Center and Children's Hospital. She met more than a hundred sick kids that day!

Miley's big heart also drew her onto a highly rated episode of *Extreme Makeover: Home Edition*, which found her surprising the Gilyeat family, whose four kids got backstage passes to see her in concert.

"I love the show's message," she told *TV Guide*. "No matter how sad or negative the family's situation is, everyone comes out smiling. I can't get enough of the show. It's a thrill to watch so many people get the help they deserve."

Miley's always thinking of others—and since she's rumored to be worth tens of millions of dollars, that's good news for all the worthy charities that touch her heart!

"We have a little thing called phone friends. We call people in the hospital with cancer and, you know, all kinds of diseases. We call them and they get to ask us questions. It's really great to get, you know, not only get to do what you love but help other people reach their dreams, too."

WHICH *Cause* IS FOR *You?*

Miley's big heart is a big inspiration to us all. Wanna help others but you're not sure how? Take this quiz for guidance!

When faced with a dramatic situation that requires a human touch, my most likely reaction would be described as . . .
A. warm!
B. strong!

If I see a stray animal in my neighborhood, I . . .
A. want it!
B. feel sad!

When one of my best friends gets sick, I'm most likely to . . .
A. go for a visit!
B. send a card

There's no way to know for sure what's happening inside another person's heart, but I think most people are basically . . .
A. good-intentioned!
B. too selfish!

Some people avoid sad movies at all costs. In my experience, a sad movie would probably make me . . .
A. cry!
B. think!

Visiting Sick Kids!

Like Miley, you might just be perfectly cut out for visiting children in the hospital who could use a friend! Miley has visited ailing kids many times, as has her role model Hilary Duff, usually with no publicity. It's not always about getting attention for your good deeds, and you understand this better than most.

130

If I had to work with some classmates to cook up a business plan as part of my homework, I'd start off by telling them I'm better at . . .

A. hands-on work!

B. creative ideas!

If I entered a contest where the prize was winning $5,000 to give to charity, I'd . . .

A. spread it around!

B. focus on one cause!

When I start big new home-work assignments, I . . .

A. work carefully!

B. work fast!

Going Green!

You could have a good mind for the big picture! Putting it to use on ways to improve the environment could be for you. This is a charitable field that is exploding lately, with so much attention focused on global warming and overall environmentalism. Protecting nature is second *nature* for you.

Saving Animals!

It's likely that our furry friends mean the world to you. Why not fight for their rights? Groups such as PETA have grown exponentially as young supporters have swelled their ranks, bringing enthusiasm and a deep appreciation for the sanctity of four-legged life. Animals are people, too, and people can sometimes be animals—consider working toward a world where we can all live in harmony.

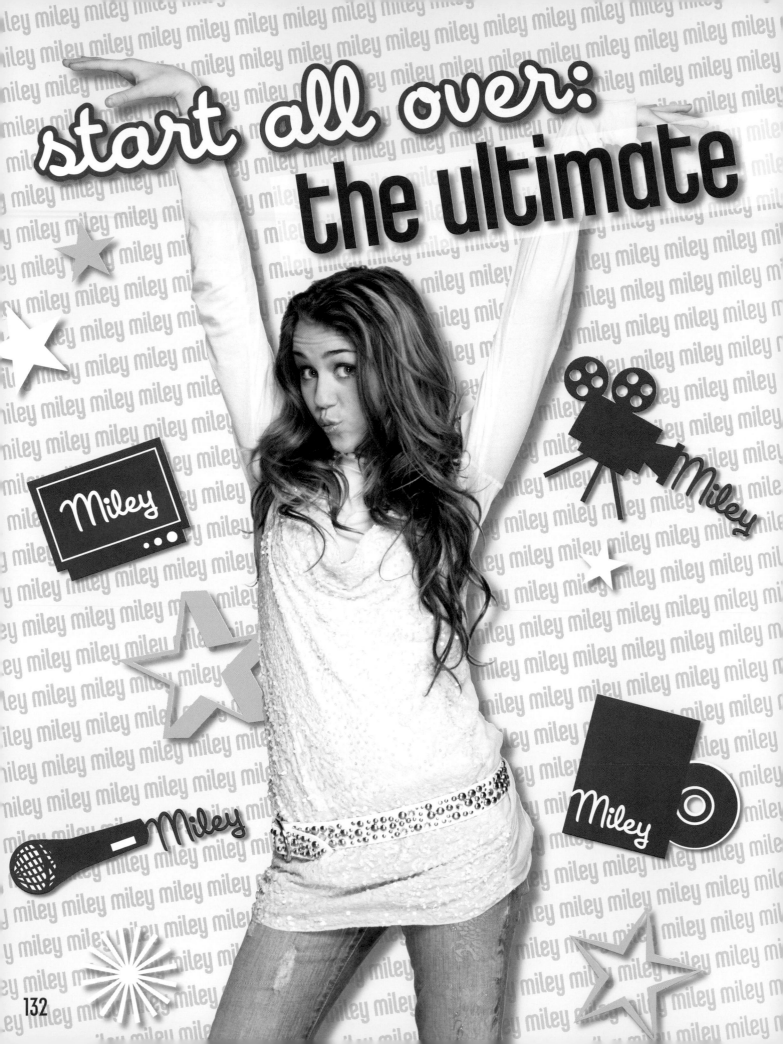

mileyography!

if we were a movie: movies!

Big Fish (Columbia Pictures, PG-13)
Director: **Tim Burton**
Theatrical release: **December 10, 2003**
DVD release: **April 27, 2004 (Sony)**
Budget: **$70 million**
Domestic gross: **$66,809,693**
International gross: **$56,109,362**
Character: **Ruthie, age eight (credited as "Destiny Cyrus")**

Best of Both Worlds Concert: The 3-D Movie
(Buena Vista/PACE, G)
Director: **Bruce Hendricks**
Theatrical release: **February 1, 2008**
DVD release: **August 19, 2008**
Domestic gross: **$65,256,800**
International gross: **$3,969,745**
Character: **Herself/Hannah Montana**

With what was supposed to be only a one-week run, *Hannah Montana/Miley Cyrus: Best of Both Worlds Concert Tour* broke records, forcing Disney to extend its time in theaters to five weeks. The film made more than $31 million in its opening weekend thanks in large part to enormous advance sales: more than $9 million in advance tickets were sold by Fandango.com alone! Also helping its case was the movie's short running time—just over an hour—guaranteeing many more screenings. By the time it left theaters, the film had played on every one of the country's 683 3-D screens, giving millions of fans a chance to see Hannah, Miley, and the Jonas Brothers in a way they'd been unable to after the sold-out concert wrapped.

"I'm excited! Once I heard the news of what it was doing in the theaters, my first thought was just, 'Wow!' . . . I'm super-stoked."

—Miley to Ryan Seacrest on her concert film's number-one debut

Bolt (Walt Disney Animation Studios)
Director: Chris Williams and Byron Howard
Theatrical release: November 26, 2008
Character: Penny

Miley voices the role of Penny in this animated feature about a doggie actor who finds out his character's superpowers are just TV magic when he's separated from his beloved show. Miley's distinctive voice was a welcome addition to a movie that also featured the voice talent of Hollywood superstar John Travolta.

The Hannah Montana Movie (Buena Vista)
Director: Peter Chelsom
Theatrical release: May 1, 2009
Character: Miley Stewart/Hannah Montana

make some noise: music!

Hannah Montana: Songs from and Inspired by the Hit TV Series (Walt Disney Records)

Released: October 24, 2006
Debut: number one (281,000 in the first week)
Peak position: number one

1. "The Best of Both Worlds" (as "Hannah Montana")
2. "Who Said" (as "Hannah Montana")
3. "Just Like You" (as "Hannah Montana")
4. "Pumpin' Up the Party" (as "Hannah Montana")
5. "If We Were a Movie" (as "Hannah Montana")
6. "I Got Nerve" (as "Hannah Montana")
7. "The Other Side of Me" (as "Hannah Montana")
8. "This Is the Life" (as "Hannah Montana")
9. "Pop Princess" (by The Click Five)
10. "She's No You" (by Jesse McCartney)
11. "Find Yourself in You" (by Everlife)
12. "Shining Star" (by B5)
13. "I Learned from You" (by Miley Cyrus and Billy Ray Cyrus)

Hannah Montana: 2-Disc Special Edition Soundtrack (Walt Disney Records)

Released: March 20, 2007

DISC 1:

1. "The Best of Both Worlds" (as "Hannah Montana")
2. "Who Said" (as "Hannah Montana")
3. "Just Like You" (as "Hannah Montana")
4. "Pumpin' Up the Party" (as "Hannah Montana")
5. "If We Were a Movie" (as "Hannah Montana")
6. "I Got Nerve" (as "Hannah Montana")
7. "The Other Side of Me" (as "Hannah Montana")
8. "This Is the Life" (as "Hannah Montana")
9. "Pop Princess" (by The Click Five)
10. "She's No You" (by Jesse McCartney)
11. "Find Yourself in You" (by Everlife)
12. "Shining Star" (by B5)
13. "I Learned from You" (by Miley Cyrus and Billy Ray Cyrus)

Bonus track. "Nobody's Perfect" (as "Hannah Montana")

DISC 2:

1. Exclusive Hannah Montana Backstage Secrets
2. "Nobody's Perfect" live (as "Hannah Montana")

"It's more of a meeting-me type thing. You're getting more into who I am."
—Miley on her *Hannah Montana 2/ Meet Miley Cyrus* CD, Popstar!

"When I was working on my album, I made sure that every song was for a specific person and came from a certain inspiration."

—Miley, *Twist*

Hannah Montana 2/Meet Miley Cyrus

(Walt Disney Records)
Released: June 26, 2007
Debut: **number one** (326,000 in the first week)
Peak position: **number one**

DISC 1 (AS "HANNAH MONTANA"):

1. "We Got the Party"
2. "Nobody's Perfect"
3. "Make Some Noise"
4. "Rock Star"
5. "Old Blue Jeans"
6. "Life's What You Make It"
7. "One in a Million"
8. "Bigger Than Us"
9. "You and Me Together"
10. "True Friend"

DISC 2:

1. "See You Again"
2. "East Northumberland High"
3. "Let's Dance"
4. "G.N.O. (Girl's Night Out)"
5. "Right Here"
6. "As I Am"
7. "Start All Over"
8. "Clear"
9. "Good and Broken"
10. "I Miss You"

"I was on a raft in my backyard pool when someone told me. I was pretty freaked out! It was my second number-one album in less than a year, and it sold more than the album by Kelly Clarkson, who's actually one of my favorite artists. I was like, 'If I could come in second or third after her, I'd still be a happy camper.' But when I heard the news, I was like, 'This is the best day ever!' "

—Miley, on hitting number one, *Bop*

137

Hannah Montana (Miley Cyrus): The Best of Both Worlds Concert CD+DVD (Walt Disney Records)

Released: **April 15, 2008**

Debut: **3**

Peak position: **3**

1. "Rock Star"
2. "Life's What You Make It"
3. "Just Like You"
4. "Nobody's Perfect"
5. "Pumpin' Up the Party"
6. "I Got Nerve"
7. "We Got the Party" (featuring the Jonas Brothers)
8. "Start All Over"
9. "Good and Broken"
10. "See You Again"
11. "Let's Dance"
12. "East Northumberland High"
13. "G.N.O (Girl's Night Out)"
14. "The Best of Both Worlds"

"Zip-A-Dee-Doo-Dah" from *Disneymania 4* (Walt Disney Records) by various artists
Released: April 24, 2006

"Stand" (by Billy Ray Cyrus featuring Miley Cyrus) from *Wanna Be Your Joe* (New Door) by Billy Ray Cyrus
Released: August 22, 2006

"Part of Your World" from *Disneymania 5* (Walt Disney Records) by various artists
Released: March 27, 2007

"Rockin' Around the Christmas Tree" from *Disney Channel Holiday* (Walt Disney Records)
Released: October 16, 2007

"Ready, Set, Don't Go" (duet with Billy Ray Cyrus) from *Home at Last* (Walt Disney Records) by Billy Ray Cyrus
Released: October 22, 2007

"Since she was little, she would look at me confidently and say, 'I'm going to blow by you, Daddy. I'm going to be a singer, songwriter, entertainer,'" Billy Ray told USA Today. "She was born with a song. Musically, she is—this is the only time I'm going to brag—she's the real deal musically. . . . You know the saying she's got an old soul? Well, she's got an old soul, and her old soul's got a lot of soul."

ARE YOU A *Miley Maestro?*

Take this quiz to see how "in tune" you are with the musical side of Miley!

Which two Miley songs can be found in the video game *Thrillville: Off the Rails?*

A. "Life's What You Make It" and "See You Again"

B. "Start All Over" and "See You Again"

C. "East Northumberland High" and "Good and Broken"

"G.N.O" stands for "_____ Night Out."

A. "Girl's"

B. "Guy's"

C. "Great"

Which song was written for Miley's grandfather, who had recently passed away?

A. "One in a Million"

B. "I Miss You"

C. "You and Me Together"

Who sings the duet "I Learned from You" with Miley?

A. Billy Ray Cyrus

B. Nick Jonas

C. Corbin Bleu

Which of these pop acts did *not* have a song on the *Hannah Montana* Soundtrack?

A. The Click Five
B. Jesse McCartney
C. Chris Brown

Which of these Disney classics did Miley *not* sing on a *Disneymania* CD?

A. "Zip-A-Dee-Doo-Dah" from *Song of the South*
B. "Part of Your World" from *The Little Mermaid*
C. "Whistle While You Work" from *Snow White and the Seven Dwarfs*

Where did Miley Cyrus— as Hannah Montana— give her first public performance?

A. Typhoon Lagoon at Walt Disney World!
B. Madison Square Garden in New York!
C. On her ranch in Tennessee!

Which of these groups was the opening act for most of Miley's *Best of Both Worlds Tour*?

A. Kelly Clarkson
B. Cheetah Girls
C. Jonas Brothers

Which of Miley's songs is her favorite?

A. "Clear"
B. "See You Again"
C. "As I Am"

Which of Miley's videos was nominated as "Tearjerker Video of the Year" by the CMT Music Awards?

A. "Start All Over"
B. "Ready, Set, Don't Go"
C. "The Other Side of Me"

Answers

1. C	6. C
2. A	7. A
3. B	8. C
4. A	9. B
5. C	10. B

0–2 Right!
Beginner!
This is a tough quiz unless you really know your Miley! Listen a little harder!

3–6 Right!
Pro!
You're pumpin' up the party with the best of the Miley fans!

7–10 Right!
Maestro!
No doubt about it—you're a Miley-music mastermind!

WHAT KIND OF Pop Star WOULD YOU BE?

I'm better at . . .
A. dancing!
B. singing

Stage fright?
A. sometimes!
B. never!

I'd rather . . .
A. write a song!
B. dress up!

In public, I prefer . . .
A. all eyes on me!
B. some privacy!

If I hear a new song, I . . .
A. can hum it!
B. immediately know it!

Sizzlin' Stage Sensation!

You'd be a visual treat tearing across the stage and keeping whole stadiums entertained with your antics!

I hope to be good at...
A. everything!
B. one special thing!

Art should...
A. entertain!
B. inspire!

I think my talent is...
A. obvious!
B. hidden!

If I sing, I focus on...
A. the message!
B. the high notes!

Vocal Wonder!
You'd be known the world over for your powerhouse singing!

All-Around Triple Threat!
Chances are you'd be an acting/singing/dancing jill-of-all-trades!

Rockin' Role Model!
Your brand would be anchored in your sweet, upstanding personality!

the other side of me: TV!

TV SERIES!

Hannah Montana (Disney Channel)
First airdate: March 24, 2006
Character: Miley Stewart/Hannah Montana

TV GUEST SPOTS!

Doc (PAX TV)
Episode: "Men in Tights"
Airdate: November 16, 2003
Character: Kylie

The Suite Life of Zack & Cody (Disney Channel)
Episode: "That's So Suite Life of Hannah Montana"
Airdate: July 28, 2006
Character: Miley Stewart/Hannah Montana

The Emperor's New School (Disney Channel)
Episode: "The Emperor's New Musical"
Airdate: June 23, 2007
Character: Yata (voice)

The Replacements (Disney Channel)
Episode: "The Frog Prince/Snow Place Like Nome"
Airdate: July 21, 2007
Character: Celebrity star/herself (voice)

The Emperor's New School (Disney Channel)
Episode: "The Emperor's New Tuber/Room for Improvement"
Airdate: December 3, 2007
Character: Yata (voice)

DISNEY GAMES GIRL!

Miley has competed in Disney Channel's annual athletic challenge every year since 2006, but don't expect her to say she likes it! "I did my hair so I could be like, 'I really don't want to be in this game but my hair looks really good,' " she told *Popstar!* Miley has described her participation as being more about hanging out with all her friends than about taking the sporting aspects too seriously!

Miley's record in the games has been spotty! "I didn't win," she said of her 2007 rock, paper, scissors loss. "I was against my best friend, Emily, so that's kind of unfair. Like last year I was against Vanessa and they're both one of my best friends so I was like, 'You don't do that to people.' "

The truth is that Miley does not see herself as competitive. "I'm not really into the Games as much. Everyone else is really into it and I'm just like, 'Yeah, whatever, I have to go get my nails done after this. Hey, Ashley you want to go tanning?' Like me and her are here to really just hang out and have a good time!"

Miley also could be described as a nervous gamer. On a Canadian music show she was asked to play a game that found her wearing 50 Cent's name on her head, having to guess who it was by asking people who could see the name a series of questions. She eventually got it right, but not before muttering, "I'm a baby. It makes me nervous playing games!"

> ## "I'm a baby. It makes me nervous playing games!"

HOT RUMOR!

Word is that Miley might do *Further Adventures in Babysitting* with Disney Channel alum Raven-Symoné . . . but hold that thought, because nothing is confirmed!

145

MILEY: CHOICE TEEN!

Miley already has an impressive history with both Nickelodeon's Kids' Choice Awards and Fox's Teen Choice Awards.

At the 2007 Teen Choice Awards, Miley and the Jonas Brothers were introduced by Hilary Duff and promptly announced to the screaming fans that they were about to tour together. As everyone knows, that tour became one of the hottest tickets in years. They gave an award for Choice R&B Track to Sean Kingston for his "Beautiful Girls" megahit, but beautiful Miley also cleaned up at the show—she won Choice Summer Artist and Choice TV Actress: Comedy (beating America Ferrera, Eva Longoria, Tia Mowry, and Emma Roberts) that year.

In 2007 Miley won Favorite TV Actress at Kids' Choice. By 2008 she was duplicating that feat and adding Favorite Female Singer to her haul. That year's show was even more exciting thanks to a live performance of "G.N.O. (Girl's Night Out)," which featured a customized car with her name on it.

pop princess: DVDs!

Hannah Montana: Livin' the Rock Star Life (Walt Disney Video)
Released: October 24, 2006

That's So Suite Life of Hannah Montana
(Walt Disney Video)
Released: January 16, 2007

Hannah Montana: Popstar Profile
(Walt Disney Video)
Released: June 26, 2007

Hannah Montana: Life's What You Make It
(Walt Disney Video)
Released: October 9, 2007

Wish Gone Amiss: Cory in the House/Hannah Montana/The Suite Life of Zack & Cody
(Walt Disney Video)
Released: November 27, 2007

Hannah Montana: One in a Million
(Walt Disney Video)
Released: January 29, 2008

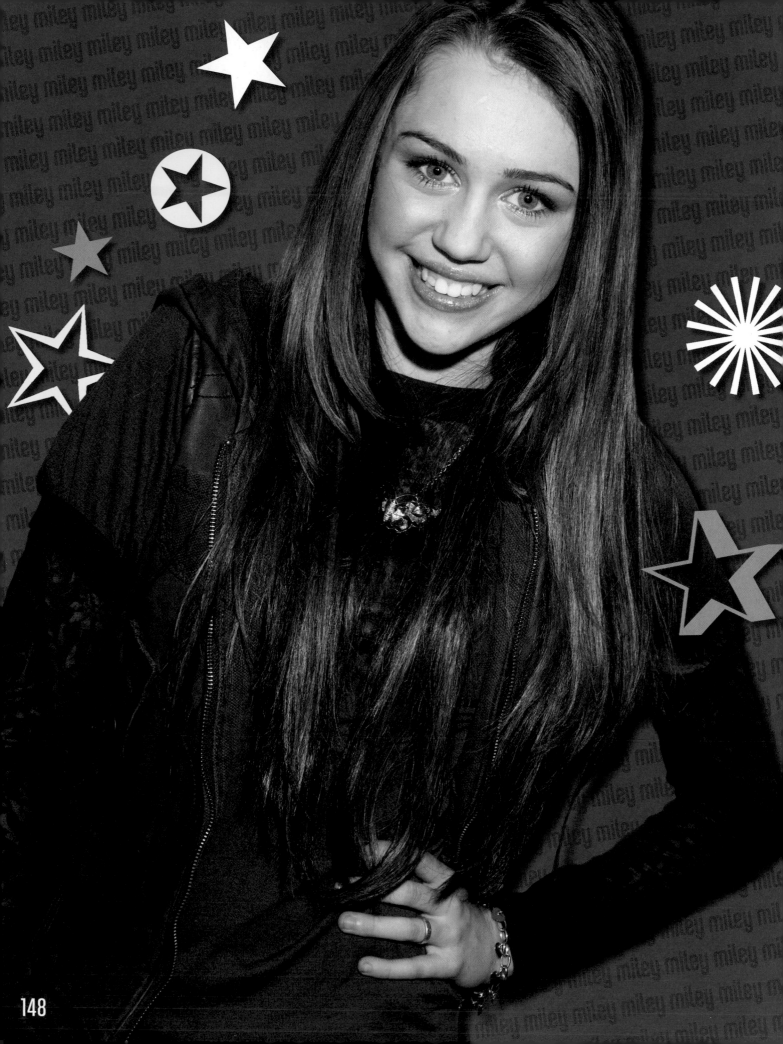

as i am: miley A to z!

A

AUTOGRAPHS: "When I was in school," Miley told *Bop* magazine, "I would write my autograph over and over and think, 'OMG, I can't wait until I really have to do this.' Now I'm doing it for real!"

B

BAKED ZITI: Miley's family recipe for this Italian dish is so amazing it was reprinted in several teen magazines in 2007 after the Disney Channel took photos of her making it with her mom, Tish!

BIKES: As Miley told *PBS Kids*: "It's My Life" online, she's a huge fan of cycling! "I ride my bike four miles every day." But she takes her passion for pedaling one step further, admitting, "I actually collect bikes!"

BLEU, CORBIN: Miley is great friends with the star of *High School Musical* and *Jump In!*—he even made a guest appearance on the very first episode of *Hannah Montana* that was ever aired! There are no plans in the works (yet), but what would you think of a romantic comedy pairing Miley and Corbin? Miley told popstaronline.com that she thinks it's a great idea! "Corbin was on the show, so we need to have him back—for sure!"

BURGER KING: One of Miley's fave fast-food indulgences. She told *Tiger Beat Celebrity Spectactular* that her half brother, Trace "always takes me to Burger King and gets everything for a dollar."

C

CAFFEINE: Miley's not allowed to have caffeine before a show, and her parents don't keep it in the house. No soda pop for this pop star!

CARTWHEELS: Mitchel told *Tiger Beat Celebrity Spectacular* that Miley and Emily can often be found doing "acrobatic" stuff on the set, such as turning cartwheels!

CHURCH CAMP: Miley went every summer as a kid. "My best summer memories were made at church camp. It's always an adventure," she reminisced to *Tiger Beat*.

CINNAMON: Miley's allergic to cinnamon, but she especially loves cinnamon-scented candles. As she told *Good Morning America*, "Can't eat it, smell it!"

CLARKSON, KELLY: Before *Hannah Montana 2/Meet Miley Cyrus* was released, the media hyped up a sales war between the record and Kelly Clarkson's *My December*, which came out the same day. Miley confessed to *Popstar!*, "I'm definitely nervous because it's actually Kelly Clarkson's new album . . . coming out with me, but I'm probably her ultimate biggest fan so if I come out second to Kelly Clarkson that's totally validating. I love her!"

COLORS: Lime green and hot pink are Miley's colors of choice. "Pink isn't just a color, it's an attitude!" *Life Story: Miley Cyrus* quotes her as saying. Couldn't agree with her more!

D

DIARY: Miley started a secret journal in 2006 and writes in it every so often, especially after a major event she wants to remember forever! She also lists her goals there.

DON'T DIE, MY LOVE: Miley's fave book nowadays is this tearjerker by Lurlene McDaniel.

DOWNTIME: Usually Miley says she has *none*! But when she does get some time to herself, she does what any normal girl would do! "Mostly when I'm home, I just like to write songs and play my guitar," she told a group of international journalists, "and hang out with my little sister, just hang out with my family."

F

FAITH: Miley told *USA Today* that her faith is not only important to her, it's also behind the reason she's famous in the first place. "That's kind of why I'm like here in Hollywood—to be like a light, a testimony to say God can take someone from Nashville and make me this, but it's His will that made this happen."

FAT-FACED: This is one of our girl's fave Mileyisms! According to costar Jason Earles, "All the kids on the show, we horse around and joke around and play with each other a ton. Miley has this whole vernacular that I don't understand, it's like this country talk. Like 'fat-faced' was a term that I'd never, ever heard before and that's when you're angry but you're trying to hide it. She's like, 'You're totally fat-faced right now.' And I'm like, 'What are you *talking* about???' She's always throwing weird terms like that out."

FIRST KISS: Miley told *M* her first kiss was at age six! "It happened when I was in the first grade playing on the playground. I was underneath the slide and my friends and I were playing this game called 'marriage.' So I got fake-married to a boy named Austin and that was it. I was like, 'You wanna marry me?' And then we kissed!"

FRIDAY: When *Hannah Montana* is filming, this is the day they shoot in front of a live studio audience. If you ever get tickets, you're in for an amazing time!

G

GRANDFATHER: Miley's beloved grandfather Ronald Ray (Ron to his friends) Cyrus was an important local politician in Greenup County, Kentucky, who sadly passed away from lung cancer in 2006. Miley has said her song "I Miss You" is dedicated to his memory. Ron and his wife, Ruth Ann, were divorced before Miley was born.

GRANDMOTHER: On her mom's side, Loretta Finley is often pictured at family events with Miley—the apple of her eye.

H

HAIR DRYER: Miley's hair dryer is light purple with sparkles! She's had it since she was eight years old, when her nanny gave it to her.

HALLOWEEN: You might think she's too old for costumes, but Miley disagrees! "I want to go and be a Fanta girl!" she recently said. "I was a hippie last year and I looked like the worst hippie ever, so I want to be a Fanta girl. The red one!"

HIDE-AND-SEEK: Miley 'fessed up during an early Disney Channel promotional day that this was her fave childhood game! "Me and my little sister used to play!"

HOROSCOPES: Miley enjoys checking out her horoscope. "We were readin' one the other day," she told *Popstar!* during an early interview. "I was tearin' my little horoscope out. It actually *did* kinda relate to me, like, 'the guy . . . is gonna be interested in other people and is gonna be ignoring you but that's his way of making you jealous!' I was like, 'I told you, Mitch!' "

I

ICE CREAM: Miley's favorite flavor of ice cream is cheesecake!

iPHONE: Miley's got one, according to Cody Linley! "We both got iPhones! When we first got them, I was like, 'I got an iPhone!' and she was like, 'So did I!' "

J

JAMBA JUICE: One of Miley's fave refreshments is the Strawberries Wild smoothie from this popular chain!

JUDGE JUDY: Miley met the famous TV judge when Judge Judy brought her grandkids to a *Hannah Montana* taping. "I freaked out when I met Judge Judy. She's my idol! I was like, 'Oh, my goodness, what do I say to her? What if she thinks I'm weird?' But she was the nicest lady ever!"

K

KETCHUP: Miley went on *The Tonight Show* in February 2008 and showed off her love for Heinz 57 ketchup by "drinking" it straight from a squeeze bottle. Miley's arguments for drinking ketchup were that it has few calories, is technically "a fruit" (?), and "tastes so good!"

KUTCHER, ASHTON: Miley and Emily both have huge crushes on the *Punk'd* prankster!

L

LIP GLOSS: Miley is never without some lip gloss in her purse—she's obsessed with having some around at all times!

LITTLE BALLERINA, THE: This adorable children's book by H. L. Ross was Miley's all-time favorite as a little girl. The story follows a would-be ballerina struggling to learn the basics about ballet, which might be what gave Miley her determination to excel at cheerleading. Now it's her little sister Noah's favorite!

LONG JOHN SILVER'S: This seafood chain offered to donate $10,000 to the Friends of the World Food Program if Miley could stop in to sample their famous fish platter. Alas, Miley wasn't able to make the appearance.

M

MASSEY, KYLE: Miley is good pals with the star of *Cory in the House*, and told *Popstar!* she'd love to have him guest-star on her show. "I love Kyle Massey! He's so funny. Like, there's not a dull moment ever. I'm like, 'Oh, my gosh, Kyle, seriously—I'm hyper but not *that* hyper, calm down!' I can't keep up!"

McCARTNEY, JESSE: The singer/songwriter (and, let's face it, hottie!) was Miley's personal pick as a guest star on *Hannah Montana*. "Jesse McCartney was my one that I wanted to be on the show. I love his acting. So I kind of got my dream come true," she told pop staronline.com. Jesse appeared on the show playing himself, causing Miley to have to choose between her school science project and a date with the heartthrob. A fantasy sequence showed the couple taking a romantic gondola ride and even sharing a kiss.

MILE: Another of Billy Ray's nicknames for his daughter.

MOTTO: Miley's motto, as told to *Tiger Beat*, is, "A trying time is no time to quit trying!"

MUSIC: Some of Miley's favorite contemporary artists include Kelly Clarkson, Christian rock bands such as Under Oath, They Said We Were Ghosts, and Copeland, as well as Michelle Branch's girl-powered duo The Wreckers. Two legendary country singer/song-writers whose music inspires Miley are Willie Nelson and Dolly Parton. Thanks to her dad's influence, she's also way into old-school bluegrass artists.

NEW ORLEANS: Miley famously got sick during a concert in this great city in January 2008. She mentioned from the stage that she felt bad, then she left. Five minutes later, though, she came back out and used a stool for the rest of her show. "Thanks, you guys. I feel a lot better, but I'm going to sit this one down!"

"NO, I JUST LOOK LIKE HER": Mitchel Musso gave Miley a T-shirt with this slogan, which she wears for a laugh. It confuses the heck out of her fans!

O

OSCARS: Miley appeared at the 2008 Oscars wearing a bright-red Valentino capped-sleeve gown. She chose it because it was the brightest of all her choices and would look "classy and hot" at the same time!

She almost didn't get to appear onstage at the Oscars at all—the powers that be doubted she deserved the distinction. But as she told Lisa Rinna on the red carpet, her concert movie with its massive box-office take earned her stage time.

Miley nearly fell on a slippery spot on the stage as she entered (several other A-list stars nearly did the same thing!), but she was the picture of poise and elegance as she introduced Kristin Chenoweth, who sang "That's How You Know" from the hit movie *Enchanted*.

P

PARTON, DOLLY: The legendary country singer guested on *Hannah Montana*—and everybody loved her! "It was really awesome for all of us to get to watch Dolly and see how she treats people," Miley told the press. "She is the nicest person you will ever meet. She's had such an amazing success and to get to watch her, you know. She's from Tennessee, too, so it's good to see her success, and knowing that that can happen to a small-town girl is awesome."

Billy Ray humbly said that working with Dolly was one of the highlights of his whole career, and Emily noted that Dolly would go around the set saying, "Have I hugged you yet today?"

Dolly's closer to Miley than most of her show's guest stars . . . she's her real-life godmother!

PHOTOGRAPHY: Miley's half sis, Brandi, takes portraits of local Nashville bands and studies photography. Miley thinks so highly of her, is it any wonder she hopes to follow in Brandi's footsteps? "I definitely plan to continue acting and singing after the show is over and would like to take a break for college. I would like to study photography," she said at the *New York Times* Sixth Annual Arts & Leisure event. "That would be a lot of fun."

PRESLEY, ELVIS: Miley used to sing songs of his such as "Hound Dog" and "Blue Suede Shoes" as an attention-grabbing toddler, and to this day she has a fave blanket with his face on it that she carries with her everywhere!

R

RANCH DRESSING: Miley is the world's worst prankster! She infamously tried to rig a trick that would have squirted ranch dressing all over Mitchel once, but it went out all over *herself* while she was testing it!

RING TONES: "I have, like, a thousand ring tones on my phone. I'm constantly playing them," Miley confirmed during her first appearance on MTV's *TRL* with Ashley Tisdale in June 2006.

ROCK CLIMBING: Miley told *Popstar!* that she has decided on this as one of her most exhausting (and scariest!) goals! "I want to go rock climbing. . . . I've only done the walls and I'm really good at the walls, but I'm kind of scared to do anything else, but that's what I really want to do!" You know Miley—once she sets her mind to it, she'll do it sooner or later!

S

SANDLER, ADAM: After the *DC Games* in 2006, Miley confessed that one of her dream costars would be none other than this famously funny guy! "I would like to act with Adam Sandler—I just met him and he's so nice!"

SAVAGE, FRED: This famous former child actor was the star of the series *The Wonder Years*. Now he's a director, and has directed several episodes of *Hannah Montana*. Mitchel remembered to *Popstar!* that Fred was welcomed to the set the first day with some good-natured joking around!

"Oh, he was *so* cool! It was so exciting," he said. "I think it was Miley who said, 'Oh, weren't you on *Happy Days*?' It was so funny. And he goes, 'Yeah, yeah, oh, well—how old am I?' He didn't care, he was just joking, he was like, 'I'm just playing with you.' He was *so* funny. And he's, like, younger . . . such a kid at heart."

SCRAPBOOKING: This is one of Miley's hobbies, something she enjoys doing with her little sister!

SECRETS: Miley's no good at keeping them, that's for sure! She told *PBS Kids*, "If you were my friend, I'd tell you not to tell me a secret, like who you have a crush on. Because you'd come over to my house and someone there would say something like, 'Oh, my gosh, I cannot believe you like him!' " Sound like it's based on experience? Oh, it is! "My best friend works at Smoothie King and she has a crush on her manager. Of course I ended up telling my mom. The next time my friend walked in the door, my mom said, 'I had no idea that you like him! I am best friends with his mother! I will totally talk to her for you.' I was like, 'Oh, no, Mom, please stop . . . she's going to kill me!' So I stopped asking secrets. Don't tell me. I don't want to know."

SHOPPING: Miley's a regular girl, just like you . . . she loves a good shopping trip! But she tends to sell it to her dad as some form of therapy. Sneaky, much? When *Hannah Montana 2: Meet Miley Cyrus* was about to drop and Miley was swamped with promotional activities, she confessed to popstaronline.com, "My excuse is, 'Dad, me and my girlfriends are going to go shopping. I never get to do stuff like that, Dad. It's good for the soul! Daddy, it's really good for you to go out shopping. Bring your credit card!' "

SHOWER: When Miley was little, she loved to lock people in her family's glass-door shower stall!

SIDEKICK: "I'm obsessed with my Sidekick!" Miley candidly admits. "I take that everywhere!"

STARBUCKS: Miley's such a big fan of the coffee chain that she once *performed* there! Why? "I got in serious trouble because I lost my credit card that I had just gotten," she told *Twist*. "I had no money and I wanted to go shopping so I played at Starbucks." Guess how much she earned? Seven measly dollars!

SUMO WRESTLER: Miley's second appearance on MTV's *TRL* in October 2006 was quite eventful! Host Damien Fahey warned her he was about to wipe the smile off of her face with a big surprise. "Why would you want to *take away* my smile? People usually want to *make* you smile!" she protested. Then out came a gigantic sumo wrestler, proving Damien wrong—good-humored Miley wound up smiling bigger than ever!

T

TARDINESS: Miley's so bad about being on time that her recording sessions are always scheduled for late afternoon!

TEETH: According to Emily Osment, who blabbed to *Tiger Beat*, Miley's "obsessed" with brushing her teeth! "Whenever I spend the night at her house, she'll say, 'I'm going to brush my teeth now. You have to brush your teeth, too!'"

THANKSGIVING: Turkey Day is Miley's fave holiday! Why? "It's (around) my birthday. It's like a feast for *me*, but with cake afterward, not fruitcake or whatever it's called!"

TRIBUNE STUDIOS: The Los Angeles facility where *Hannah Montana* is filmed!

TRUMP HOTEL: In December 2007, Nick Jonas and Miley planned a holiday party at this New York City hot spot in the ballroom.

U

URBAN OUTFITTERS: Among her many fave stores, Miley told *Bop* that she and her sister Brandi are addicted to Urban Outfitters! "There's one down the street from our house and we go crazy. We go every other day, we can't stop!"

V

VALENTINE'S DAY: Miley admitted to *Popstar!*, "I'm not a big Valentine's Day person." But in a pinch, her fave gifts from boys on V-Day are teddy bears!

VEGETARIAN: Miley doesn't eat meat! But she doesn't miss it. "My mom makes the best veggie patties!" she told *Tiger Beat*.

Y

YOU: Miley's fans mean the world to her—that's something she's always said when asked how it feels to be approached in public for autographs or how it feels to be onstage hearing countless screams. "You do everything for the fans," Miley told popstaronline.com shortly after her career took off. "Without your fans, you can't do the things you want to do—singing, acting, or anything else." In fact, Miley and her BFF Mandy Jiroux started The Miley & Mandy Show on YouTube to have a direct link to Miley's fans, to entertain you (for free), to answer your questions, and to be themselves. In the end, this is one major reason why Miley has so many fans in the first place—she's always *herself*.

Bibliography!

Barbara Walters Special. February 24, 2008.

Brady, James. "In Step with Miley Cyrus." *Parade*, February 4, 2007.

Bop. "*Bop*'s Top 10 Miley-isms." October 2007.

———. "Boys?! Aargh!" January 2007.

———. "Get My Look!" June/July 2007.

———. "Miley's Biggest Moments." January 2008.

———. "Miley's Dating Drama." February 2008.

———. "My Perfect Day." December 2007.

———. "My Secret Journal: You Can Read It!" June/July 2007.

Connelly, Chris. "Too Young for Hollywood?" ABC News.com, October 12, 2007.

Disney Adventures. "Go on Set with Hannah Montana." October 2007.

Disney Channel International Press Tour. 2006.

Gerome, John. "Tennessee Lands Filming for *Hannah Montana* Movie." *USA Today,* February 25, 2008.

Graser, Marc. "Hudson Acquires Tribune Studios." *Variety*, January 31, 2008.

J-14. "Dating Do's & Don'ts." February 2008.

———. "Party Like Miley." January 2008.

———. "Shop with Miley." December 2007.

———. "Why Miley Will Never Be Britney." July 2007.

Life Story: Jonas Brothers—Share Every Minute of Their Incredible Rise to Fame! Bauer, 2008.

Life Story: Miley Cyrus—America's Most-Beloved Teen Star! Bauer, 2008.

Life Story: Miley—She's Living a Dream Come True! Bauer, 2007.

Life Story: Miley Cyrus—A Tribute to America's #1 Teen Sensation! Bauer, 2007.

M. "Don't Settle for the Wrong Guy." January/February 2008.

———. "The Fight That Changed My Life." March 2007.

———. "Hook-Ups & Heartache." March 2008.

———. "Star Scrapbook." December 2007.

———. "Truth or Rumor? Special." May 2007.

———. "When Will I Meet the Right Guy?" April 2007.

———. "Who's Making JB Blush?" March 2008.

Motavalli, Maya, with Ed Martin. "Miley Cyrus Talks about Her New Disney Channel Series *Hannah Montana.*" MediaVillage.com, May 23, 2006.

New York Times. Sixth Annual Arts & Leisure Weekend. January 4, 2007.

———. "Hannah Montana and Miley Cyrus: A Tale of Two Tweens." April 20, 2006.

Oldenburg, Ann. "Miley Cyrus Fulfills Her Destiny." *USA Today*, January 14, 2007.

PBSKids.org, "It's My Life." June 26, 2007.

Popstar! Issues of April 2006 to May 2008.

Rocky Today: The Magazine of Rocky Mountain College 2006. 2006.

Steinberg, Jacques. "Choosing Family over Fame and Fortune." ABCNews.com, March 13, 2004.

Teen. "Best of Both Worlds." Spring 2007.

Tiger Beat. "Come to Miley's Sleepover." March 2008.

———. "Hollywood BFF Secrets—Revealed." May 2007.

———. "I Didn't Give Up!" June 2007.

———. "I Had a Bad Day." April 2007.

———. " 'I Met Miley!' " January/February 2008.

———. "Miley On . . ." October 2007.

———. "Miley's Crush Drama." November 2007.

———. "Miley's Summer Secrets." September 2007.

———. "100 Star Secrets!" November 2007.

———. "30 Ways to Make 2008 Rock" January/February 2008.

Tiger Beat Celebrity Spectacular. "My Secret Talent!" Winter 2008.

———. "Wanna Hang at *Hannah* with Me?" Winter 2008.

———. "You Don't Know This, but . . ." Winter 2008.

Hochman, David. "Miley Cyrus Sings for *Extreme Makeover: Home Edition.*" *TV Guide*, February 1, 2008.

Twist. "The Craziest Thing I Did for a Guy." May/June 2007.

———. "Fact or Fiction?" January 2008.

———. "Fashion Obsessions." July 2007.

———. "Flirt Fest: Summer Love Secrets!" July 2007.

———. "Miley Dishes on Dating Nick!" February 2008.

———. "Miley & Nick: Getting Close on Tour." December 2007.

———. "Miley & Nick's Holiday on Tour!" January 2008.

———. "Miley Shops for Her Tour!" December 2007.

———. "Miley Update!" February 2008.

Official Miley Sites!

MileyCyrus.com

MileyWorld.com

MySpace.com/MileyCyrus

Youtube.com/mileymandy

Other Sites!

AccessHollywood.com

Amazon.com

BoxOfficeMojo.com

Disney.com

EOnline.com

IMDB.com

Myspace.com/popstarmagazine

Popstaronline.com

Tigerbeatmag.com

TVTome.com

Wikipedia.org

Youtube.com/popstarmagazine